DRAWING AND PAINTING
ANIMALS

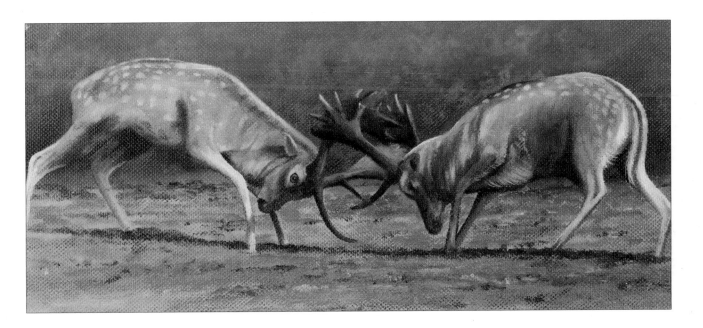

How to create beautiful artworks of mammals, amphibians and reptiles, with expert tutorials and 14 projects shown in more than 470 photographs and illustrations

JONATHAN TRUSS AND SARAH HOGGETT

southwater

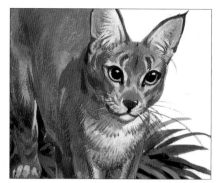
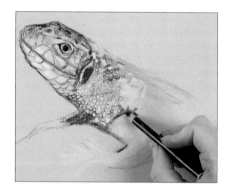

This edition is published by Southwater
an imprint of Anness Publishing Ltd
Blaby Road, Wigston
Leicestershire LE18 4SE
info@anness.com

www.southwaterbooks.com
www.annesspublishing.com

If you like the images in this book and would
like to investigate using them for publishing,
promotions or advertising, please visit our website
www.practicalpictures.com for more information.

© Anness Publishing Ltd 2012

A CIP catalogue record for this book
is available from the British Library.

Publisher: Joanna Lorenz
Senior Editor: Felicity Forster
Photographers: Martin Norris and Jessica Madge
Designer: Ian Sandom
Cover Design: Nigel Partridge
Production Controller: Mai-Ling Collyer

Previously published as part of a larger volume,
A Masterclass in Drawing & Painting Animals

Special thanks to the following artists for producing the sketches
and step-by-step demonstrations used in this book:
Lucie Cookson: 37; 94–9; 112–17; 118–21.
Paul Dyson: 39 (top); 54–9; 76–81.
Timothy Easton: 45.
Abigail Edgar: 36 (top); 64–9; 100–5; 122–5.
Trudy Friend: 32 (left); 34 (right); 38 (bottom).
Wendy Jelbert: 82–7.
Beverley Johnston: 70–5.
Melvyn Petterson: 48–53; 60–3.
Jonathan Truss: 26; 27 (bottom); 28; 29 (top); 30 (both); 32 (right);
33; 34 (left); 35; 38 (top); 46 (bottom); 88–93; 106–11.

Thanks also to the following for permission to reproduce photographs:
Pat Ellacott (www.patellacott.co.uk): 44 (bottom).
Tracy Hall (www.watercolour-artist.co.uk): 42 (top); 47 (top).
Jonathan Hibberd: 60 (top); 64 (top).
iStockphoto: 70 (top); 94 (top); 100 (top); 118 (top); 122 (left).
Jonathan Latimer (www.jonathanlatimer.com): 43 (bottom);
44 (top left and top right).
Martin Ridley (www.martinridley.com): 43 (top); 46 (top).
David Stribbling (www.davidstribbling.com): 42 (bottom); 47 (bottom).
Jonathan Truss (www.jonathantruss.com): 7 (both); 33 (top);
34 (bottom); 112 (left).
Tina Warren (www.artist-tinawarren.com): 6 (bottom).

PUBLISHER'S NOTE

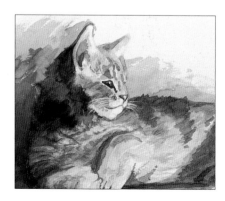
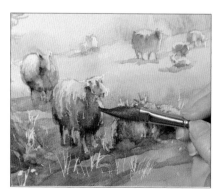
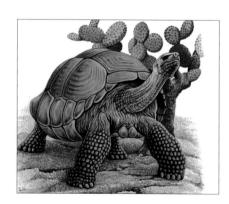

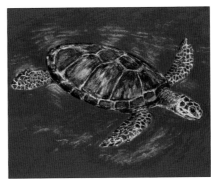

Contents

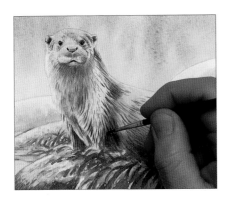
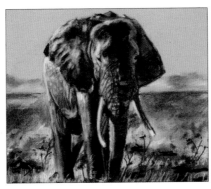

Introduction

Paintings of wildlife are among the oldest surviving forms of pictorial representation on earth, created thousands of years ago by cave dwellers who had only the most rudimentary of tools. Wildlife was, however, largely ignored by Western artists as potential subject matter for many centuries. There are notable exceptions, of course. To name but two, the works of the German artist Albrecht Dürer (1471–1528) include wonderfully detailed watercolours of animals that remain unsurpassed to this day, while the English artist George Stubbs (1724–1806) is still renowned as one of the greatest equestrian artists ever. There is also a long history of painting flora and fauna in the interests of scientific research. Illustrators accompanied many of the great explorers on their voyages in order to make visual records of the new flora and fauna they discovered.

Animals in the history of art

In terms of art history, animals have featured in paintings more often for their symbolic meaning (particularly in the religious art of the Middle Ages and Renaissance) than for any other reason. Even paintings in which they are the main subject, such as the works of Sir Edwin Landseer (1803–73), often tend to portray animals in an idealized, romanticized landscape that says more about the individual artist's view of the world than about the animals themselves.

It is only relatively recently – perhaps in the last 100–150 years or so – that wildlife art has become widely accepted as a subject in its own right. The German painter Friedrich Wilhelm Kühnert (1865–1926) was perhaps one of the first European artists to specialize in painting wildlife, and travelled widely in east Africa in order to paint animals in their natural habitat. Maybe this growing interest in wildlife is a result of people seeing more of the wonders of the natural world – through

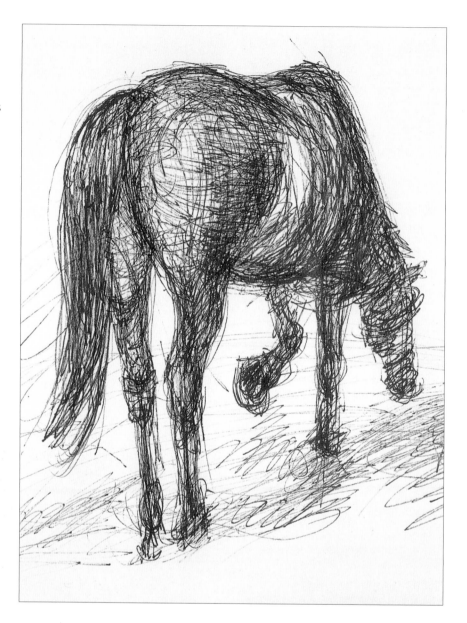

▲ **Careful control**
This pen-and-ink sketch has a spontaneous feel but it has been carefully thought out. The lines and scribbles may appear random, but they follow either the form of the animal or the direction in which the hair grows: note the curved lines on the barrel of the body, the long flowing lines of the tail, and how some areas on the flank and belly are left virtually untouched to convey the play of bright light on the form.

▶ **Tonal awareness**
With an almost monochromatic subject such as this gorilla, careful observation of the tones is the key. Note how the soft fur, created by blending the oil paint wet into wet, frames the animal's expressive face.

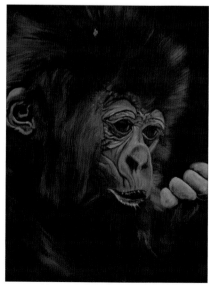

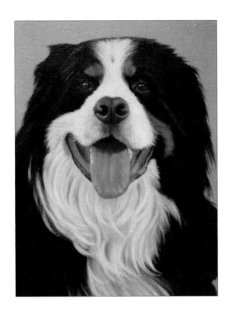

▲ **The familiar**
If you're new to drawing and painting, a family pet is a good subject to start with, as you will know instantly if you've managed to capture its character and personality.

their own travels or through natural history documentaries; at the same time, they have also become more aware of the importance of biodiversity and conservation. Either way, more and more people are entranced by the beauty of the natural world and the creatures that we share it with.

Anyone who has painted a landscape scene full of wildlife knows about the detail involved in producing 'animal art'. The animal artist has to think about exactly the same things as any other artist – composition, light, tones, colour, shadows, and so on. But he or she also has to contend with topics that are peculiar to wildlife subjects, such as how to paint fur or scales, and how to make sure that the animals are appropriate to the landscape in which they're placed – and so the whole subject area provides many challenges that are quite unique to animal art.

How this book is organized

This book is designed to provide a thorough introduction to drawing and painting mammals, amphibians and reptiles. After a quick look at the tools and materials available – from pencils and pastels to paints and paintbrushes – we move on to a tutorials section that sets out some of the technicalities, from learning how to paint eyes, teeth, claws and hooves to capturing the texture of fur, skin and scales. Here you will find short practice exercises that you can use as a starting point alongside sketches and studies by professional artists. If you're a complete beginner, it's a good idea to work through this chapter page by page to give yourself a thorough grounding. If you've already done some wildlife painting, turn to it for a refresher course whenever you need extra guidance on specific topics.

The next part of the book begins with a gallery of works by professional artists that you can use as a source of inspiration, followed by a series of step-by-step demonstrations covering a range of subjects in different media, from domestic pets to animals in the wild, in their natural habitat. All the demonstrations are by professional artists with many years' experience.

Even if the subject does not appeal to you, or the artist works in a medium with which you are not familiar, take the time to study them. You'll glean all kinds of useful tips and insights that you can include in your own work. You will also quickly realize that you do not have to fly to an exotic location to find interesting animals; even in your own garden or local park there will be an abundance of animals to draw and paint, or you could visit your local zoo or wildlife park.

Capturing the beauty of the natural world is an engrossing challenge, and this book will help you to produce studies and artworks of all kinds of animals.

▼ **Unobtrusive background**
The browns, ochres and creamy yellows of the giraffe's coat are echoed in the background, the colours blended on the canvas to create a soft, impressionistic blur against which the animal stands out sharply.

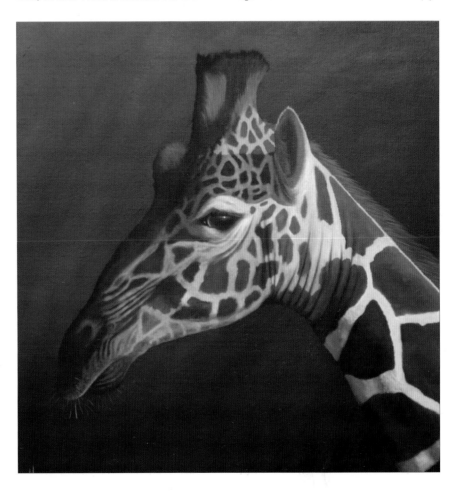

Materials

Most artists have one medium in which they prefer to work. For some, it's the translucency of watercolour that captures their imagination, while others love the linear detailing that can be achieved with pen and ink. Or perhaps it's the versatility of soft pastels that appeals, or the soft, buttery consistency of oil paints. You might use easily portable pencils, charcoal or coloured pastels for quick sketches of animals in their natural habitat, and another quick-drying medium, such as acrylics, for more detailed studies back at home, in your own studio. The important thing is to become familiar with what your chosen materials can do, so this chapter sets out the characteristics of all the main drawing and painting media. And if you're already experienced in one medium, then why not use the information given here to try out something different? Experimenting with a range of different materials is a great way to create exciting new visual effects.

Monochrome media

For sketching and underdrawing, as well as for striking studies in contrast and line, there are many different monochrome media, all of which offer different qualities to your artwork. A good selection is the foundation of your personal art store, and it is worth exploring many media, including different brands, to find the ones you like working with.

Pencils

The grading letters and numbers on a pencil relate to its hardness. 9H is the hardest, down to HB and F (for fine) and then up to 9B, which is the softest. The higher the proportion of clay to graphite, the harder the pencil. A choice of five grades – say, a 2H, HB, 2B, 4B and 6B – is fine for most purposes.

Soft pencils give a very dense, black mark, while hard pencils give a grey one. The differences can be seen below – these marks were made by appying the same pressure to different grades of pencil. If you require a darker mark, do not try to apply more pressure, but switch to a softer pencil.

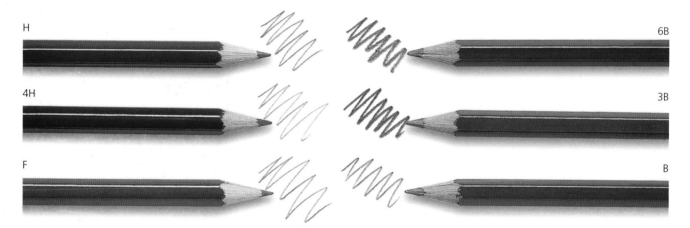

Water-soluble graphite pencils

There are also water-soluble graphite pencils, which are made with a binder that dissolves in water. Available in a range of grades, they can be used dry, dipped in water or worked into with a brush and water to create a range of watercolour-like effects. Water-soluble graphite pencils are an ideal tool for sketching on location, as they allow you to combine linear marks with tonal washes. Use the tip for fine details and the side of the pencil for area coverage.

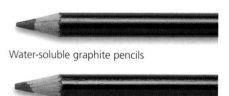

Water-soluble graphite pencils

Graphite sticks

Solid sticks of graphite come in various sizes and grades. Some resemble conventional pencils, while others are shorter and thicker. You can also buy irregular-shaped chunks and fine graphite powder, as well as thinner strips of graphite in varying degrees of hardness that fit into a barrel with a clutch mechanism to feed them through.

Graphite sticks are capable of making a wider range of marks than conventional graphite pencils.

For example, you can use the point or edge of a stick to make a thin mark, or stroke the whole side of the stick over the paper to make a broader mark.

Charcoal

The other monochromatic drawing material popular with artists is charcoal. It comes in different lengths and in thin, medium, thick and extra-thick sticks. You can also buy chunks that are ideal for expressive drawings. Stick charcoal is very brittle and powdery, but is great for broad areas of tone.

Compressed charcoal is made from charcoal dust mixed with a binder and fine clay and pressed into shape. Sticks and pencils are available. Unlike stick charcoal, charcoal pencils are ideal for detailed, linear work. As with other powdery media, drawings made in charcoal should be sprayed with fixative to hold the pigment in place and prevent smudging during and after working on the piece.

Thick and thin charcoal sticks

Pen and ink

With so many types of pens and colours of ink available, not to mention the possibility of combining linear work with broad washes of colour, this is an extremely versatile medium and one that is well worth exploring. Begin by making a light pencil underdrawing of your subject, then draw over with pen – but beware of simply inking over your pencil lines, as this can look rather flat and dead. When you have gained enough confidence, your aim should be to put in the minimum of lines in pencil, enough to simply ensure you have the proportions and angles right, and then do the majority of the work in pen.

Rollerball, fibre-tip and sketching pens

Rollerball and fibre-tip pens are ideal for sketching out ideas, although finished drawings made using these pens can have a rather mechanical feel to them, as the line does not vary in width. This can sometimes work well as an effect. By working quickly with a rollerball you can make a very light line by delivering less ink to the nib. Fibre-tip and marker pens come in a range of tip widths, from super-fine to calligraphic-style tips, and also in a wide range of colours. Sketching pens and fountain pens enable you to use ink on location without having to carry bottles of ink.

Dip pens and nibs

A dip pen does not have a reservoir of ink; as the name suggests, it is simply dipped into the ink to make marks. Drawings made with a dip pen have a

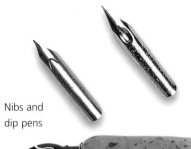

Nibs and dip pens

unique quality, as the nib can make a line of varying width depending on how much pressure you apply. You can also turn the pen over and use the back of the nib to make broader marks. As you have to keep reloading with ink, it is difficult to make a long, continuous line – but for many subjects the rather scratchy, broken lines are very attractive.

When you first use a new nib it can be reluctant to accept ink. To solve this, rub it with a little saliva.

Sketching pen

Fibre-tip pen

Rollerball pen

Bamboo, reed and quill pens

The nib of a bamboo pen delivers a 'dry', rather coarse line. Reed and quill pens are flexible and give a subtle line that varies in thickness. The nibs break easily, but can be recut with a knife.

Quill and bamboo pens

Inks

The two types of ink used by artists are waterproof and water-soluble. The former can be diluted with water, but are permanent once dry, so line work can be worked over with washes without any fear of it being removed.

They often contain shellac, and thick applications dry with a sheen. The best-known is Indian ink, actually from China. It makes great line drawings, and is deep black but can be diluted to give a beautiful range of warm greys.

Water-soluble inks can be reworked once dry, and work can be lightened and corrections made. Do not overlook watercolours and soluble liquid acrylics – both can be used like ink but come in a wider range of colours.

Waterproof ink

Water-soluble ink

Liquid acrylic

Coloured drawing media

Containing a coloured pigment and clay held together with a binder, coloured pencils are impregnated with wax so that the colour holds to the support with no need for a fixative. They are especially useful for making coloured drawings on location, as they are a very stable medium and are not prone to smudging. Mixing takes place optically on the surface of the support rather than by physical blending, and all brands are inter-mixable, although certain brands can be more easily erased than others; so always try out one or two individual pencils from a range before you buy a large set. Choose hard pencils for linear work and soft ones for large, loosely applied areas of colour.

Box of pencils ▲
Artists who work in coloured pencil tend to accumulate a vast range in different shades – the variance between one tone and its neighbour often being very slight. This is chiefly because you cannot physically mix coloured pencil marks to create a new shade (unlike watercolour or acrylic paints). So, if you want lots of different greens in a landscape, you will need a different pencil for each one.

Water-soluble pencils

Most coloured-pencil manufacturers also produce a range of water-soluble pencils, which can be used to make conventional pencil drawings and blended with water to create watercolour-like effects. In recent years, solid pigment sticks that resemble pastels have been introduced that are also water-soluble and can be used in conjunction with conventional coloured pencils or on their own.

Wet and dry ▼
Water-soluble pencils can be used dry, the same way as conventional pencils.

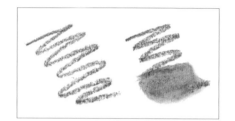

Conté crayons and pencils

The best way to use Conté crayons is to snap off a section and use the side of the crayon to block in large areas, and a tip or edge for linear marks.

The pigment in Conté crayons is relatively powdery, so, like soft pastels and charcoal, it can be blended by rubbing with a finger, rag or torchon. Conté crayon drawings benefit from being given a coat of fixative to prevent smudging. However, Conté crayons are harder and more oily than soft pastels, so you can lay one colour over another, letting the under-colour show through.

Conté is also available in pencils, which contain wax and need no fixing (setting); the other benefit is that the tip can be sharpened to a point.

Conté crayons ▼
These small, square-profile sticks are available in boxed sets of traditional colours. Drawings made using these traditional colours are reminiscent of the wonderful chalk drawings of old masters such as Michelangelo or Leonardo da Vinci.

Conté pencils ▼
As they can be sharpened to a point, Conté pencils are ideal for drawings that require precision and detail.

Pastels

Working in pastels is often described as painting rather than drawing, as the techniques used are often similar to those used in painting. Pastels are made by mixing pigment with a weak binder, and the more binder used the harder the pastel will be. Pastels are fun to work with and ideal for making colour sketches as well as producing vivid, dynamic artwork.

Soft pastels

As soft pastels contain relatively little binder, they are prone to crumbling. For this reason they sometimes have a paper wrapper to help keep them in one piece. Even so, dust still comes off, and can easily contaminate other colours nearby. The best option is to arrange your pastels by colour type and store them in boxes.

Pastels are mixed on the support either by physically blending them or by allowing colours to mix optically. The less you blend, the fresher the image looks. For this reason, pastels are manufactured in a range of hundreds of tints and shades.

As pastels are powdery, use textured paper to hold the pigment in place. You can make use of the texture of the paper in your work. Spray soft pastel drawings with fixative to prevent smudging. You can fix (set) work in progress, too – but colours may darken.

Pastel pencils

A delight to use, the colours of pastel pencils are strong, yet the pencil shape makes them ideal for drawing lines. If treated carefully, they do not break – although they are more fragile than graphite or coloured pencils. The pastel strip can be sharpened to a point, making pastel pencils ideal for

Hard pastels

One advantage of hard pastels is that, in use, they do not shed as much pigment as soft pastels, therefore they will not clog the texture of the paper as quickly. For this reason, they are often used in the initial stages of a work that is completed using soft pastels. Hard pastels can be blended together by rubbing, but not as easily or as seamlessly as soft pastels.

Hard pastels

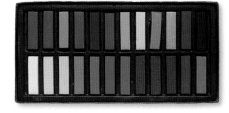

Box of soft pastels ▼
When you buy a set of pastels, they come packaged in a compartmentalized box so that they do not rub against each other and become dirtied.

describing detail in drawings that have been made using conventional hard or soft pastels.

Available in a comprehensive range of colours, pastel pencils are clean to use and are ideal for linear work. Ideally, store them in a jar with the tips upward to prevent breakage.

Oil pastels

Made by combining fats and waxes with pigment, oil pastels are totally different to pigmented soft and hard pastels and should not be mixed with them. Oil pastels can be used on unprimed drawing paper and they never completely dry.

Oil-pastel sticks are quite fat and therefore not really suitable for detailed work or fine, subtle blending. For bold, confident strokes, however, they are absolutely perfect.

Oil-pastel marks have something of the thick, buttery quality of oil paints. The pastels are highly pigmented and available in a good range of colours. If they are used on oil-painting paper, they can be worked in using a solvent such as white spirit (paint thinner), applied with a brush or rag. You can also smooth out oil-pastel marks with wet fingers. Oil and water are not compatible, and a damp finger will not pick up colour.

Oil pastels can be blended optically on the support by scribbling one colour over another. You can also create textural effects by scratching into the pastel marks with a sharp implement – a technique known as sgraffito.

Less crumbly than soft pastels, and harder in texture, oil pastels are round sticks and come in various sizes.

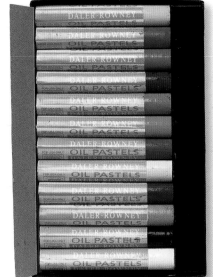

A box of oil pastels

Pastel pencils

Watercolour paint

One of the most popular media, watercolour paint comes in pans, which are the familiar compressed blocks of colour that need to be brushed with water to release the colour; or tubes of moist paint. The same finely powdered pigments bound with gum arabic solution are used to make both types. The pigments provide the colour, while the gum arabic allows the paint to adhere to the paper, even when diluted.

It is a matter of personal preference whether you use pans or tubes. The advantage of pans is that they can be slotted into a paintbox, making them easily portable, and this is something to consider if you often paint on location. Tubes, on the other hand, are often better if you are working in your studio and need to make a large amount of colour for a wash. With tubes, you need to remember to replace the caps immediately, otherwise the paint will harden and become unusable. Pans of dry paint can be rehydrated.

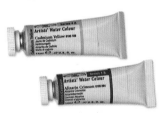

Tubes (above) and pans (right) of watercolour

Grades of paint

There are two grades of watercolour paint: artists' and students' quality. Artists' quality paints are the more expensive, because they contain a high proportion of good-quality pigments. Students' quality paints contain less pure pigment and more fillers.

If you come across the word 'hue' in a paint name, it indicates that the paint contains cheaper alternatives instead of the real pigment. Generally speaking, you get what you pay for: artists' quality paints tend to produce more subtle mixtures of colours. The other thing that you need to think about when buying paints is their

permanence. The label or the manufacturer's catalogue should give you the permanency rating. In the United Kingdom, the permanency ratings are class AA (extremely permanent), class A (durable), class B (moderate) and class C (fugitive). The ASTM (American Society for Testing and Materials) codes for light-fastness are ASTM I (excellent), ASTM II (very good) and ASTM III (not sufficiently light-fast). Some pigments, such as alizarin crimson and viridian, stain more than others: they penetrate the fibres of the paper and cannot be removed.

Working with watercolour paint

Different pigments have different characteristics. Although we always think of watercolour as being transparent, you should be aware that some pigments are actually slightly opaque and will impart a degree of opacity to any colours with which they are mixed. These so-called opaque pigments include all the cadmium colours and cerulean blue. The only way to learn about the paints' characteristics is to use them, singly and in combination with other colours.

Judging colours

It is not always possible to judge the colour of paints by looking at the pans in your palette, as they often look dark. In fact, it is very easy to dip your brush into the wrong pan, so always check before you put brush to paper.

Even when you have mixed a wash in your palette, do not rely on the colour, as watercolour paint always looks lighter when it is dry. The only way to be sure what colour or tone you have mixed is to apply it to paper and let it dry. It is always best to build up tones gradually until you get the effect you want. The more you practise, the better you will get at anticipating results.

Appearances can be deceptive ▼
These two pans look very dark, almost black. In fact, one is Payne's grey and the other a bright ultramarine blue.

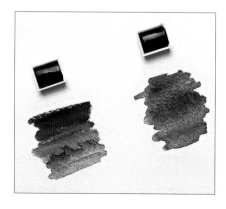

Test your colours ▼
Keep a piece of scrap paper next to you as you work so that you can test your colour mixes before you apply them.

Gouache paint

Made using the same pigments and binders found in watercolour, gouache is a water-soluble paint. The addition of *blanc fixe* – a precipitated chalk – gives the paint its opacity. Because gouache is opaque you can paint light colours over darker ones – unlike traditional watercolour, where the paint's inherent transparency means that light colours will not cover any darker shades that lie underneath.

Recently some manufacturers have begun to introduce paint made from acrylic emulsions and starch. The best-quality gouache contains a high proportion of coloured pigment. Artists' gouache tends to be made using permanent pigments that are light-fast. The 'designers' range uses less permanent pigments, as designers' work is intended to last for a short time.

Working with gouache paint

All of the equipment and techniques used with watercolour can be used with gouache. Like watercolour, gouache can be painted on white paper or board; due to its opacity and covering power it can also be used on a coloured or toned ground and over gesso-primed board or canvas. Gouache is typically used on smoother surfaces than might be advised for traditional watercolour, as the texture of the support is less of a creative consideration.

If they are not used regularly, certain gouache colours are prone to drying up over time. Gouache is water-soluble so can be rehydrated when dry, but dried-up tubes can be difficult to use. On the support, you can remedy any cracking of the dried paint by re-wetting it. During your work on the painting, you need assured brushwork when applying new paint over previous layers to avoid muddying the colours. Certain dye-based colours are particularly strong and, if used beneath other layers of paint, can have a tendency to bleed. With practice, this is easy to cope with.

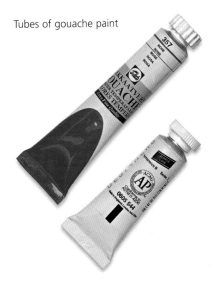

Tubes of gouache paint

Bold brushwork ▲
Gouache remains soluble when it is dry, so if you are applying one colour over another, your brushwork needs to be confident: a clean stroke, as here, will not pick up paint from the first layer.

Muddied colours ▲
If you scrub paint over an underlying colour, you will pick up paint from the first layer and muddy the colour of the second layer, as here. To avoid this effect, see bold brushwork, left.

Change in colour when dry ▼
Gouache paint looks slightly darker when dry than it does when wet, so it is good practice to test your mixes on a piece of scrap paper – although, with practice, you will quickly learn to make allowances for this.

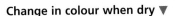

Wet gouache paint Dry gouache paint

Wet into wet ▲
Like transparent watercolour paint, gouache paint can be worked wet into wet (as here) or wet on dry.

Removing dry paint ▲
Dry paint can be re-wetted and removed by blotting with an absorbent paper towel.

Oil paint

There are two types of traditional oil paint – professional, or artists', grade and the less expensive students' quality. The difference is that artists' paint uses finely ground, high-quality pigments, which are bound in the best oils and contain very little filler, while students' paints use less expensive pigments and contain greater quantities of filler to bulk out the paint. The filler is usually *blanc fixe* or aluminium hydrate, both with a very low tinting strength.

Students' quality paint is often very good and is, in fact, used by students, amateur painters and professionals.

Tubes or cans? ▼

Oil paint is sold in tubes containing anything from 15ml to 275ml (1 tbsp to 9fl oz). If you tend to use a large quantity of a particular colour – for toning grounds, for example – you can buy paint in cans containing up to 5 litres (8¾ pints).

Drawing with oils ▶

Oil bars consist of paint with added wax and drying agents. The wax stiffens the paint, enabling it to be rolled into what resembles a giant pastel.

Water-mixable oil paint

Linseed and safflower oils that have been modified to be soluble in water are included in water-mixable oil paint. Once the paint has dried and the oils have oxidized, it is as permanent and stable as conventional oil paint. Some water-mixable paint can also be used with conventional oil paint, although its mixability is gradually compromised with the more traditional paint that is added.

Working with oil paint

However you use oil paint, it is most important to work on correctly prepared supports and always to work 'fat over lean'. 'Fat' paint, which contains oils, is flexible and slow to dry, while 'lean' paint, with little or no oil, is inflexible and dries quickly. Oil paintings can be unstable and prone to cracking if lean paint is placed over fat. For this reason, any underpainting and initial blocking in of colour should always be done using paint that has been thinned with a solvent and to which no extra oil has been added. Oil can be added to the

Glazing with oils ▲

Oils are perfect for glazes (transparent applications of paint over another colour). The process is slow, but quick-drying glazing mediums can speed things up.

Alkyd oil paints

Although they contain synthetic resin, alkyd oils are used in the same way as traditional oil paints and can be mixed with the usual mediums and thinners.

Alkyd-based paint dries much faster than oil-based paint, so it is useful for underpainting prior to using traditional oils and for work with glazes or layers. However, you should not use alkyd paint over traditional oil paint, as its fast drying time can cause problems.

paint in increasing amounts in subsequent layers. You must allow plenty of drying time between layers.

Working 'fat over lean' ▲

The golden rule when using oil paint is to work 'fat' (or oily, flexible paint) over 'lean', inflexible paint that has little oil.

Judging colour ▼

Colour mixing with oils is relatively straightforward: the colour that you apply wet to the canvas will look the same when it has dried, so (unlike acrylics, gouache or watercolour) you do not need to make allowances for changes as you paint. However, colour that looks bright when applied can begin to look dull as it dries. You can revive the colour in sunken patches by 'oiling out' – that is, by brushing an oil-and-spirit mixture or applying a little retouching varnish over the area.

| Wet oil paint | Dry oil paint |

Acrylic paint

Unlike oil paint, acrylic paint dries quickly and the paint film remains extremely flexible and will not crack. Acrylic paint can be mixed with a wide range of acrylic mediums and additives and is thinned with water. The paint can be used with a range of techniques, from thick impasto, as with oil paint, to the semi-transparent washes of watercolour. Indeed, most techniques used in both oil and watercolour painting can be used with acrylic paint. Acrylic paints come in three different consistencies. Tube paint tends to be of a buttery consistency and holds its shape when squeezed from the tube. Tub paint is thinner and more creamy in consistency, which makes it easier to brush out and cover large areas. There are also liquid acrylic colours with the consistency of ink, sold as acrylic inks.

You may experience no problems in mixing different brands or consistencies, but it is always good practice to follow the manufacturer's instructions.

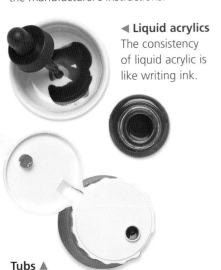

◀ **Liquid acrylics**
The consistency of liquid acrylic is like writing ink.

Tubs ▲
Acrylic paint in tubs stores easily.

Tubes ▶
Acrylic paints in tubes are convenient to carry and use with a palette.

Working with acrylic paint

Being water soluble, acrylic paint is very easy to use, requiring only the addition of clean water. Water also cleans up wet paint after a work session. Once it has dried, however, acrylic paint creates a hard but flexible film that will not fade or crack and is impervious to more applications of acrylic or oil paint or their associated mediums or solvents.

Acrylic paint dries relatively quickly: a thin film will be touch dry in a few minutes and even thick applications dry in a matter of hours. Unlike oil paints, all acrylic colours, depending on the thickness of paint, dry at the same rate and darken slightly. A wide range of mediums and additives can be mixed into acrylic paint to alter and enhance its handling characteristics.

Another useful quality in acrylic mediums is their good adhesive qualities, making them ideal for collage work – sticking paper or other materials on to the support.

Extending drying time ▲
The drying time of acrylic paint can be extended by using a retarding medium, which gives you longer to work into the paint and blend colours.

Covering power ▲
Acrylic paint that is applied straight from the tube has good covering power, even when you apply a light colour over a dark one, so adding highlights to dark areas is easy.

Texture gels ▲
Various gels can be mixed into acrylic paint to give a range of textural effects. These can be worked in while the paint is still wet.

Glazing with acrylics ▲
Acrylic colours can be glazed by thinning the paint with water, although a better result is achieved by adding an acrylic medium.

Shape-holding ability ▲
Like oil paint, acrylic paint that is applied thickly, straight from the tube, holds its shape and the mark of the brush as it dries, which can allow you to use interesting textures.

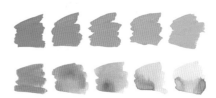

Lightening acrylic colours ▲
Acrylic colours can be made lighter by adding white paint, which maintains opacity (above top), or by adding water, which increases transparency (bottom).

Palettes

The surface on which an artist arranges colours prior to mixing and applying them to the support is known as a palette. (Somewhat confusingly, it is the same word that is used to describe a range of colours used by an artist, or the range of colours found in a painting.) The type of palette that you use depends on the medium in which you are working, but you will probably find that you need more space for mixing colours than you might imagine.

A small palette gets filled with colour mixes quickly and it is a false economy to clean the mixing area too often: you may waste usable paint or mixed colours that you could use again. Always buy the largest palette practical.

Wooden palettes

Flat wooden palettes in the traditional kidney or rectangular shapes with a thumb hole are intended for use with oil paints. They are made from hardwood, or from the more economical plywood.

Before you use a wooden palette with oil paint for the first time, rub linseed oil into the surface of both sides. Allow it to permeate the surface. This will prevent oil from the paint from being absorbed into the surface of the palette and will make it easier to clean. Re-apply linseed oil periodically and a good wooden palette will last for ever.

Wooden palettes are not recommended for acrylic paint, however, as hardened acrylic paint can be difficult to remove from the surface.

Holding and using the palette ▼
Place your thumb through the thumb hole and balance the palette on your arm. Arrange pure colour around the edge. Position the dipper(s) at a convenient point, leaving the centre of the palette free for mixing colours.

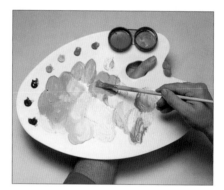

White palettes

Plastic palettes are uniformly white. They are made in both the traditional flat kidney and rectangular shapes. The surface is impervious, which makes them ideal for use with either oil or acrylic paint. They are easy to clean, but the surface can become stained after using very strong colours such as viridian or phthalocyanine blue.

There are also plastic palettes with wells and recesses, intended for use with watercolour and gouache. The choice of shape is entirely subjective, but it should be of a reasonable size.

White porcelain palettes offer limited space for mixing. Intended for use with watercolour and gouache, they are aesthetically pleasing but can easily be chipped and broken.

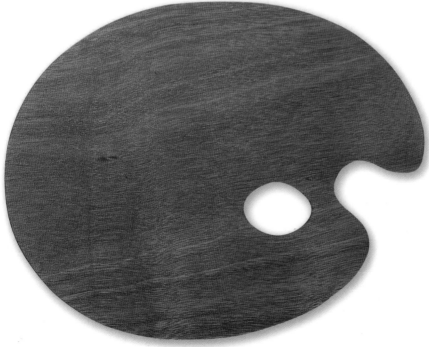

Wooden palette ▲
Artists working with oil paints generally prefer a wooden palette. Always buy one that is large enough to hold all the paint and mixes that you intend to use.

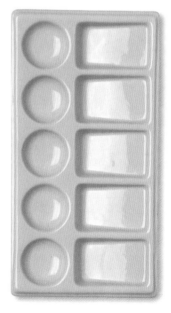

Slanted-well palette ▲
This type of porcelain palette is used for mixing gouache or watercolour. The individual colours are placed in the round wells and mixed in the rectangular sections.

Disposable palettes

A relatively recent innovation is the disposable paper palette, which can be used with both oils and acrylics. These come in a block and are made from an impervious parchment-like paper. A thumb hole punched through the block enables it to be held in the same way as a traditional palette; alternatively, it can be placed flat on a surface. Once the work is finished, the used sheet is torn off and thrown away.

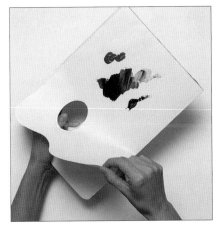

Paper palette ▲
Disposable palettes are convenient and make cleaning up after a painting session an easy task.

Stay-wet palette

Intended for use with acrylic paints, the stay-wet palette will stop paints becoming dry and unworkable if left exposed to the air for any length of time. The palette consists of a shallow, recessed tray into which a water-impregnated membrane is placed. The paint is mixed on the moist membrane. If you like, you can simply spray acrylic paint with water to keep it moist while you work. If you want to leave a painting halfway through and come back to it later, you can place a plastic cover over the tray (many come with their own lids), sealing the moist paint in the palette. The entire palette can be stored in a cool place or even in the refrigerator, and will keep for up to three weeks. If the membrane does dry out, simply re-wet it using a spray bottle of water.

Stay-wet palette

Containers

A regular supply of containers, such as empty jam jars for cleaning and storing brushes, can be recycled from household waste and are just as good as a container bought for the purpose.

Among the most useful specially designed containers are dippers – small, open containers for oil and solvent that clip on to the edge of the traditional palette. Some have screw or clip-on lids to prevent the solvent from evaporating when it is not in use. You can buy both single and double dippers, like the one shown on the right. Dippers are useful when you want to work at speed, for example when painting on location.

Dipper ▼
Used in oil painting, dippers are clipped on to the side of the palette and contain small amounts of oil or medium and thinner.

Storing brushes ▲
After cleaning your brushes, squeeze the hairs to remove any excess water and then gently reshape the brush with your fingertips. Leave to dry. Store brushes upright in a jar to prevent the hairs from becoming bent as they dry.

Acrylic and oil additives

Artists working with oils and acrylics will need to explore paint additives, which bring various textures and effects to their work. Although oil paint can be used straight from the tube, it is usual to alter the paint's consistency by adding a mixture of oil or thinner (solvent). Simply transfer the additive to the palette a little at a time and mix it with the paint. Manufacturers of acrylic paints have also introduced a range of mediums and additives that allow artists to use the paint to its full effect. Oils and mediums are used to alter the consistency of the paint, allowing it to

be brushed out smoothly or to make it dry more quickly. Once exposed to air, the oils dry and leave behind a tough, leathery film that contains the pigment. Different oils have different properties – for example, linseed dries relatively quickly but yellows with age so is only used for darker colours.

A painting medium is a ready-mixed painting solution that may contain various oils, waxes and drying agents. The oils available are simply used as a self-mixed medium. Your choice of oil or medium will depend on several factors, including cost, the type of finish

required, the thickness of the paint being used, as well as the range of colours employed.

There are several alkyd-based mediums on the market. They all speed the drying time of the paint, which can reduce waiting between applications. Some alkyd mediums are thixotropic; these are initially stiff and gel-like but, once worked, become clear and loose. Other alkyd mediums contain inert silica and add body to the paint; useful for impasto techniques where thick paint is required. Talking to an art stockist will help you decide which you need.

Types of finish

When acrylic paints dry they leave a matt or gloss surface. Gloss or matt mediums can be added, singly or mixed, to give the desired finish.

Gloss and matt mediums ▲
Both gloss (left) and matt (right) mediums are white. Gloss will brighten and enhance the depth of colour. Matt increases transparency and can be used to make matt glazes.

Gel mediums

With the same consistency as tube colour, gel mediums are available in matt or gloss finishes. They are added to the paint in the same way as fluid mediums. They increase the brilliance and transparency of the paint, while maintaining its thicker consistency. Gel medium is an excellent adhesive and extends drying time. It can be mixed with various substances such as sand or sawdust to create textural effects.

Modelling paste ▲
These pastes dry to give a hard finish, which can be sanded or carved into using a sharp knife.

Retarding mediums

Acrylic paints dry quickly. Although this is generally considered to be an advantage, there are occasions when you might want to take your time over a particular technique or a specific area of a painting – when you are blending colours together or working wet paint into wet, for example. Adding a little retarding medium slows down the drying time of the paint considerably, keeping it workable for longer. Retarding medium is available in both gel and liquid form – experiment to find out which suits you best.

Retarding gel

Heavy gel medium ▲
Mixed with acrylic paint, heavy gel medium forms a thick paint that is useful for impasto work.

Flow-improving mediums

Adding flow-improving mediums reduces the water tension, increasing the flow of the paint and its absorption into the surface of the support.

One of the most useful applications for flow-improving medium is to add a few drops to very thin paint, which can tend to puddle rather than brush out evenly across the surface of the support. This is ideal when you want to tone the ground with a thin layer of acrylic before you begin your painting.

When a flow-improving medium is used with slightly thicker paint, a level surface will result, with little or no evidence of brushstrokes.

The medium can also be mixed with paint that is going to be sprayed, as it greatly assists the flow of paint and also helps to prevent blockages within the spraying mechanism.

Without flow-improving medium

With flow-improving medium

Oils and thinners

If you dilute oil paints using only oil, the paint may wrinkle or take too long to dry. A thinner makes the paint easier to brush out, and then evaporates. The amount of thinner that you use depends on how loose or fluid you want the paint to be. If you use too much, however, the paint film may become weak and prone to cracking. Ideally, any thinner that you use should be clear and should evaporate easily from the surface of the painting without leaving any residue. There are a great many oils and thinners available. The common ones are listed below.

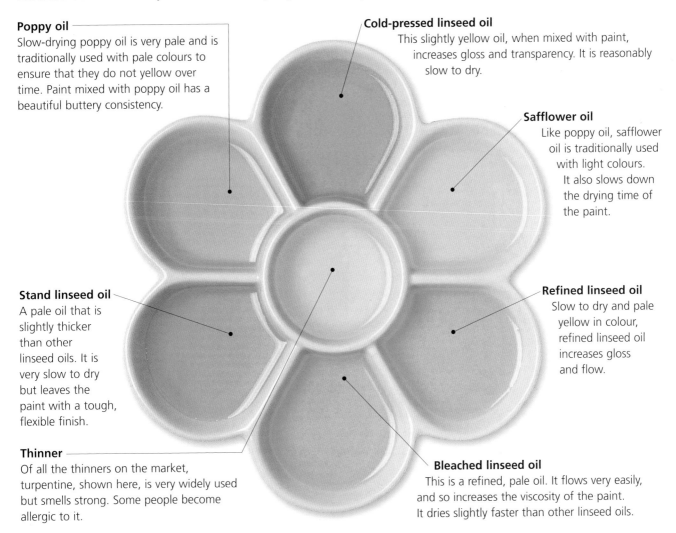

Poppy oil
Slow-drying poppy oil is very pale and is traditionally used with pale colours to ensure that they do not yellow over time. Paint mixed with poppy oil has a beautiful buttery consistency.

Cold-pressed linseed oil
This slightly yellow oil, when mixed with paint, increases gloss and transparency. It is reasonably slow to dry.

Safflower oil
Like poppy oil, safflower oil is traditionally used with light colours. It also slows down the drying time of the paint.

Stand linseed oil
A pale oil that is slightly thicker than other linseed oils. It is very slow to dry but leaves the paint with a tough, flexible finish.

Refined linseed oil
Slow to dry and pale yellow in colour, refined linseed oil increases gloss and flow.

Thinner
Of all the thinners on the market, turpentine, shown here, is very widely used but smells strong. Some people become allergic to it.

Bleached linseed oil
This is a refined, pale oil. It flows very easily, and so increases the viscosity of the paint. It dries slightly faster than other linseed oils.

Turpentine
This is the strongest and best of all the thinners used in oil painting, turpentine has an extremely strong smell. Old turpentine can discolour and become gummy if exposed to air and light. To help prevent this, store it in cans or dark glass jars.

White spirit
Paint thinner or white spirit is clear and has a milder smell than turpentine. It does not deteriorate and dries faster than turpentine. However, it can leave the paint surface matt.

Oil of spike lavender
Unlike other solvents, which speed up the drying time of oil paint, oil of spike lavender slows the drying time. It is very expensive. Like turpentine and white spirit, it is colourless.

Low-odour thinners
Various low-odour thinners have come on to the market in recent years. The drawback of low-odour thinners is that they are relatively expensive and dry slowly. However, for working in a confined space or for those who dislike turpentine's smell, they are ideal.

Citrus solvents
You may be able to find citrus thinners. They are thicker than turpentine or white spirit but smell wonderful. They are more expensive than traditional thinners and slow to evaporate.

Liquin
Just one of a number of oil and alkyd painting mediums that speed up drying time considerably – often to just a few hours – liquin also improves flow and increases the flexibility of the paint film. It is excellent for use in glazes, and resists age-induced yellowing well.

Paintbrushes

Oil-painting brushes are traditionally made from hog bristles, which hold their shape well and can also hold a substantial amount of paint. Natural hair brushes are generally used for watercolour and gouache, and can be used for acrylics and fine detail work in oils, if cleaned thoroughly afterward. Synthetic brushes are good quality and hard-wearing, and less expensive.

Brush shapes

Rigger brush

Liner brush

Rounded or 'mop' brush

Flat wash brush

Flat brushes ▼
These brushes have square ends and hold a lot of paint. Large flat brushes are useful for blocking in and covering large areas quickly and smoothly, whatever type of paint you are using – ask your stockist to advise which type of bristle or hair is best for your preferred medium. Short flats, known as 'brights', hold less paint and are stiffer. They make precise, short strokes, ideal for impasto work and detail.

Short flat brush

Large flat brush

Brushes for fine detail ◄
A rigger brush is very long and thin. It was originally invented for painting the rigging on ships in marine painting – hence the name. A liner is a flat brush which has the end cut away at an angle. Both of these brushes may be made from natural or synthetic fibres.

Wash brushes ◄
The wash brush has a wide body, which holds a large quantity of paint. It is used for covering large areas with a uniform wash of paint. There are two types: rounded or 'mop' brushes are commonly used with watercolour and gouache, and flat wash brushes are more suited to oils and acrylics.

Round brushes ▼
These round-headed brushes are used for detail and for single strokes. Larger round brushes hold a lot of paint and are useful for the initial blocking in. The point can quickly disappear, as it becomes worn down by the rubbing on the rough support. The brushes shown here are made of natural hair.

Small round brush

Large round brush

Unusually shaped brushes ▼
Fan blenders are used for mixing colours on the support and drybrushing. A filbert brush combines some qualities of a flat and round brush.

Fan blender Filbert

Cleaning brushes

1 Cleaning your brushes thoroughly will make them last longer. Wipe off any excess wet paint on a rag or a piece of newspaper. Take a palette knife and place it as close to the metal ferrule as possible. Working away from the ferrule toward the bristles, scrape off as much paint as you can.

2 Pour a small amount of household white spirit (paint thinner) – or water, if you are using a water-based paint such as acrylic or gouache – into a jar; you will need enough to cover the bristles of the brush. Agitate the brush in the jar, pressing it against the sides to dislodge any dried-on paint.

3 Rub household detergent into the bristles with your fingers. Rinse in clean water until the water runs clear. Reshape the bristles and store the brush in a jar with the bristles pointing upward, so that they hold their shape.

Other paint applicators

Brushes are only part of the artist's toolbox. You can achieve great textual effects by using many other types of applicator, from knives to rags.

Artists' palette and painting knives

Palette knives are intended for mixing paint with additives on the palette, scraping up unwanted paint from the palette or support, and general cleaning. Good knives can also be found in DIY or decorating stores.

You can create a wide range of marks using painting knives. In general, the body of the blade is used to spread paint, the point for detail and the edge for making crisp linear marks.

Regardless of the type of knife you use, it is very important to clean it thoroughly after use. Paint that has dried on the blade will prevent fresh paint from flowing evenly off the blade. Do not use caustic paint strippers on plastic blades, as they will dissolve; instead, peel the paint away.

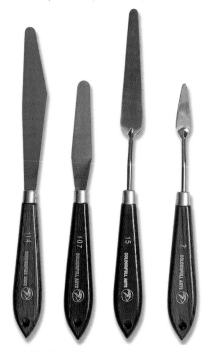

Steel knives ▲
A wide range of steel painting and palette knives is available. In order to work successfully with this method of paint application, you will need a variety.

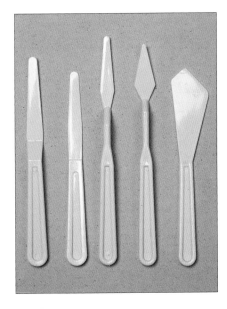

Plastic knives ▲
Less expensive and less durable than steel knives, plastic knives manipulate watercolour and gouache paints better than their steel counterparts.

Alternative applicators

Paint can be applied and manipulated using almost anything. The cutlery drawer and toolbox are perhaps a good starting point, but you will no doubt discover plenty of other items around the home that you can use. Card, rags, wire (steel) wool and many other objects around the house can all be pressed into service.

Rag (left) and wire wool

Natural sponge (left)
and man-made sponge

Paint shapers, foam and sponge applicators

A relatively new addition to the artist's range of tools are paint shapers. They closely resemble brushes, but are used to move paint around in a way similar to that used when painting with a knife. Shapers can be used to apply paint and create textures, and to remove wet paint. Instead of bristles, fibre or hair, the shaper is made of a non-absorbent silicone rubber.

Nylon foam is used to make both foam brushes and foam rollers. Foam rollers can cover large areas quickly. Sponge applicators are useful for initial blocking in. Both are available in a range of sizes and, while they are not intended as substitutes for the brush, they are used to bring a different quality to the marks they make.

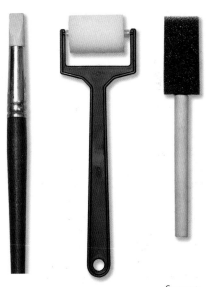

Paint shaper Foam roller Sponge applicator

Natural and man-made sponges ◀
With their pleasing texture, man-made and natural sponges are used to apply washes and textures, and are invaluable for spreading thin paint over large areas and for making textural marks. They are also useful for mopping up spilt paint, and for wiping paint from the support in order to make corrections. Man-made sponges can be cut to shape.

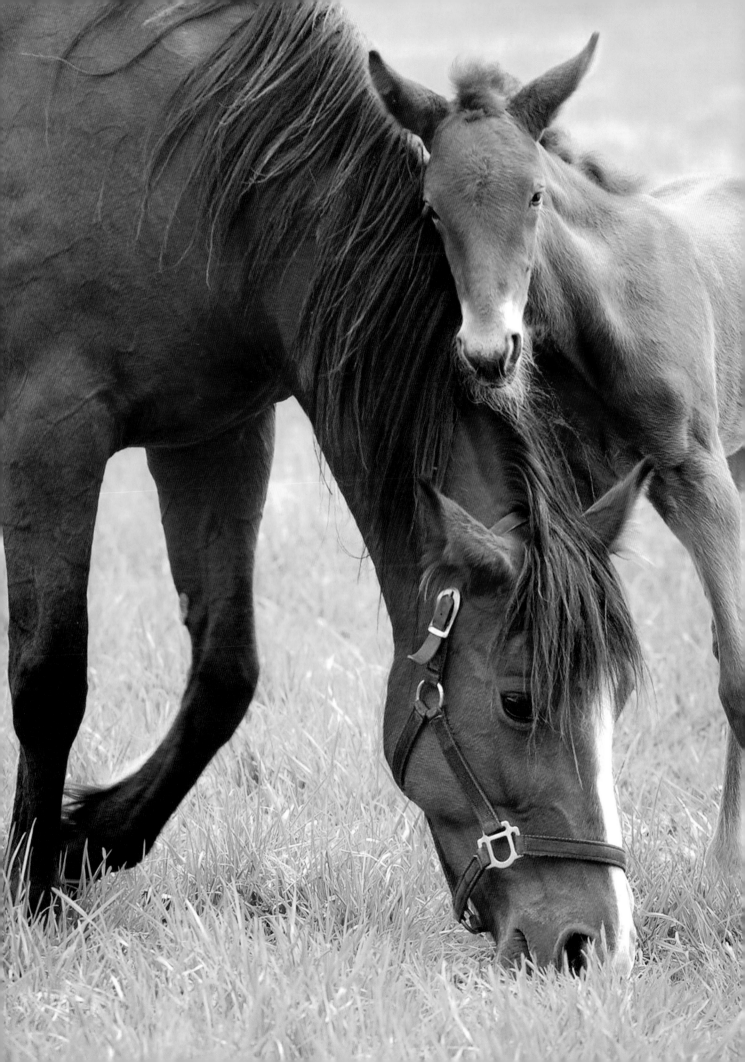

Tutorials

The natural world provides an infinite supply of subjects to draw
and paint and it's impossible to cover every species in detail –
in reality, you do not need a detailed knowledge of animal
anatomy in order to be a good artist. The purpose of this chapter
is to encourage careful observation and to provide some practical
guidance that will help you tackle unfamiliar wildlife subjects.
From getting the basic shape right to capturing anatomical
details, textures and markings, this chapter provides a solid yet
easy-to-follow grounding in the technicalities of wildlife art.
There are also a number of short exercises that give you a chance
to put your new-found skills into practice. Whether you're a
complete beginner or a more experienced artist looking for
a refresher course on particular aspects of drawing and
painting animals, these tutorials are an invaluable resource
that you can turn to time and time again.

Mammals

If you want to specialize in animal art, then a good book on animal anatomy will be a useful addition to your reference library. However, unless you're a qualified veterinarian, you can't possibly know the names of all the bones and muscles in all the animals that you're likely to want to paint – and you don't need to. Regardless of whether you are working from life or from a photographic reference, it's the surface of the animal that you see, not the skeleton beneath – and it is the surface of the animal that you should concentrate on.

Your first step – as with drawing any subject – is to take measurements and to really look at the shapes involved.

Of course, the proportions of an animal vary from species to species: for example, a giraffe has a very long neck and legs in relation to its body size, whereas a mouse has a very short neck and legs. Even within species, different breeds have very different proportions: a greyhound, which is built for running, has relatively long legs and a slim body, while a bulldog does not.

Start by looking for a basic unit of measurement against which you can compare the size of other features. You might decide to use the head of the animal you're drawing as your standard unit of measurement. By working how many times this head measurement fits into the neck, or the

back of the body, or the leg, you can check that each part of the animal is correctly proportioned in relation to the rest. Alternatively, particularly if you're viewing an animal face-on to paint a 'portrait', you might choose a smaller unit of measurement, such as the distance between the outer corners of the eyes – but the principle remains the same. Get the basic measurements right and everything else will fall into place.

The next thing to consider is how to make the animal look rounded. Instead of starting with an outline of its shape, try to convey the feeling that it's a three-dimensional form right from the start.

Try making a series of very quick sketches of your chosen subject,

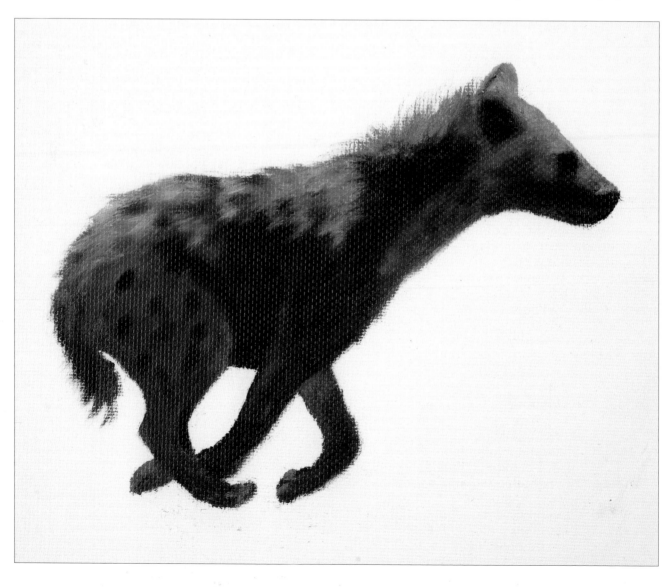

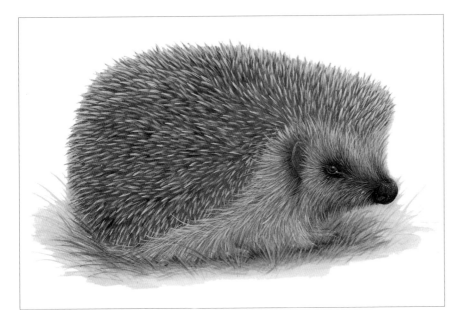

Positive shape ◄

Whatever you're drawing, try to see it as a geometric shape to get a feel for it as a three-dimensional object. This hedgehog can be viewed as a rounded 'box' shape; note how the top of the head is lighter than the side facing us.

Negative shapes ▼

In addition to measuring, look at the negative shapes – the spaces in between things – as it's often easier to assess these than the positive shapes of your subject. Here, for example, the curved space between the branch and the spider monkey's arm and tail forms a distinctive shape that you can use as a guide, as does the space between the monkey's left arm and its legs.

reducing it to simple geometric shapes rather than attempting to draw it in any detail. Then look at the same animal from a different viewpoint and see how perspective affects the shapes. If you're looking at, say, an elephant from the side, you might see the body as an almost square but shallow box and the legs as cylinders. If the animal turns slightly, so that you get a three-quarter view, the box shape of the body will appear to taper a little towards the rear and the 'cylinders' of the back legs will be shorter than those of the front legs. When the elephant turns to face you, the effects of perspective on those geometric shapes will become even more apparent: the 'box' of the body will appear deeper and shorter.

If you can train yourself to think in this way, you'll find it easier to add important details and textures.

Measure carefully ◄

Although hyenas bear some physical resemblance to dogs and many people think of them as a kind of canine, their front legs are longer than their back legs. The neck is also more elongated than one might expect. If you attempt to draw such an animal without carefully comparing the size of one feature against others, you may find that you get the proportions completely wrong.

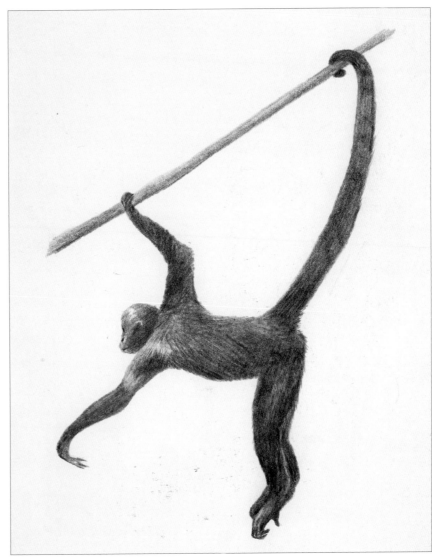

▶

Next, look at how the animal stands and moves. Some animals place the full length of their feet on the ground when they walk, in the same way as humans. Many others walk on only parts of the foot. Cats and dogs, for example, place their toes on the ground, but not the heel, and there are noticeable anatomical differences between the limbs of these two groups of animals. Animals that walk on their toes have long carpals and tarsals, which means that the bones that correspond to the human ankle are much higher in the limb than in a human. There is also a third group of animals, which walk on the very tips of their digits, typically on hooves; this group includes horses and cattle.

The type of locomotion affects both the way the animal stands and its gait, so it is worth observing – even if you do not need to draw or paint the feet in any detail because they are obscured by long grass or sink into sand or mud.

Look at the ears, too. One mistake that beginners make is to place the ears on the top of the animal's head. In fact, the ears lie above and behind the eyes, and slightly below the top of the head. The ears are very expressive: you can tell by looking at them whether the animal is relaxed or listening for predators.

Think about what the animal eats, as this determines the shape of the jaw and mouth. For example, a predator such as a lion has strong, powerful jaws

that can open wide to hold its prey, while a ruminant such as a cow has a mouth that's designed for chewing and does not open as wide.

All these things will help you capture the essence and character of the animal.

Of course, you cannot completely ignore the bones and muscles as they have a visible effect on the surface of the body. When bones and muscles lie close to the surface, you will see shadows on the animal's fur or hide – you must render these shadows accurately to make the animal look three-dimensional. Similarly, when an animal is in motion or a particular set of muscles is under tension (perhaps strong neck muscles when a lion is

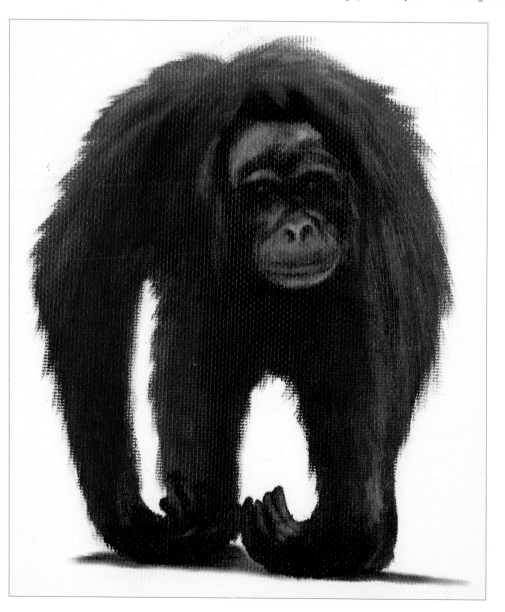

Orangutan walking ◄
When orangutans are on the ground, as here, they walk on all four limbs, using the knuckle pads on the back of the digits on the hands, and appear very ungainly and awkward. They move through the trees by 'brachiating', or hooking their long fingers over branches and swinging by their arms. Brachiation is the more usual mode of locomotion, hence their powerful forelimbs are longer than their hindlimbs. Although the animal's long, shaggy fur obscures the shapes of the limbs and underlying muscles, it is important to convey the form of the animal; to do this, look for shadows within the fur that give a sense of its volume.

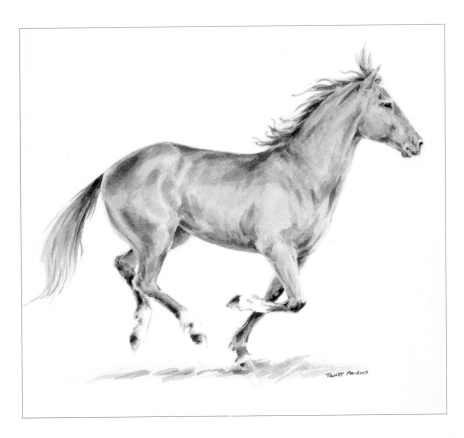

How do limbs move? ◄

If you want to paint a moving animal, do your research and find out how the limbs move. It was not until 1877 that ground-breaking photographer Eadweard Muybridge first proved that the legs of a horse at full gallop are all tucked under the body; in paintings from before that date, galloping horses were usually depicted with their forelegs stretched out in front of them and their hind legs stretched out behind. Note how the flowing mane and tail in this watercolour sketch also contribute to the sense of movement.

Alert pose ▼

The pricked-up ears, sharply focused gaze and tense muscles of this rabbit tell us that it is on alert for predators, poised for flight should danger present itself. Always look for clues such as these, as they can tell you a lot about the character of the animal and whether it is predator or prey.

tearing meat from a dead gazelle), muscles will appear more pronounced.

However, you do need to ensure that any shadows that you paint really are part of the animal. If you put in a shadow that's cast by something else, you will create a muscle that isn't there.

Another thing to bear in mind is that a wild animal, especially a big cat, may look very different to a zoo or safari park animal. You cannot paint a lioness from a zoo or safari park and simply place it in an African setting. The most obvious difference is the colour. The light at the time of day your scene is painted at may be different from that of the subject animal. The colour of the ground plays a part as well – not only because the animal may have been rolling in the dust or soil, but also because some of the ground colour will be reflected up onto the animal's skin or hide. You will also notice that the muscles of a wild animal tend to be more pronounced than those of a captive animal. Wild animals have to catch their food, so they are stronger than captive animals; they also have to do battle with other animals in order to survive, and so may bear some scars.

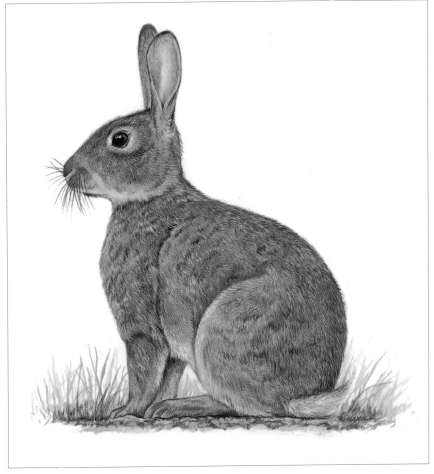

Amphibians

Of the three groups of living amphibians, only two – newts and salamanders, and frogs and toads – are likely to be of interest to you as a painter.

Amphibians, of course, spend much of their time in water, so you might like to try painting the animal as it has just emerged from the water. Unlike reptiles, amphibians do not have a scaly skin.

The light bouncing off a wet body will make a far more interesting painting. In addition to putting in the highlights with white paint (or reserving the highlights with masking fluid if you are using watercolour), where you think the sun is reflecting off the wet body, take note of the subtle changes of colour as the body curves away from the light.

Take care to get the proportions right. Amphibians such as frogs rely on their sight to catch their prey, so have surprisingly large eyes, and their hind legs are designed for leaping, and so may be longer than you expect. The hands generally end in four fingers, and the feet in five toes – but this varies from species to species – so count carefully!

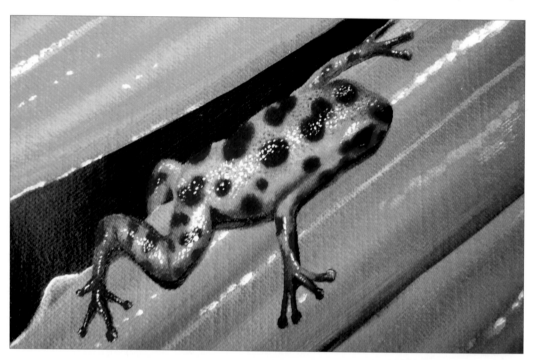

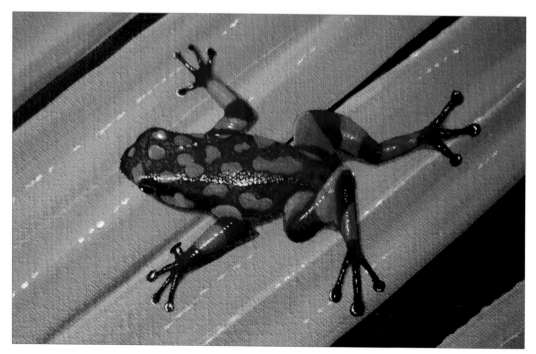

Tree frogs ◄
The most immediately striking thing about these two paintings is the use of colour – the richly saturated orange and red of the frogs set against the vibrant green of the leaves. Look more closely, however, and you will see how skilfully the artist has used highlights to convey the form of the subject: a whole series of tiny white highlights indicates light reflecting off the frogs' wet bodies and the leaves, too, have highlights running across them, showing that they are slightly ridged. Small shadows under the bodies and legs also help to make the frogs appear three-dimensional. Finally, note how the leaves run diagonally through the pictures, creating a very dynamic composition.

Reptiles

Many reptiles, such as lizards and snakes, are covered in scales, sometimes in very bright colours. These can be a challenge to paint because the scales act as mirrors, reflecting all the colours around them. The exercise at the end of this chapter explains in detail how to draw and paint scales, using a chameleon as the subject.

The bodies of other reptiles, such as tortoises and turtles, are covered by a hard shell. These are quite simple to draw and paint. The most important thing is to observe how the light reflects off the hard surface; if you assess these tones properly, you can convey the changes of plane within the subject. In order to convey the form, you need to look for the different tones within it as the shape curves away from the light. There will be bumps and indentations in the shell, and the transition from one tone to another will be pronounced.

With a graphite pencil, vary the amount of pressure you apply to create different tones. Start quite softly; once you're happy with the general shape, you can press a little harder. The darker the shell, of course, the harder you need to press. When using oil or acrylic paints, you can cover the whole shell with a mid-tone colour and apply the

lighter and darker tones once the initial paint has dried. Always test out your mixes on scrap paper before you apply a dark tone over your base coat, to see if they work.

The shells of tortoises and turtles have interesting patterns. Whatever your chosen medium, it really helps to sketch out the patterns before you begin painting. Begin with very light pencil marks, as you'll probably have to adjust the pattern slightly before you get it right. There's no point in painting part of the pattern and then finding out you've misjudged how big or small it needs to be. Observe how the pieces interlock and how there seems to be a uniformity over the shell. This is the key to getting it right.

Once you've established the basic pattern, you can apply the colour. In oils, pastels or acrylics, try putting down some mid-toned base colours first. Once they have dried, you can apply the lighter and darker colours on top, following the direction of the pattern. In watercolour, allowing the base colours to bleed into each other wet into wet can create a lovely mottled effect.

Generally speaking, the surface of a tortoise or turtle shell is rough rather than shiny. The ridges on tortoise shells

are quite shallow, but need to be observed. To convey the roughness of the texture, look at the highlights along the edge of the ridges. Although the ridges are small, you'll see that there's a shaded and a lit side. Drybrush techniques (in watercolour or acrylics), sgraffito, pen-and-ink detailing on top of dry watercolour paint and oil pastel on top of watercolour are all techniques that you might like to consider trying.

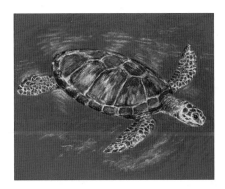

Turtle in mixed media ▲
The base colours of the shell and flippers were applied first, using acrylic paints, and then oil pastels were used for the shell markings. The oil pastels were scribbled on quite loosely, and the colours blended together where necessary using a rag.

Multi-coloured lizard ▲
This tree agama makes an interesting subject as its head is a different colour from the rest of its body. You don't need to draw every scale individually, but try to create an overall impression of the scaly texture.

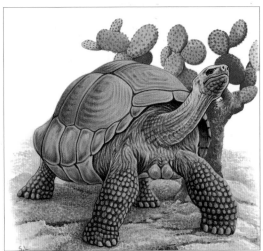

Shell patterns ▲
Reptiles such as this Galápagos tortoise have shells comprising complex shapes. Observe them carefully, making a light sketch before you begin painting.

Fur

One of the biggest challenges for any wildlife artist who wishes to paint in a realistic style is how to paint fur. How on earth can anyone paint all the fine hairs on an animal, long or short? The simple answer is that you can't! Instead, you have to learn how to create the impression of the fur though your brush marks and use of colour.

You may find it easier to paint long fur or hair than very short hair, as it's more obvious how the fur flows. Start by putting in the general shape of clumps of fur. Then later on you can flick the brush or pencil outwards at the edges of the animal to create the impression of individual hairs. Look at other artists' paintings of furry animals, then try to analyse exactly how they've painted the fur.

The colour of the fur can also make a difference to how difficult it is to paint. Look at the colours underneath – the bits in between the lighter areas, the shadow areas. Get this colour right from the start and it will save a lot of work later on. It's as if you are working from the inside out. Remember that the fur is just a covering: the viewer should

still be aware of the shape of the skeleton beneath. Even though you cannot see them, you should always think about the shape of the major bones and where they are located.

Even if the whole animal appears to be just one colour, it won't be. The fur of a ginger-coloured cat will be various tones of this colour, while the coat of a white-haired animal may contain shades of grey, blue and purple. This is because the animal's body is turning towards or away from the light and by putting in these different tones you can convey a sense of the animal's form and make it look three-dimensional. In this respect, the fur is rather like clothing on a person – the way it drapes over the body.

Note that each hair or clump of hair may change tone along its length, as it turns towards or away from the light. Don't get carried away putting in lines of a single colour; a hair only looks like this if it's lying flat and is straight – but fur generally doesn't do that.

If you're using pencil or charcoal, do not be tempted to draw in one line to represent one long hair. Look at the hair

and see how the tone changes along its length; you may even need to leave a gap in the line for a very bright area.

Even though fur is not a reflective surface, it will still contain highlights where the light hits the animal. Each medium requires different techniques. With oils and acrylics, work the darker areas first and apply the highlights afterwards. With watercolour, you can mask out the highlights and paint in the darker areas, rubbing off the masking fluid to reveal the white paper underneath. With graphite and coloured pencil, you can use an eraser to create the highlights, although with coloured pencil take care not to press to hard initially. Pastels lend themselves well to fur and can easily be highlighted with lighter tones. Work out where the lighter areas are from the outset.

It's also absolutely essential to observe the direction of the hair. No matter what your medium is, you need to go with the flow. Your brush or pastel marks will become the fur. Moving your brush in the wrong direction means the fur will appear to flow in the wrong direction.

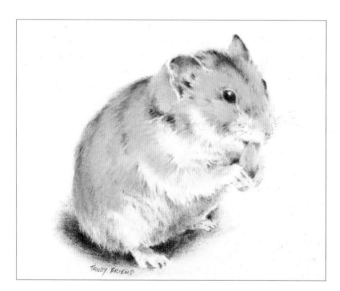

Hamster in coloured pencil ▲
The colour and texture of the fur were built up gradually by applying several layers. On the hamster's chest and along the edge of its back, strokes of grey and reddish brown were 'flicked' on to the white background, so that the spaces in between the coloured strokes stand for white hairs.

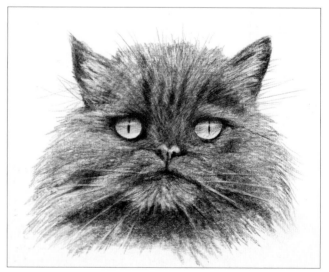

Cat in soft graphite pencil ▲
This sketch was made using just one grade of pencil – a 4B. For broad areas of tone, such as the dense black under the cat's chin, the artist used the side of the pencil lead and smudged the marks with his fingertips. The fine white hairs were 'drawn' using a kneaded eraser pulled to a sharp point.

Practice exercise: **Long fur in oils**

In this exercise, oil paint is used wet into wet to blend areas of different tone together. Don't worry about placing every strand of fur exactly; a general impression of the way it falls is sufficient.

Materials
- *Canvas paper*
- *3B pencil*
- *Oil paints: brown ochre, burnt umber, cadmium red, titanium white, lamp black*
- *Low-odour thinner*
- *Brushes: selection of short flats, small round or rigger, soft round*

The subject
Here, the dog's fur falls in thick, flowing strands and is a lovely rich, reddish brown that glows in the light.

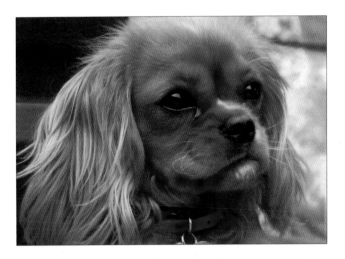

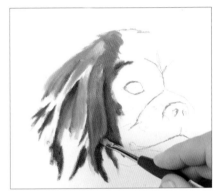

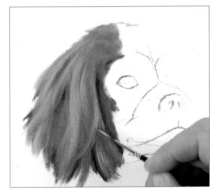

1 Using a 3B pencil, make a light underdrawing to map out the main features. Mix a rich brown from brown ochre, burnt umber and a little cadmium red and, using a small flat brush, put in the darkest areas of fur. Use long, flowing strokes that follow the direction in which the fur grows.

2 Now mix the mid tones from brown ochre, burnt umber and titanium white, varying the proportions of the colours in the mix as necessary. Apply them in the same way as the dark tones, blending the edges of one tone into the next, wet into wet.

3 Add more titanium white to the mix. Using a small round or rigger brush, depending on how fine you need the highlights to be, put in the highlights. Look carefully at how the light falls: the highlights are what will give the fur its sheen.

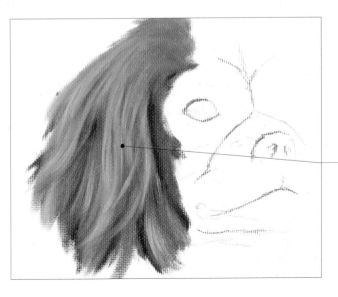

The finished drawing
This sketch beautifully captures the way the fur falls in flowing strands. The paint has been applied in long, calligraphic strokes and skilfully blended wet into wet, so that the tones merge almost imperceptibly together. The contrast between the highlights and the tones of the dark, shaded areas gives the fur a feeling of volume.

Note that the highlights are not painted as a continuous line; they break as the fur turns away from the light.

Skin

There's something very satisfying about painting or drawing an animal's skin. Skin can be dry, wet or even muddy, so getting it right can be a challenge.

If you are painting an animal with hide – an elephant, perhaps – you need to decide right from the start how much detail you want to put in. You can't put in some details and leave out others. The ears, for instance, are full of veins and including them will really add to the sense of realism. But if you put in details in the ears, you'll have to do the same for the trunk and the rest of the body.

The best way to approach it is to look at the animal as a whole. Before you start to apply any paint, sketch in where the deeper folds of skin are, as this will help you position the smaller creases in the right place later. If you're making a pencil drawing, the same applies. The darker the pencil lines, the deeper the wrinkles. Don't even attempt to put in every wrinkle and fold; instead, pick out the main lines. If you put in every single line, you'll lose sight of the drawing or painting as a whole. You can add extra details as the whole painting comes together later if you wish.

Remember that wrinkles and folds are not simply lines on the surface – they are crevices, albeit shallow ones.

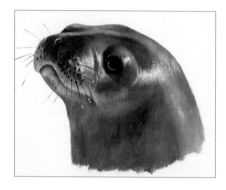

Seal in oils ▲
This sketch was painted wet into wet, the colours blended on the canvas to create subtle tonal variations within the skin. The tiny water droplets on the whiskers complete the study.

One side will be lighter than the other, where the light hits it, although the tonal differences may be quite subtle if the folds are not very deep. So look for the highlights along the edges of the folds. In pencil or charcoal, you can create the highlights by lifting off pigment with a kneaded eraser. When using watercolour, leave the white of the paper showing; in oils, acrylics, coloured pencils and soft pastels, use a lighter tone. If working in charcoal use less pressure at the top of the folds.

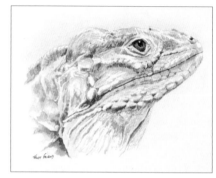

Lizard in watercolour ▲
With very rough, textured skin, pay particular attention to the different tones. Note here how darker tones indicate shaded areas on the surface where folds of skin overhang.

Generally speaking, don't try to complete one section of an animal at a time. Work across the painting as a whole, so that everything progresses at the same rate, slowly building up the complete picture so that you do not overemphasize one part at the expense of the rest. There is a practical reason for doing this, too: if you paint and finish one part of an animal, then you may not be able to recreate exactly the same colour mix again when you need it for another part of the animal.

Practice exercise: **Elephant skin in pencil**

The most important thing to remember in this exercise is that the wrinkles and folds are not some kind of surface decoration: they are three-dimensional, like little ditches or channels in the skin. If you merely draw them as a series of lines without attempting to give them any depth, it'll just look like crazy paving and you'll get no sense of the form of the animal. Take the time to assess how deep the folds are and how dark they need to be.

Materials
• *Good-quality drawing paper*
• *3B pencil*
• *Kneaded eraser*

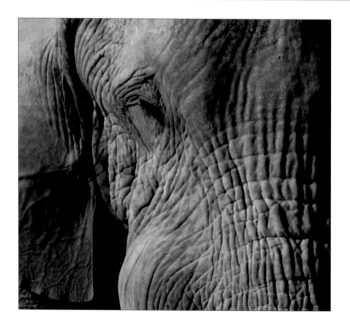

The subject
Strong side lighting from the left clearly shows up the creases in the elephant's skin.

1 Using a 3B pencil, begin sketching the animal. Start from the eye, which is an easily identifiable focal point in an otherwise confusing jumble of lines, and then relate all subsequent lines to that. Put in only the main lines to begin with; then, when you're sure of their placement, you can start putting in more detail.

2 Block in the dark area between the ear and the side of the face and begin putting in the main creases in the skin, using the tip of the pencil sharpened to a fine point. The deeper and darker the crease, the more pressure you need to apply.

3 Shade in the mid tones, using the side of the pencil and varying the amount of pressure as necessary to create lighter or darker mid tones.

The finished drawing
This is a carefully observed tonal study that makes the animal's skin look convincingly three-dimensional and captures the texture perfectly. The soft 3B pencil has created a surprisingly broad range of tones, from the dense black in the space between the elephant's ear and the side of its face to pale greys in the most brightly lit areas. Without the eye, this sketch would be little more than an abstract pattern; even when closed, as here, the eye tells us that this is a living animal.

4 Finish putting in the creases, again using the tip of the pencil. You may find that you need to strengthen some of the very dark lines that you put in earlier so that they stand out clearly against the mid tones.

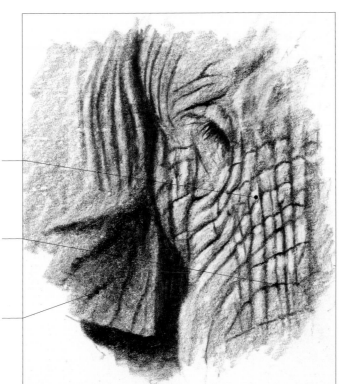

Bright highlights are visible where the skin catches the light.

The dark creases are created using the tip of the pencil.

The veins in the ear can clearly be seen below the surface of the skin.

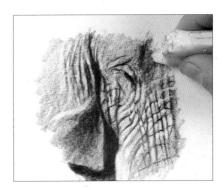

5 In very strong directional lighting, as here, you may see a highlighted edge along one side of a skin wrinkle or fold. Pull the corner of a kneaded eraser to a fine point and carefully wipe off pigment to create the most important of these highlights.

Scales

Part or all of the bodies of reptiles is covered in a series of tiny scales. It is worth knowing a little about what scales are made of and how they are formed, as this may make it easier for you to draw and paint them.

Reptile scales are composed of the protein keratin, just like the keratin that makes up human fingernails. In lizards, a scale typically begins as a fold in the epidermis – the top layer of skin. The upper layer of the epidermis hardens, and the dermis (the bottom layer of skin) withdraws, leaving a series of tough, overlapping scales. Look for slight shadows that indicate these overlaps. In turtles and crocodiles, most scales do not overlap; however, bony plates may develop underneath the scales, so the skin surface will appear bumpy rather than smooth and shiny. Again, look for shadows that indicate minor changes of plane on the surface of the body.

There are two main types of scales found in snakes: smooth scales, which are shiny and reflective, and what is known as keeled scales, which have one or more ridges down the central axis of the scale. Snakes' body scales are packed close together; they overlap and are arranged in diagonal rows. When you're drawing a snake in close-up detail, remember that keeled scales will appear rougher than smooth scales; put in some hint of light and shade to convey a sense of form.

Scale patterns vary just as much as fur and skin. The size and shape, can vary considerably. Remember to take note of how the scales appear to get smaller as they curve around the body. It can be difficult to get this right, so it is important that you take your time.

On the body of a reptile there may be hundreds of scales, in different sizes. All those scales act like mirrors, reflecting the colours around them, especially where direct sunlight hits the reptile's body. Pay attention to these colours; they will be of a much lighter tone but they will all be there. You may think they are too subtle to matter, but it's these little details that will make the scales look correct.

Even if you're aiming for a photorealistic rendition, don't try to draw the detail of every single scale. Instead, try to give a general impression of the shapes and sizes. Try half-closing your eyes and squinting at your subject, so that some of the detail disappears.

Unless there are specific markings that need to be observed, it can be a good idea to put in all the base colours across the entire animal, and then draw or paint in the shape of the scales afterwards.

Applying pencil or pen-and-ink on top of paint to outline shapes works well. Other techniques that you might like to try include sgraffito (scratching into oil paint or oil pastels to create texture), and using an acrylic medium

such as a glass-bead texture gel to create the scaly effect. Alternatively, find something that has the same general shape of the scales (perhaps a net bag of the type in which fruit are often sold), dip it into your chosen paint medium and press it on to your paper or canvas. This is a good subject on which to try out different techniques.

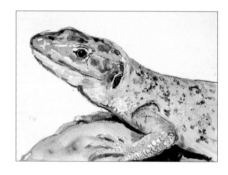

Scales in acrylics ▲
This painting, which is based on the same subject as the step-by-step demonstration opposite, demonstrates several techniques for painting scales. After applying the initial base colours in acrylics, the artist drew in the larger scales on the legs in charcoal. Glass-bead texture gel was used to create shiny, slightly raised patches on the back: when the paste dries, it creates a slightly shiny, knobbly texture. Tonal contrasts – small, light strokes next to dark – indicate minor changes in plane and convey the slightly raised form of the scales.

Practice exercise: **Chameleon in soft pastels**

The base colour of the chameleon's skin is applied first, with the scales being drawn on later. Look for the highlights, as these show you how the skin stretches over the skeleton. Note that the scales tend to be closer together, and smaller, the further away they are.

Materials
• *Pale blue pastel paper*
• *Pastel pencils: dark brown, yellow ochre*
• *Soft pastels: bright green, bright yellow, pale blue, white*

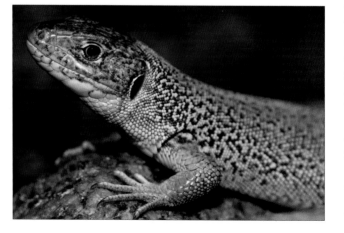

The subject
The scales on this chameleon vary considerably in size and shape. Although it would be a mistake to try and draw every single one, you do need to create a generalized impression of their texture.

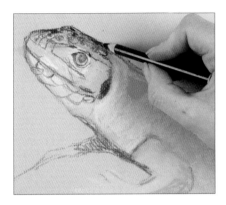 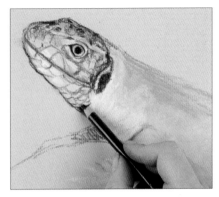 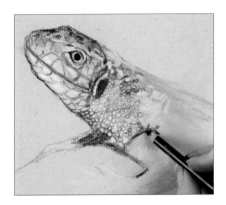

1 Using a dark brown pastel pencil, sketch the outline of the chameleon. Scribble on bright green soft pastel on the back where appropriate, and blend the pigment with your fingers. Repeat, using bright yellow on the underbelly and legs. Apply a little pale blue and white over the head. Begin putting in the larger scales with the brown pencil, as well as the dark markings on the top of the head.

2 Apply other colours to the head where necessary – yellow ochre pastel pencil around the eye, for example. Continue mapping out the scales again using the dark brown pastel pencil and paying careful attention to the shapes and sizes. It is important not to make the scales all the same shape and size – otherwise your drawing will look too mechanical.

3 Put in the scales on the back, using a combination of small, open circles through which the base colours can be seen and filled-in scribbles for the dark brown scales. Begin blocking in the legs, using the side of a bright green soft pastel and allowing some of the 'tooth' of the pastel paper to show through to imitate the rough texture of the legs.

The finished drawing
This is quite a loosely drawn picture, but it demonstrates how effectively textures can be built up when painting a scaly animal such as a lizard or other reptile.

Note how the changing shapes of the scales convey how the skin is stretched over the bones of the leg.

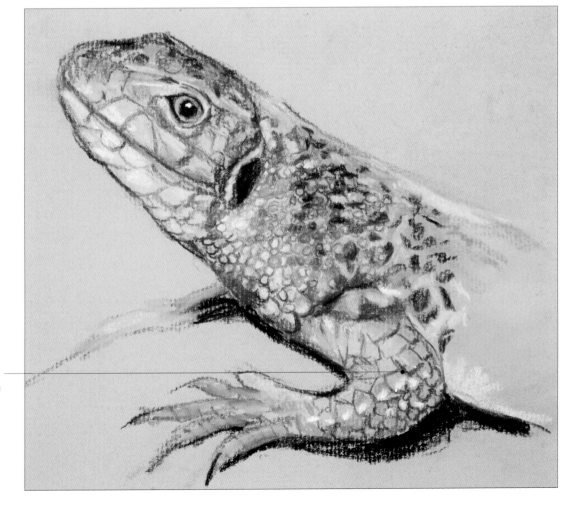

Teeth, claws and hooves

Teeth, claws and hooves are all hard surfaces that contrast with the softness of fur and skin, and if your animal drawings are to look lifelike, it's important that you master these textures.

Within the animal kingdom there are many differences in shape, of course. Specialist meat eaters such as big cats have huge canine teeth designed to hold their prey and carnassial teeth to shear through tough skin and meat, while herbivores get their energy from eating plants and have teeth designed for that purpose.

Similarly, animal claws come in a wide variety of shapes and sizes: big cats have long, curved claws; reptiles have small, stout claws; and primates have flat, rounded fingernails that look very similar to human fingernails.

Hooves, too, may be either smooth and rounded – as in horses – or cloven into two separate toes – as in sheep, goats and deer.

Despite such differences, the techniques of drawing and painting these hard surfaces are essentially the same.

Teeth

Teeth can be a real challenge to paint, no matter what medium you choose. They are never just white or any other single colour.

Even the teeth of the same animal will not all be the same colour – particularly if one part of the mouth is in sunlight and another in shade. Take careful note of changes of colour and tone, as these are critical in establishing a sense of form and making the teeth appear three-dimensional.

You will find that the teeth of a carnivore such as a big cat tend to look cleaner than those of herbivores as they are automatically cleaned when they bite against bone and tough meat. Generally, the colours you will need will be white, yellow ochre, cadmium orange, cadmium yellow (medium), burnt umber, cadmium red and a little black. For more heavily stained teeth, you are likely to need raw sienna and raw umber as well. The gums are generally a shade of red – perhaps alizarin crimson or cadmium red mixed with ultramarine, indigo or a little black for the darker areas.

If you want teeth to look smooth and wet, working wet into wet is the best option, lightly blending the colours together where they meet with a very soft brush and careful strokes. If the tooth is wet, more light will be reflected off it and the highlight will seem whiter than the rest of the tooth – especially where the tooth curves nearest to the light source. This may be the whitest part of the scene, so don't overdo the white in other parts of your painting.

Horse's teeth in oils ▲
The paint has been blended wet into wet to create very subtle transitions in tone. Darker lines indicate the vertical ridges in the teeth. Note, too, the tonal variation in the gums; they are lightest where the teeth protrude from them and darker as they slope backwards into the jaw.

Claws and hooves

The hard edge of claws and hooves will reflect light in the same way as a wet tooth, getting darker towards the edges and thus giving the claw or hoof its shape. You can get a crisp, sharp-edged highlight with subtle darkening of tones towards the edges; this is what helps to convey the impression that the surface is hard and unyielding. Look closely at the way these hard edges reflect light. Pay attention to the colour, too: a very dark shiny surface can reflect the colours from its surroundings.

In pencil and charcoal, you can create this effect by lifting off the pencil with a kneaded eraser to reveal the white paper underneath. You can, of course, avoid pencilling in the lighter areas in the first place by varying the pressure you apply to it. With watercolour, mask off the very brightest area first, so that when you lift away the masking fluid it reveals the white of the paper underneath. For oils, acrylics and pastels, the white or the lightest colour is the last thing you add.

When painting or drawing claws or hooves, don't be daunted at how many examples you have to try before you are successful. Get the elements all in the right place first and treat each one separately when you paint them, getting each one right. There may be subtle variations in tones, but you will use the same colours for them all. You may find that the last one you paint will be the best, as you'll have gained experience by the time you get to it.

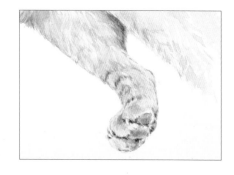

Cat's paw in watercolour ▲
Note the contrast between the hard claws (where the highlights are left white and a mid-grey line is painted down the shaded side) and the soft pad and surrounding fur. The claws are small, but getting them right is an important part of making the animal look lifelike.

Eyes

The success or failure of your painting can depend entirely on how you paint the gaze of your subject, as the eyes are probably the first thing that the viewer will notice.

One of the most common mistakes is to make the eyes too small or too close together; conversely, making the eyes too big will give your painting a cartoon-like effect. However, the position of the eyes varies from species to species: in cats and dogs, for example, the eyes are set on the front of the head, while in horses and sheep they are set on the side of the head. Whatever the position, each eye has to be in the correct position relative to the other and positioned symmetrically in relation to the nose and mouth. Measure the size of the eyes and compare the distance between them. If you take the size of the eye as being one unit, then the distance between them may be as much as four units. You can then follow the same procedure to get the nose, mouth and ears in the correct place.

Putting the pupils in the right place is also an important factor; the painting may look awkward if they do not face in the same direction. Always lightly map out the position, size and shape of the eyes and make sure they are correct before you begin to apply colour.

The shape of the pupils is something to consider, too. In some animals (sheep, for example) the pupils lie laterally, while in others they are vertical.

It's also important to make eyes look rounded. To do this, use light and dark tones to imply the curvature of the eyeball; needless to say, this requires very careful observation.

Note that the eyelid casts a shadow over the eyeball: the eye gets steadily darker nearer the eyelid, and is brighter at the base as less shadow is cast from the eyelid. The white of the eye is often not pure white: like the rest of the eye, it is shadowed by the eyelid. The eyelid also obscures part of the eye: we rarely see the complete circle of the iris.

Reflections are important, too, as light is reflected in the glassy surface of the eyes and this is what makes them look shiny. Take particular care with reflections, however. If you are working from a photograph, then the reflection that you see could be that of the photographer or even, in the case of a zoo animal, the bars of the cage. Try to work out what is being reflected: if you

know what you're painting, you'll find it easier to get it right. Remember, everything above the horizon will appear lighter in the reflection.

Similarly with highlights: you need to ask yourself if a highlight really is coming from the light source (the sun). It may just be a reflection of the flash from the camera, and if this is the case, then putting it in will look unnatural.

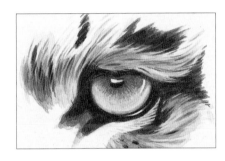

Tiger eye in watercolour ▲
The dramatic colouring and fine detailing make this a very attractive and lifelike study. Tiny touches of permanent white gouache on the pupil and lower lid reflect the light and help to show that the eyeball is rounded, while feathered brushstrokes, worked wet into wet, soften the transition from one colour to the next in the iris.

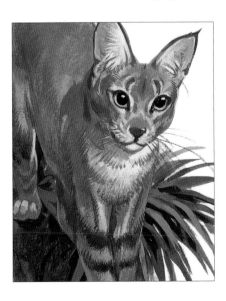

Eyes facing the front ▲
Cats' eyes are positioned on the front of their head. The pupils should be both rounded and symmetrical.

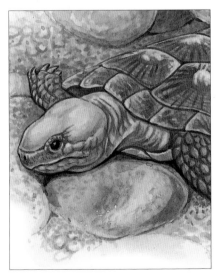

Eyes on the side ▲
Many reptiles have eyes set on the side of their head, so this tortoise can be painted with just one eye visible.

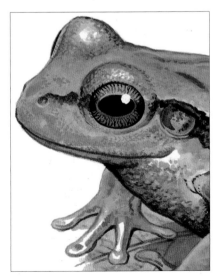

Relective pupils ▲
The clear white dot in the top right-hand area of the eye of this tree frog conveys the shiny reflection of the light source.

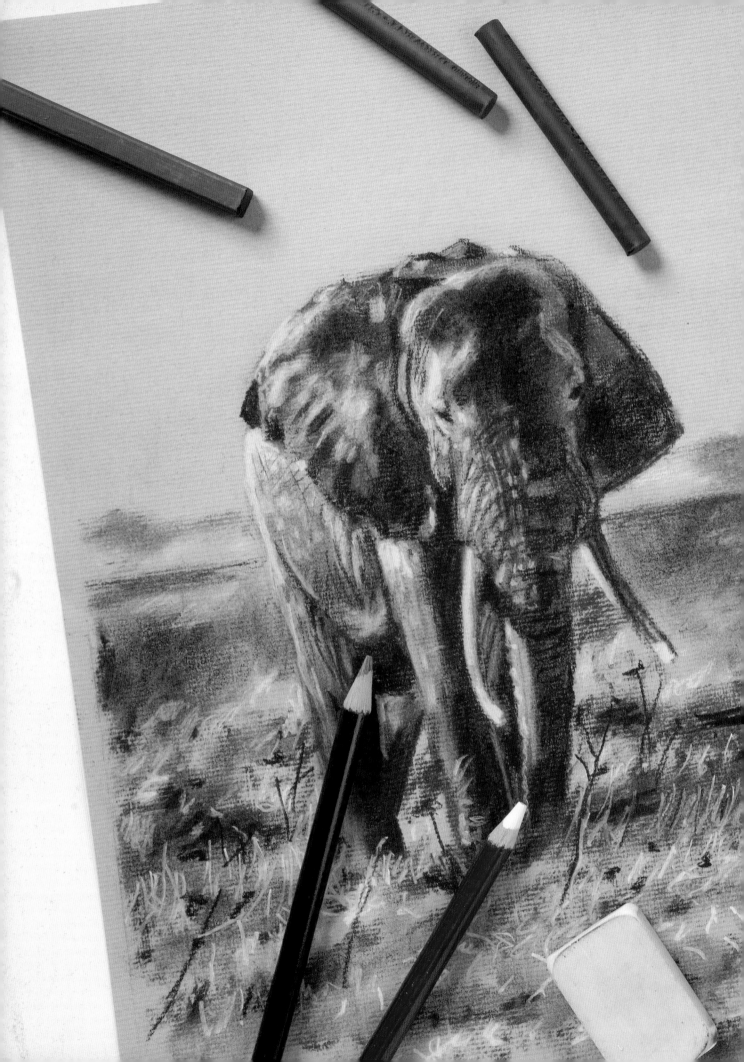

Projects

This chapter begins with a gallery of contemporary animal drawings and paintings by professional artists. Study them carefully and think about the composition and the techniques the artists used to achieve their objectives. You will undoubtedly discover things that you can apply in your own work. Next, there are fourteen detailed step-by-step projects in all the main mediums, the subjects ranging from much-loved family pets to a wild lion and an Amazonian tree frog. Even if they're in a different medium to the one you normally work in, take the time to read through the projects carefully. They're all painted by professional artists with many years' experience, so you'll find that they're packed with useful tips about collecting reference material, capturing the character of an animal and getting the right balance between your subject and its environment. Regular practice is important – it will both train your eye and sharpen your powers of observation.

Gallery

This section features a selection of animal drawings and paintings by professional wildlife artists and natural-history illustrators working in different media and styles. They range from loose and very spontaneous-looking pen-and-ink and pencil drawings to incredibly detailed watercolours and oil paintings that capture the texture of the animal's fur to perfection. Study the images carefully, and try to analyse what the artist has done. Think about the composition. Why is the subject placed in a particular part of the picture space, for example? Why might the artist have decided not to paint the whole animal?

Then try to work out how you might approach a similar subject. Would you opt for a close-up of the animal's head or would you want to paint the creature's natural habitat? How much of the surroundings would you include? Where would you choose to position the animal in the picture space? Some artists have an almost photo-realistic style, using very precise, fine brushstrokes, whereas others opt for more stylized illustrations. The approach you use is entirely down to personal preference but, even if a particular style does not appeal to you, you may well learn something that you can adapt and apply in your own work. The time that you spend looking at other artists' work is never time wasted.

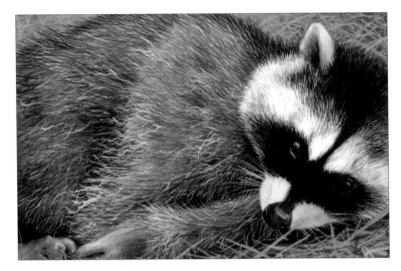

Raccoon – **Tracy Hall** ▲

This painting measures only 9 x 6.5 cm (3½ x 2½ inches), but the detail is exquisite. Using a very fine, almost dry brush and a limited palette of colours, the artist has painstakingly built up the texture in the raccoon's fur and the spiky grass on which it is lying. The composition is bold: many artists might have been tempted to include the whole animal and more of the surroundings, but cropping out the raccoon's left ear and the top of its back makes this a much more striking and intimate animal portrait. Note that when it is lying down, the animal's head is on a slight diagonal: this angle helps to create a more dynamic picture than a straight, head-on view.

Leopard – **David Stribbling** ▶

Like the raccoon painting (above), this is a beautifully detailed animal portrait. Oil paints are a wonderful medium for painting a subject such as this, as the soft, buttery consistency makes it possible to blend colours with ease to create subtle tonal shifts – a technique the artist has exploited to the full here in painting the leopard's fur. The composition is classic, with the key points of the portrait – the ears, nose and far eye – falling on the intersection of the thirds. Another classic compositional device used here is the use of a strong diagonal line – the animal's neck and head; this runs from top left to bottom right and helps to lead the viewer's eye through the image. The background foliage is soft and diffuse, so as not to detract from the leopard. The grey rock on which the animal is lying is painted in muted colours that complement the beautiful markings of the fur.

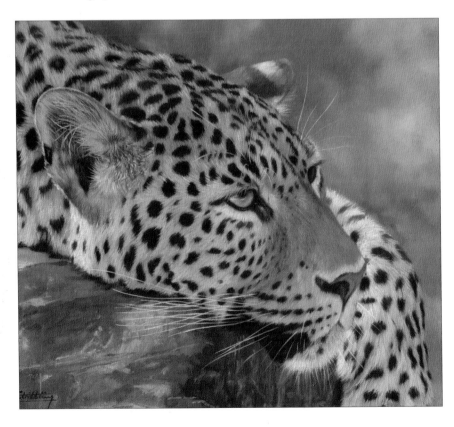

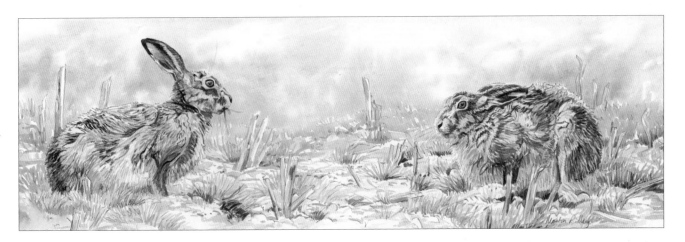

Brown hares and kale stems – Martin Ridley ▲
This watercolour is painted in quite a loose style, with the background behind the hares being little more than an impressionistic blur of very dilute burnt sienna. Nonetheless, there is a surprising amount of textural detail – particularly in the animals' coats, with the different tones being picked out in deft strokes of burnt umber, burnt sienna, and mixes of

these two colours with a little ultramarine blue. Note, too, how the white of the paper has been left to stand for the lightest parts of the animals' fur. The low eye level helps to draw us into the scene, as we see it from the animals' viewpoint. The letterbox format of the composition is unusual but effective, and one well worth experimenting with for subjects such as this.

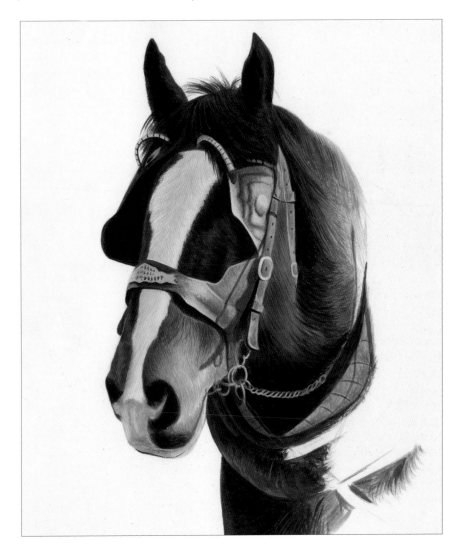

Shire horse – Jonathan Latimer ▶
This deceptively simple-looking painting of a brewery drayhorse, done in pencil and acrylic paints, captures the animal's build and strength beautifully. The three-quarter viewpoint allows the artist to show the power of the neck and shoulder muscles; a straight, head-on viewpoint would have placed the emphasis on the facial features, relegating the neck and shoulders to the background. The relatively low viewpoint, looking up at the horse's head, also emphasizes its height. The artist could have chosen to include more of the horse's day-to-day environment – the dray that it normally pulls, for example, or the yard of the brewery – but the harness and blinkers are enough to tell us immediately that this is a working animal.

▶

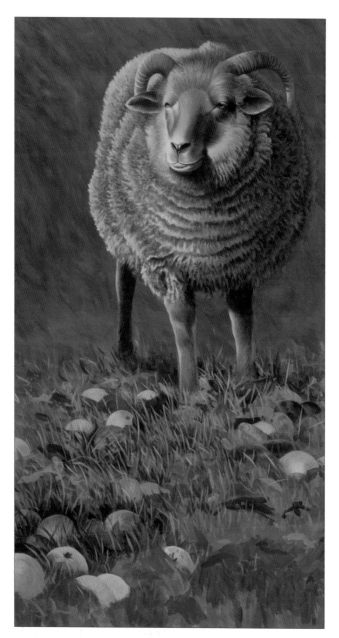

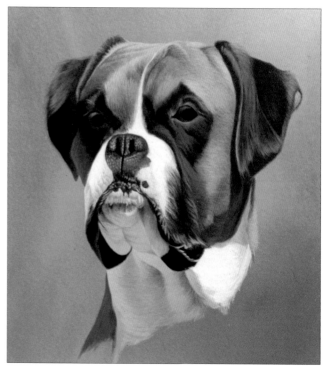

Boxer dog – Jonathan Latimer ▲
This very traditional-style portrait is a vignette of a much-loved family pet, showing the head and chunky neck of the animal rather than the whole body – a good way of depicting the animal's character and expression. The artist has chosen to paint a three-quarter profile, with his eye level matching the head height of the dog. This provides a more interesting and dynamic image than a head-on viewpoint. Note how well the artist has captured the texture of the smooth, silky fur: the different tones reveal the form of the head.

Portland sheep and windfalls – Jonathan Latimer ▲
Both the composition and format of this acrylic painting are a little unusual, but sometimes breaking with convention can pay dividends. Here, the picture space is divided vertically into two almost equal parts, with the bottom half of the image being devoted to the fallen apples on the grass and the top half to the main subject, the sheep with its beautifully curved horns and curly coat. The grass and apples in the immediate foreground are painted as soft blurs of colour, which helps to create a sense of scale and distance. The vertical letterbox format is perhaps more often used for tall subjects such as trees or buildings, but here it enhances the unusual composition. Had the sheep been placed in the very centre of the image, with an equal amount of space above and below it, the picture would have looked very static and the apples would have been a less important part of the overall painting.

Cow – Pat Ellacott ◄

In this characterful sketch, made using pastels on oiled paper, the artist has blended the pastel marks with her fingertips to create not only delicate, almost watercolour-like transitions of tone but also the texture of the animal's coat. Although we do not see the whole animal, its bulk and weight are immediately apparent. Note how the top of the cow's head is very close to the edge of the picture space; there is also a strong diagonal line running through the picture, from the dark shadow under the chest (bottom left) up to the tip of the left ear (top right). Both these factors make for a dynamic composition.

Studio window reflected – Timothy Easton ▲

Anyone who owns a cat will recognize this as a typical cat pose. Although the cat occupies only a small part of the space, there is no doubt that it is the focal point of the image. The artist has used the patch of sunlight reflected from his studio window on to the floor as a means of directing the viewer's attention toward the cat. Both the overall window shape and the shadow of the glazing bar are at a slight angle, which adds interest to what might otherwise be a very static scene. The very bright sunlight has bleached out some of the detail in the white fur, but note the number of different tones within it: pale pinks, greys and even browns are all visible.

▶

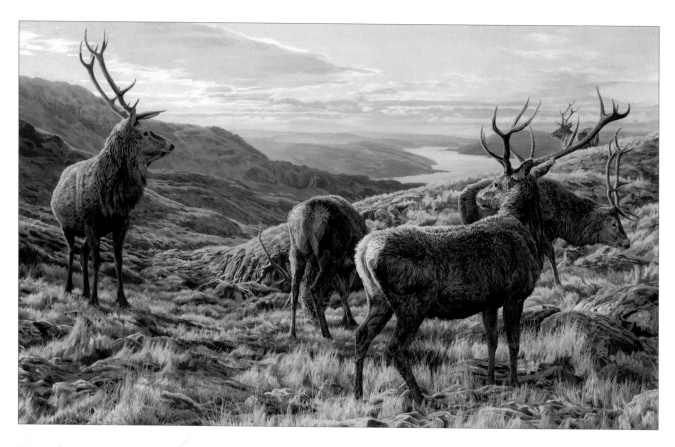

Stags above Loch Sunart – Martin Ridley ▲
Painted in the Scottish Highlands, this modern oil painting harks back in style to the romantic landscapes of the nineteenth century. The viewpoint, from behind the deer, makes the viewer feel as if he or she has just stumbled across the scene by chance. This is a beautiful example of a wildlife landscape: the animals and rugged terrain balance one another perfectly. The colours – the browns, purples and yellows of the landscape, the soft pinks and blues of the distant loch and sky, the rich browns and ochres of the stags – give the scene a warm glow that is very appealing.

Gallopers – Jonathan Truss ▼
This oil painting of zebras galloping across the plain has a wonderful sense of motion. Note, in particular, how well the artist has observed the powerful leg and shoulder muscles under tension. The angles of the heads and legs, too, show that the zebras are moving quickly, and the dust being kicked up by the animals' hooves also contributes to the feeling of movement.

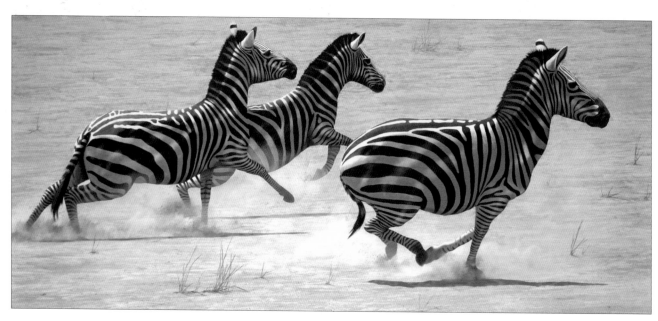

Young otters – Tracy Hall ◄

Measuring just 7.5 x 5cm (3 x 2in), this miniature watercolour painting captures the inquisitive nature of this group of young otters beautifully. The artist has included just enough of the surroundings to set the animals in their natural habitat, without drawing attention away from them. The composition is apparently very simple and uncontrived, but it has been carefully planned. As with human portraits, a group of three makes for a more interesting composition than just two animals. Here, two animals are peering over the back of the third; when the group is viewed as an overall shape, they form a circle which helps to lead the viewer's eye around the image. The foreground log provides a strong base, the solidity of which counterbalances the loose wet-into-wet washes of the water in the background.

Bear – David Stribbling ▲

Painting animals in motion is often more to do with the way the movement of the animal affects the surroundings rather than with the movement of the animals limbs. Here, the brown bear's legs and powerful shoulders are completely hidden from view, but the motion of the ripples in the water clearly show that the bear is swimming. Note how well the artist has given the water a sense of form: dark tones indicate the side of a ripple that is in shadow while light tones are used for the side of a ripple that catches the sunlight. Note also the smooth water in front of the bear: the reflection is virtually unbroken.

Tabby cat in watercolour

Cat fur is fascinating to paint and you will find a huge variety of markings, from tortoiseshell and tabby cats with their bold stripes to sleek, chocolate-point Siamese and long-haired Maine Coons. The key to painting fur is being able to blend colours in a very subtle way, without harsh edges. Even pure white or black cats, with no obvious markings, have their own 'patterns': because of reflected light and shadows, the fur of a pure white cat will exhibit clear differences in tone which you need to convey in your paintings.

Fur markings also reveal a lot about the shape of the animal. You need to look at an animal's fur in much the same way as a portrait painter looks at how fabrics drape over the body of a model: changes in tone and in the direction of the fur markings indicate the shape and contours of the body underneath. Always think about the basic anatomy of your subject, otherwise the painting will not look convincing. If you concentrate on the outline shape when you are painting a long-haired cat, for example, you could end up with something that looks like a ball of fluff with eyes, rather than a living animal. The cat in this project has relatively short hair, which makes it easier to see the underlying shape.

Cats seem to spend a lot of their time sleeping or simply sprawled out, soaking up the sunlight and, if you are lucky, you might have time to make a quick watercolour sketch. For 'action' pictures – kittens batting their paws at a toy or adult cats jumping from a wall or stalking a bird in the garden – you will almost certainly have to work from a photographic reference.

Materials
- *HB pencil*
- *140lb (300gsm) rough watercolour paper, pre-stretched*
- *Watercolour paints: yellow ochre, raw umber, alizarin crimson, ultramarine blue, cadmium red, Prussian blue, burnt sienna*
- *Gouache paints: Chinese white*
- *Brushes: medium round, fine round*

The subject
This is a typical cat pose – the animal is relaxed and sprawled out, but at the same time very alert to whatever is happening around it. The markings on the fur are subtly coloured but attractive. The face is full of character, and this is what you need to concentrate on in your painting. If you can get the facial features to look right, you are well on the way to creating a successful portrait.

A plain background allows you to concentrate on the subject.

The eyes, the most important part of the portrait, are wide open and alert.

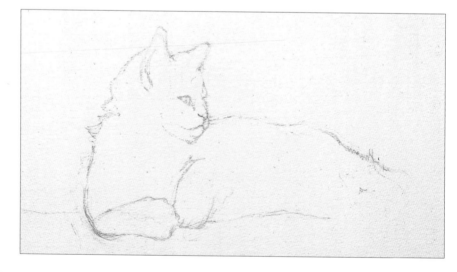

1 Using an HB pencil sketch the cat, making sure you get the angle of the head right in relation to the rest of the body. Start with the facial features, sketching the triangle formed by the eyes and nose, then work outwards. This makes it easier to position the features in relation to each other. If you draw the outline of the head first, and then try to fit in the facial features, the chances are that you will make the head too small.

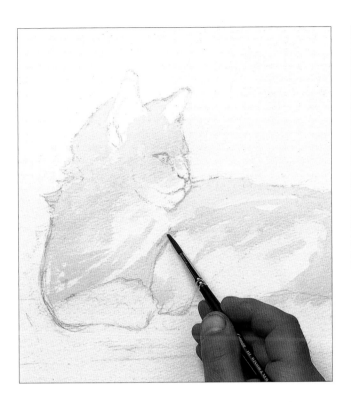

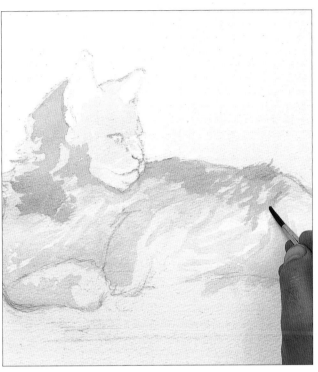

2 Mix a pale wash of a warm brown from yellow ochre and raw umber. Using a medium round brush, wash the mixture over the cat leaving the palest areas, such as the insides of the ears and the very light markings, untouched.

3 Add a little more raw umber to the mixture to make a darker brown and paint the darker areas on the back of the head and back.

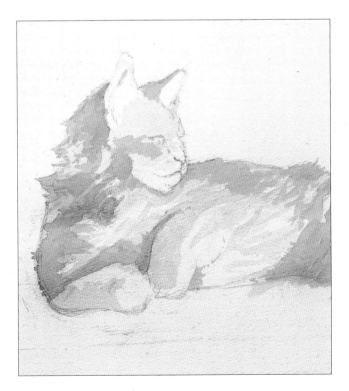

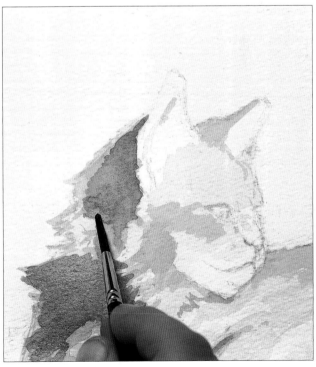

4 Continue applying the darker brown mixture, which gives the second tone. You are now beginning to establish a sense of form in the portrait.

5 Add a little alizarin crimson and ultramarine blue to the mixture to make a dark, neutral grey. Begin brushing in some of the darker areas around the head.

▶

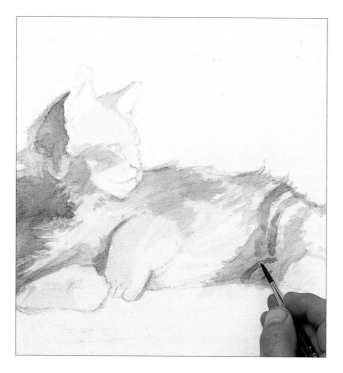

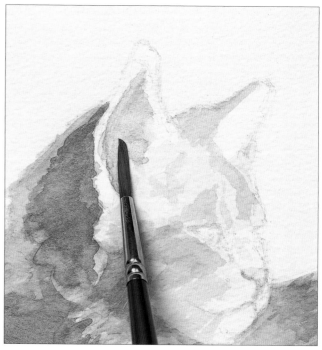

6 Add more water to the mixture and paint the cat's back, which is less shaded. Start painting some of the markings on the hind quarters, using short, spiky brushstrokes along the top of the cat's back. This indicates that the fur does not lie completely flat.

7 Mix a warm brown from yellow ochre and raw umber and brush it loosely over the mid-toned areas. Mix a warm pink from alizarin crimson and a little yellow ochre and, using a fine round brush, paint the insides of the ears, the pads of the paws, and the tip of the nose.

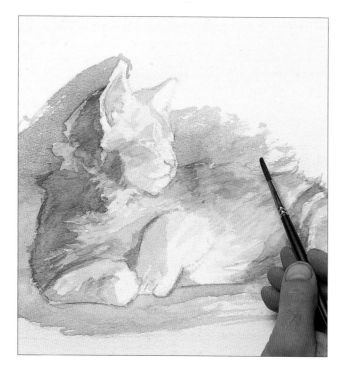

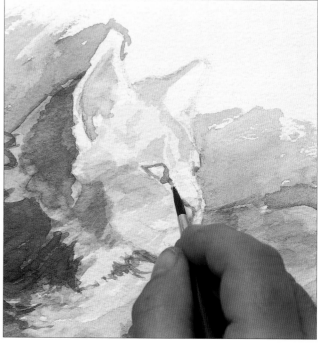

8 Mix a warm maroon colour from cadmium red, yellow ochre and alizarin crimson and paint the surface on which the cat is lying. Add ultramarine blue to darken the mixture and paint the background, carefully brushing around the cat.

9 Mix a purplish blue from ultramarine blue and cadmium red. Using a fine round brush, paint the dark fur on the side of the cat's head, the nostril, the area under the chin and the outline of the eye.

Assessment time

Although the broad outline of the cat is there, along with some indication of the markings on the fur, the painting does not yet look convincing because the body looks flat rather than rounded. In addition, the cat's head is merging into the warm colour of the background, when it needs to stand out much more clearly.

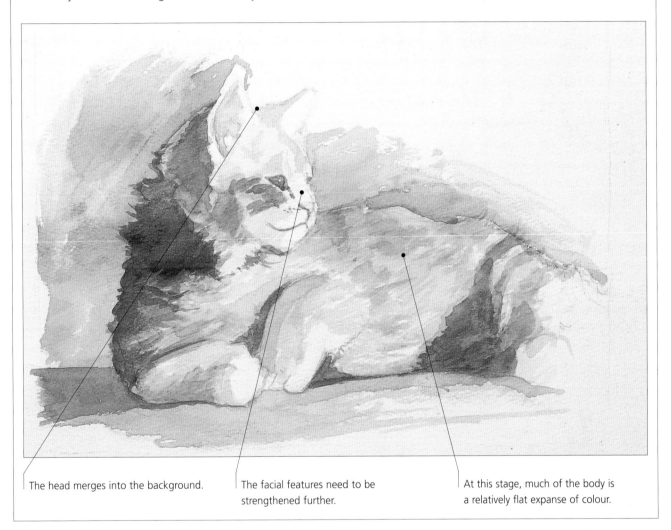

The head merges into the background.

The facial features need to be strengthened further.

At this stage, much of the body is a relatively flat expanse of colour.

10 Mix a greenish black from Prussian blue, burnt sienna and cadmium red and paint the pupil of the eye, leaving a white highlight. Brush more of the purplish-blue mixture used in Step 9 on to the shaded left-hand side of the cat and strengthen the shadow under the chin and on the back of the cat's head.

Tip: Pay careful attention to the highlight in the cat's eye. The shape and size of the white area must be accurate in order to look lifelike.

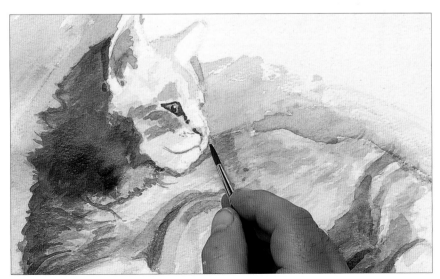

▶

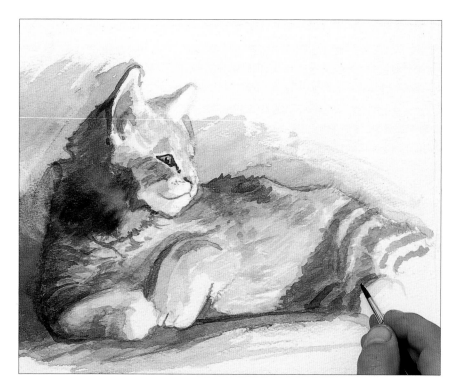

11 Using the same purplish-blue mixture, put in some of the stripes on the hind quarters and darken the tones on the back, paying careful attention to the direction of the brushstrokes so that the markings follow the contours of the body.

12 Using the same mixture, continue darkening the tones on the back to give a better sense of form.

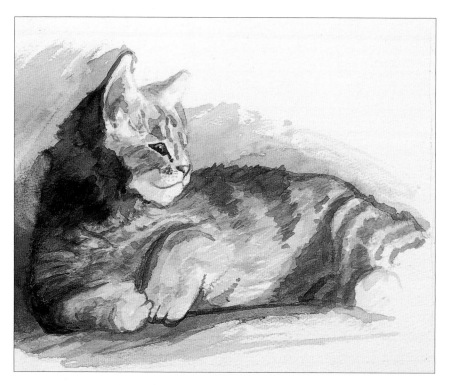

13 Adjust the tones where necessary. Now that you have put in lots of darks, you may need to tone down some of the bright areas that have been left unpainted by applying a very dilute wash of the first pale brown tone.

14 Darken the insides of the ears with alizarin crimson. Using a very fine brush and Chinese white gouache, paint the whiskers.

The finished painting

This is a lively and engaging study of a favourite family pet. All portraits, whether they are of humans or animals, need to convey the character of the subject. The artist has achieved this here by placing the main focus of interest on the cat's face and its alert expression. The fur is softly painted, with careful blends of colour, but the markings are clearly depicted.

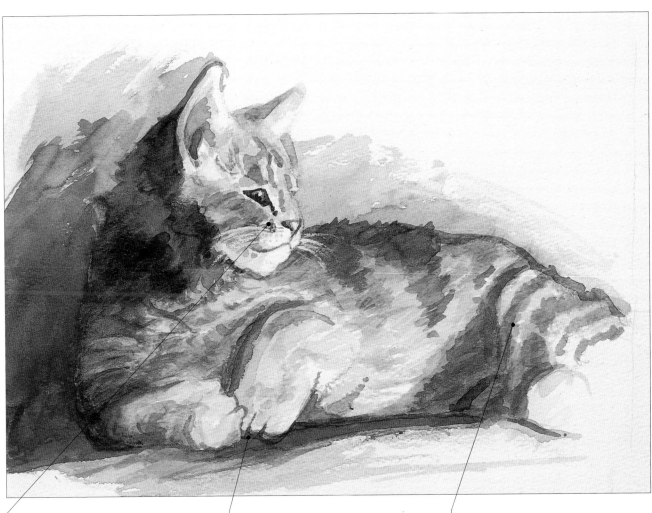

The facial features are crisply painted.

Deep shadow between the paws helps to create a sense of depth in the painting.

The markings change direction, following the contours of the body beneath.

Sleeping cat in gouache

It is lovely to be able to put your painting skills to good use to paint a portrait of a cherished family pet. Because you know your animal so well, you will easily be able to find a pose that sums up its character, and a painting like this would make a wonderful gift for another family member. Here, the artist combined a quick snapshot of the sleeping animal with a background of brightly coloured leaves from his garden.

There are several ways to approach painting fur. In a water-based medium such as acrylic, you might choose to apply loose, impressionistic washes of colour wet into wet, so that the paint blends on the support to create subtle transitions from one tone to another, perhaps lifting off colour with clean water to create lighter-toned areas. In this project, we build up the colour in thin glazes, gradually darkening the shaded areas until the right density is achieved, with each layer of paint being allowed to dry before the next one is applied. Use short brushstrokes that follow the direction in which the fur grows, and an almost dry and very fine brush. This creates the impression of individual strands of hair and is an effective way of conveying the texture of the fur.

The project also gives you the chance to practise masking. Because you need to mask out large areas in the early stages of the painting, use masking (frisket) film rather than tape or fluid. Masking film is available from most good art supply stores. To ensure that the film adheres firmly to the support and that no paint can seep under the edges, choose a smooth surface, such as illustration board.

Materials
- *Illustration board*
- *Masking (frisket) film*
- *Craft (utility) knife*
- *Gouache paints: cadmium yellow deep, flame red, burnt sienna, Vandyke brown, indigo, permanent white*
- *Brushes: medium round, fine round*

The subject
The artist used this photograph as reference material for the cat's 'pose' and for the colour and texture of its fur. However, the striped wallpaper does not make a very exciting or an attractive background.

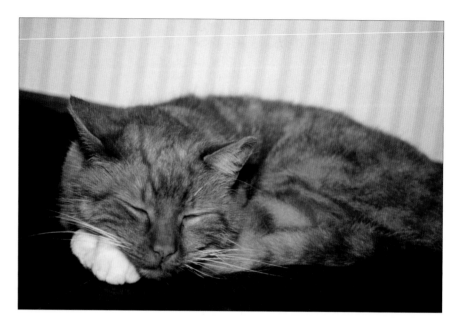

The background
Using this photograph of garden leaves provided a colourful and natural-looking background against which to position the cat.

Compositional sketch ▼

When you are combining two or more references in a painting, you must give some thought to the relative scale of the different elements. Make a quick sketch, in colour or in black and white, before you begin painting.

Tonal sketch ▼

This cat is predominantly ginger in colour, but there are many different tones within the fur. Making a tonal sketch in pencil or charcoal enables you to work out not only the different tones but also the composition of your painting.

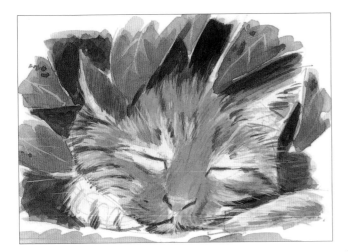

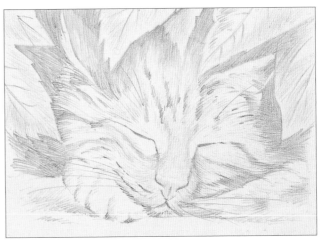

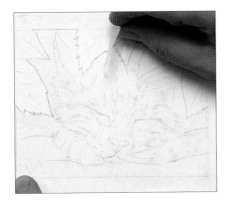

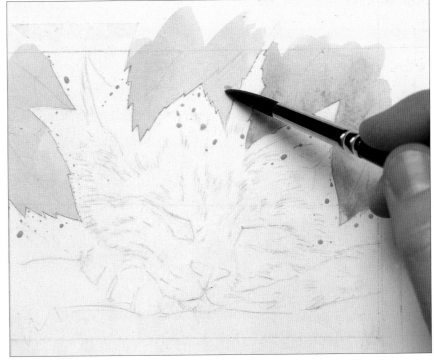

1 Referring to your initial sketch, lightly draw the cat using an HB pencil, indicating the main clumps of fur. Draw the veins on the leaves. Place masking (frisket) film over the sketch and, using a craft (utility) knife, cut around the outline of the cat. Peel away the masking film that covers the leaves.

Tip: The last thing you want is for paint to seep under the masking film on to the area of the painting that you are trying to protect. Working in one direction only, wipe a clean tissue or soft rag over the film to smooth out any wrinkles and ensure that the film is stuck down firmly. It is best to work towards the cut edges of the film.

2 Using a medium round brush, brush cadmium yellow deep gouache paint over all the leaves to establish the underlying colour. While the paint is still wet, rinse your brush in clean water and drop flame red over the tips of the leaves. The two colours will combine wet into wet to make a warm orange, creating soft-edged transitions of colour. It is important that you leave the paint to dry completely before you move on to the next stage; like watercolour, gouache paint dries very quickly, so this should only take a minute or two, but if you want to speed up the drying time, you can use a hairdryer on a warm setting. Hold the dryer well away from your painting so that you do not accidentally blow the red paint away from the tips and into the centre of the leaves.

▶

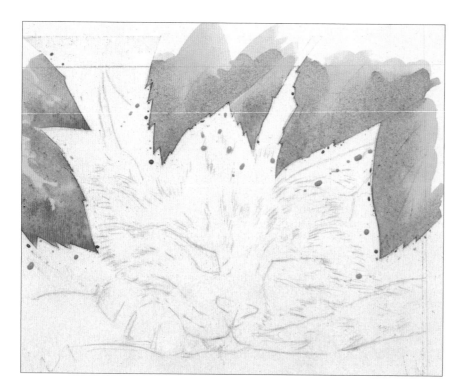

4 When you are sure that the paint is completely dry, carefully peel the masking film back from the cat. You can see how the leaves have crisp edges: it is easy to achieve this using a mask.

3 As you can see, the yellow and red merge together on the support in a way that looks completely natural. It does not matter if the colour is darker in some parts of the leaves than in others.

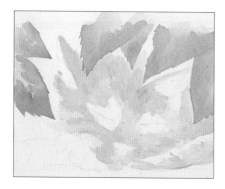

5 Mix a warm, yellowish brown from cadmium yellow deep and burnt sienna. Using the medium round brush, brush this mixture over the cat, leaving the white fur untouched. Your brushstrokes should follow the direction in which the fur grows. Leave to dry.

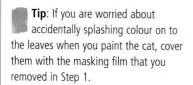

Tip: If you are worried about accidentally splashing colour on to the leaves when you paint the cat, cover them with the masking film that you removed in Step 1.

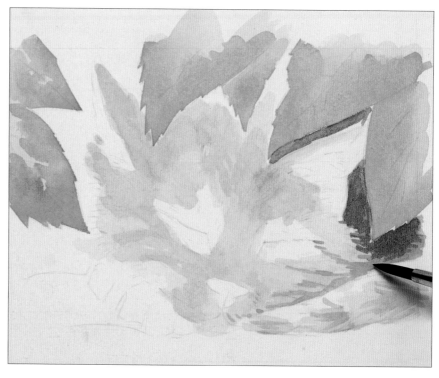

6 Mix a rich, chestnut brown from burnt sienna and Vandyke brown. Using a fine round brush, put in the dark fur on the cat's face, again using short brushstrokes that follow the direction in which the fur grows. Mix a darker brown from Vandyke brown and indigo and paint the dark fur around the edges of the ears.

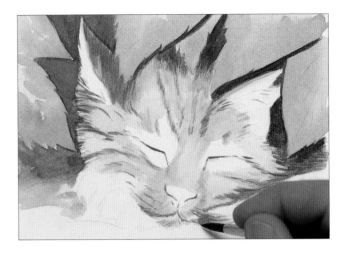

7 Use the same colour to paint the dark spaces between the leaves, so that the individual leaves stand out clearly.

8 Using Vandyke brown and the tip of the brush, start putting in the dark brown markings on the cat's face.

Assessment time

Brush a dilute version of the cadmium yellow deep and burnt sienna mixture used in Step 5 over the non-white areas of the cat's face to warm up the tones overall.

The painting is starting to take shape but more detail is needed to bring out the roundness of the face and the texture of the fur.

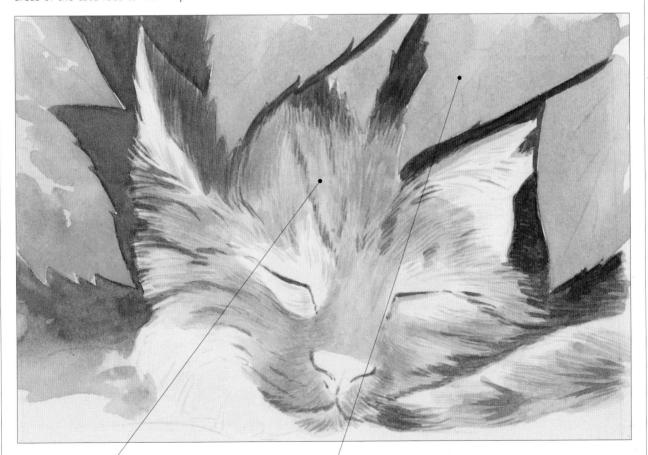

The fur contains little texture.

The cat merges with the background; the leaves do not yet look like leaves.

▶

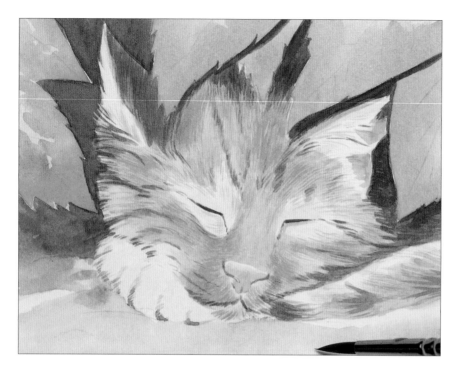

10 Mix flame red with a little cadmium yellow deep. Using a medium round brush, brush this colour over the leaves, allowing some of the original pale yellow colour to show through as the veins in the leaves.

9 Mix a very pale pink from flame red and permanent white and brush it on to the tips of the ears, which are slightly pink, and the tip of the nose. Using the Vandyke brown and indigo mixture from Step 6, put in the dark spaces between the claws. Add more water to the mixture. Brush clean water over the foreground and dot the indigo and Vandyke brown mixture into it.

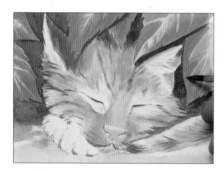

11 Using the same mixture, build up the intensity of the red, taking care not to go over the veins.

Tip: Remember that gouache looks slightly darker when it is dry than it does when it is wet, so wait until the paint is dry and assess its colour before you add another layer. It is better to build up the density of colour gradually: if you make the leaves too dark, they will overpower the cat, which is the main focus of the painting.

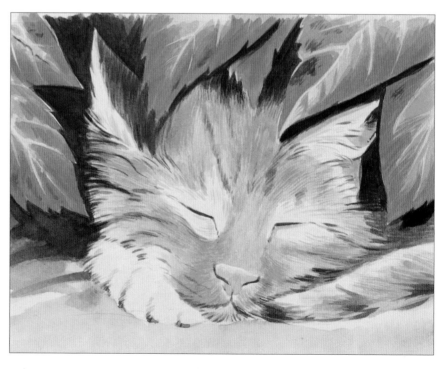

12 Using the indigo and Vandyke brown mixture, deepen the colour of the leaves. Note that the edges of the leaves are slightly serrated; use a fine brush to paint the serrations. Use the same colour to darken the very dark fur markings and the outlines of the mouth and nose.

The finished painting

This is a slightly whimsical but very appealing painting of a cherished family pet in a characteristic 'pose', sound asleep under a pretty canopy of garden foliage. The leafy background provides a colourful foil for the animal and focuses attention on its face, while delicate brushwork captures the texture of the fur. Here, the artist has used white gouache and a very fine brush to put in the whiskers and more fur texture in the final stages. It is up to you how much detail you put in: you might choose to build up the tones and textures more than has been done here.

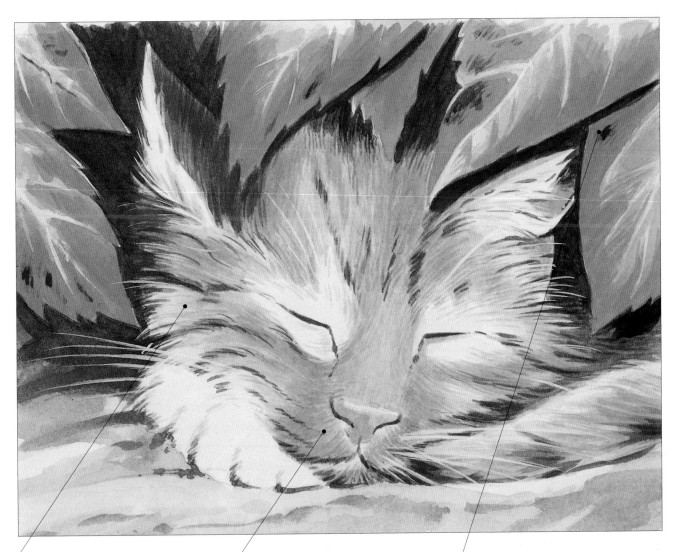

The texture of the fur has been built up gradually, using fine brushstrokes that follow the direction in which the fur grows.

Small details – the pink of the nose and the outline of the mouth – convey the character of the sleeping cat.

The richly coloured, textured autumn leaves provide a simple but dramatic backdrop to the portrait.

Old English Sheepdog in pencil

Old English Sheepdogs as a breed are delightful and their faces are full of character. A textural study seems particularly appropriate for this breed, whose whole character is defined by its long, flowing fur. For a short-haired breed such as a Whippet or a Great Dane, a more linear drawing that emphasizes the muscles might be more suitable.

When you're drawing long-haired animals such as this, however, it's very easy to be seduced into concentrating on the wispy, flyaway fur and to forget about the bone structure of the animal underneath. Always start by establishing the underlying structure, then add the decorative and textural detail on top. Start by drawing prominent features such as the eyes, nose, mouth and any bony protuberances near the surface. Once you've got their shape, size and position right, the rest will follow much more easily.

When drawing any kind of portrait, be it human or animal, it is a good idea to begin by positioning the facial features. Think of the eyes and nose as an inverted triangle: establish the outer point of each, as this will make it easier to get the rest of the features in the right place. If you start by drawing the outline of the head, you may find that you haven't left enough space to fit in the features.

In a monochrome drawing, you also have to think carefully about tone. Monochrome might seem ideal for an animal whose coat consists almost entirely of white and grey tones, but a very common beginner's mistake is to make the greys too light: consequently, the whole image can appear to be lacking in contrast. Reassess the tones continually, and be prepared to adjust them as you work and to darken the dark areas in order for the light tones to sparkle and shine through.

Materials
- *Smooth drawing paper*
- *Graphite pencils: HB, 6B*
- *Torchon*
- *Plastic eraser*

The subject
When you're drawing an animal (or a person, for that matter) always look for a characteristic pose or expression. The lolling pink tongue is typical of this breed of dog and gives the animal a quizzical, slightly comical expression that is very appealing. You can't rely on animals to stay still for long, however, so (unless you're an experienced artist and can draw quickly) you'll probably find it easiest to work from a reference photograph.

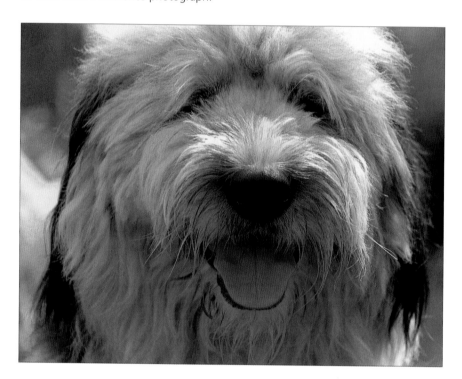

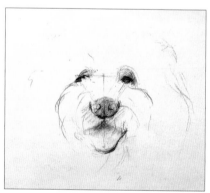

1 Using an HB pencil, lightly sketch your subject. Start with the facial features, as once you get these right, the rest will follow relatively easily. Note that the eyes and nose form an inverted triangle and begin by putting down the outer points of each as a guide. Roughly shade the eyes, nose and tongue, and indicate the direction in which the fur grows around the head.

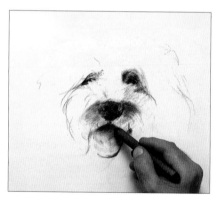

2 Using a 6B pencil, darken the nose and the sockets of the eyes. Note that, because the dog's head is turned ever so slightly to one side, one eye appears to be fractionally larger than the other. Use a torchon to blend the graphite on the nose and tongue to get a smooth, soft coverage. Also use the torchon as a drawing tool to apply some tone to the fur around the nose.

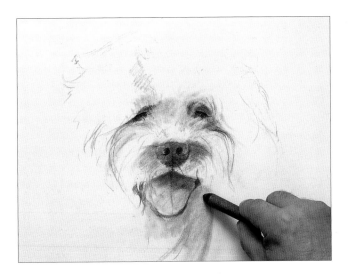

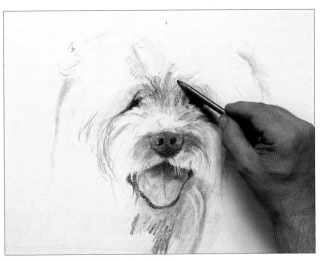

3 Again using the 6B pencil, draw the mouth (which can just be glimpsed around the tongue) more clearly. As in the previous step, use the torchon as a drawing tool to apply some tone to the fur on the dog's face and body. Your strokes should follow the direction in which the fur grows.

4 Loosely define the outer limits of the fur around the head to give yourself a boundary towards which to work. Using a 6B pencil, put in the darkest areas of fur on the dog's face, always making sure your pencil strokes follow the direction in which the fur grows.

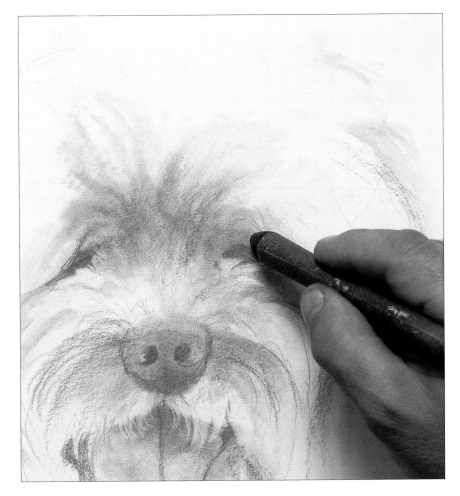

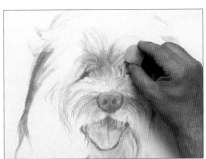

6 Using the edge of a plastic eraser, wipe off fine lines of graphite to create the white hairs around the eyes. (It is easier to wipe off white details than to apply dark tones around them.)

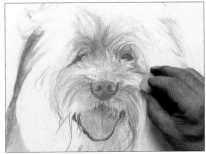

5 Blend the graphite marks with a torchon to create smooth areas of tone between the eyes and on the face.

7 Using an HB pencil, draw more mid-toned hairs around the mouth. Wipe the eraser across the dog's face above the mouth to create the lighter-toned fur in this part of the face.

Assessment time

The sheepdog's eyes, nose and mouth areas are prominent points that establish the structure of the dog's skull; the surrounding shaggy fur, by comparison, can be regarded as little more than decorative detail. For the rest of the drawing, concentrate on looking at the tones within the fur. Your shading in this area will convey the colour of the fur and also, because of the way the fur falls, imply the bony structure of the skull underneath.

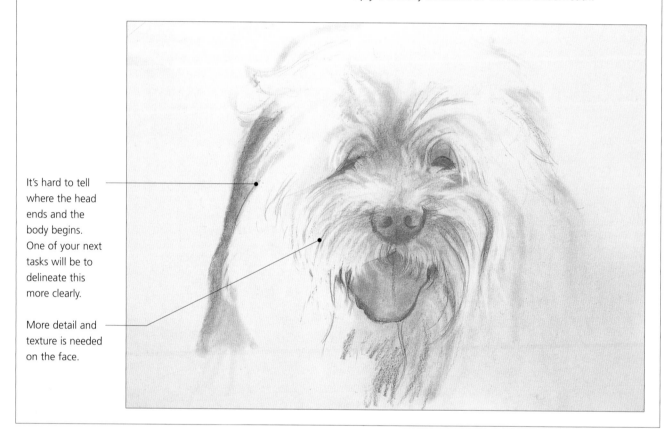

It's hard to tell where the head ends and the body begins. One of your next tasks will be to delineate this more clearly.

More detail and texture is needed on the face.

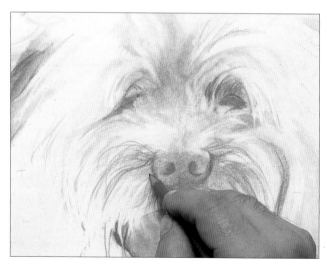

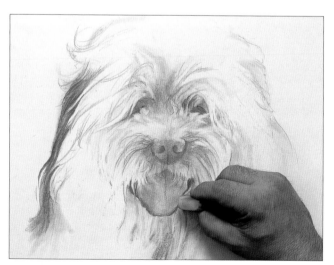

8 Now you can complete the textural detail of the fur. Using an HB pencil with a fine point, draw more individual wispy hairs – particularly around the nose and eyes. Beware of applying too much detail to the body; this would detract from the head, which is the most important part of the drawing.

9 Using a 6B pencil, reinforce the dark line on the left-hand side to try to make it clearer where the head ends. Assess the drawing as a whole and readjust tones by blending graphite with a torchon or lifting out tone with an eraser wherever you judge it to be necessary.

The finished drawing

This is a charming study of a well-loved family pet, and an interesting exercise in texture. The texture of the fur is created through a combination of softly blended pencil marks and more linear strokes for individual hairs on the face. The fact that the dog is looking directly at us immediately engages us in the portrait.

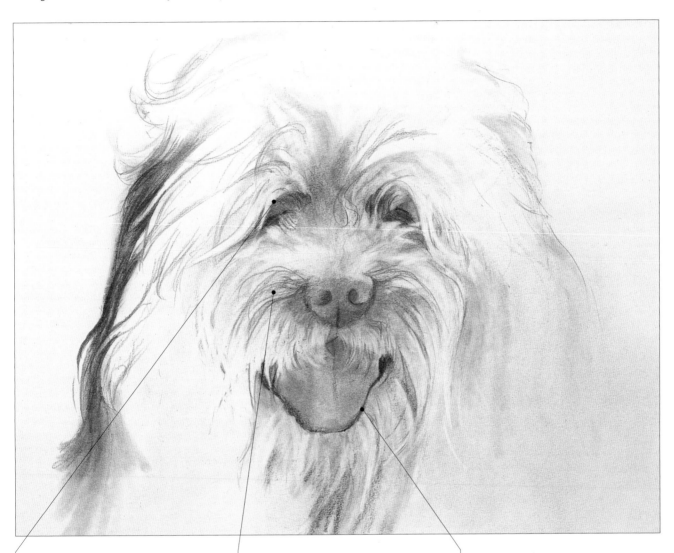

The eye socket has depth; it appears as a rounded form rather than a flat circle on the surface of the face.

The texture of the fur is created through a combination of marks blended with a torchon and individual linear strokes.

The dark line of the lower lip helps to make the lolling tongue stand out more clearly in the drawing.

Dog in acrylics

It's difficult to capture animals in motion and, particularly if you're a beginner, you will almost certainly have to work from a photograph. However, an 'action' painting of a much-loved family pet is a great way of capturing the animal's character – perhaps even more so than a conventional portrait, which can sometimes look rather static.

Start by taking as many reference photos as you can, so that you've got plenty to choose from, and use a fast shutter speed to freeze the action. It's incredibly difficult to capture exactly the right moment in a stills photo and it's surprising how much difference a slight change to the angle of the head or the twist of the body can make. You know your pet better than anyone, so you'll know when you've got something that looks 'right' for that particular animal.

Make sure that the setting does not dominate the painting. If you're painting a dog chasing a stick, for example, an open field or a beach would be a better setting than a forest, where the trees might distract from the main subject. The same applies to an indoor scene: if you want to paint a kitten chasing a ball across the floor, a plain background such as a painted wall or a varnished wooden floor will work better than a highly patterned wallpaper or carpet. Feel free to alter the background, or even omit it.

In this demonstration, the artist opted for a fairly loose painting in order to create a feeling of spontaneity and to capture the energy of the scene. You might prefer a more photo-realistic rendition, making very fine brush strokes to create more detail; however, your approach – analysing the tones on the animal to create a rounded form and observing the fall of light very carefully – should remain the same.

Materials
- *Primed board*
- *Black Conté pencil*
- *Acrylic paints: light blue violet, alizarin crimson, yellow ochre, cadmium red, titanium white*
- *Brushes: large filbert, small round*

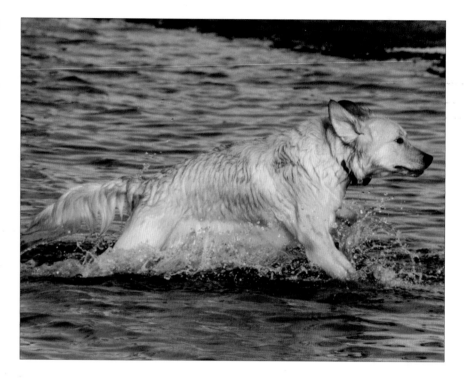

The subject
Here, the artist managed to capture the dog in mid-stride; the raised left foreleg and the ripples and splashes of water impart a lovely sense of movement to the scene. The water provides an interesting backdrop without detracting from the animal, while the use of complementary colours – the blue of the water and the orange-brown of the dog's shaggy coat – also adds to the dynamism of the picture.

1 Using a black Conté pencil, lightly sketch the scene. Try to see the dog as a series of geometric shapes, so that you get a sense of the rounded form of the animal – the body and muzzle, for example, can be seen as cylinders. As you work, look at how different features align and use these as points of reference: for example, the base of the tail is almost directly over the front of the right hind leg, and the base of the right ear lines up with the raised right foreleg.

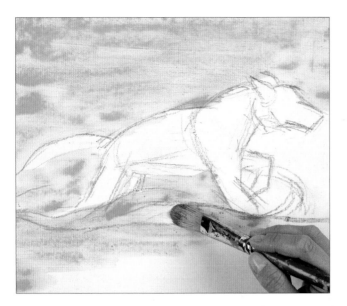

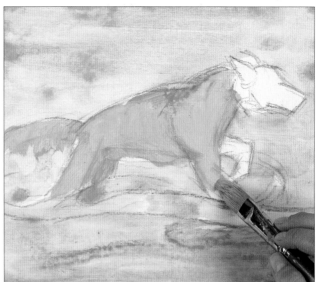

2 Mix a soft blue from light blue violet and a little alizarin crimson, using plenty of water to keep the mix very wet. Using a large filbert brush, block in the background. Use horizontal strokes to echo the ripples in the water and aim for quite a patchy coverage to allow some of the white of the board to show through for the highlights.

3 For the base colour of the dog's fur, mix an orangey-brown from yellow ochre, cadmium red and a little titanium white. Brush this over the dog, making directional strokes that follow the direction in which the hair grows so that you begin to establish a sense of form, even at this early stage in the painting.

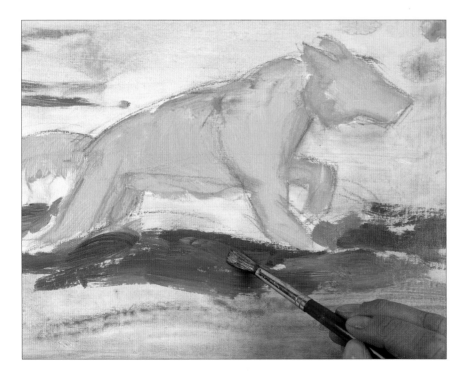

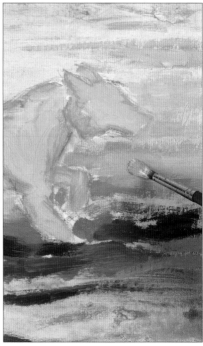

4 Mix a darker, thicker blue from light blue violet, alizarin crimson and a little yellow ochre and, using a small round brush, begin putting in some of the darker areas and ripples in the water – particularly where the dog's body casts a shadow on the water. Make sure your brushstrokes run in the same direction as the ripples. Vary the proportions of the colours in the mix, depending on whether you need a cooler blue (add more yellow ochre to 'green' the mix) or a warmer blue (add more alizarin crimson).

5 Continue putting in the ripples in the water, paying attention to the different tones – they are not all a uniform blue. For the lighter areas behind the dog, which catch more of the sunlight, mix light blue violet with titanium white.

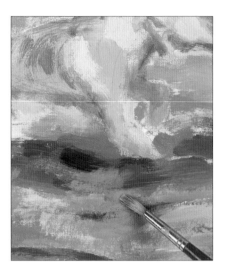

6 Once you've established the mid tones, you can start adding lighter and darker tones to create some modelling. Add a lot more titanium white to the orangey-brown from Step 3, to create a paler mix, and begin putting in the highlights on the dog's coat.

7 Continue building up the dog's fur, adding more cadmium red, yellow ochre and a tiny bit of ultramarine blue for the richer mid tones, which are a rusty brown. Use a very dry mix and 'feather' your brushstrokes to suggest some texture in the fur.

8 Using the same mix, put in the dog's reflection in the water, allowing some of the watercolour to show through in places. Note that the dog's reflection is not solid, as it would be in calm water: it is broken up by the ripples in the water.

9 Mix a dark, purply-black from ultramarine, cadmium red and a little of the orange-brown mix. Combining colours in this way to make a dark tone gives a more natural result than simply picking out details in black. Using a fine round brush, put in the darks around the dog's head – the eye, nose and mouth, the tips of the ears, around the neck and on the underside of the left foreleg.

10 Using the same mixes as in Step 9, refine the details on the head and body. Mix a dark blue from ultramarine and light blue violet and use it to define the edges of the dog.

 Tip: Try to look at the negative shapes – the spaces between the dog's legs, for example – rather than at the dog itself.

Assessment time

All the main elements of the painting are in place and, from this point onwards, you can concentrate on making relatively minor adjustments to build up the modelling and texture on the dog and create more of a sense of movement. However, it's important to remember that this is intended to be a fresh, spontaneous-looking image that captures a sense of fun and energy; if you overwork one area, you may find that it's too detailed and fussy in comparison with the rest. So take the time to really think about any changes you may need to make.

The shadows under the dog are too pale and insubstantial.

More texture and modelling are needed in the dog's fur – use dry brushwork to build up the texture and assess the differences in tone carefully to create more of a sense of form.

The water looks as if it is merely gently rippling; add more highlights and sparkling droplets to create more of a sense of movement.

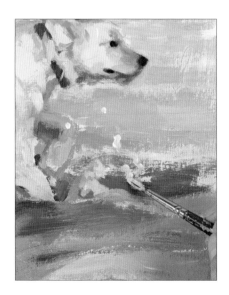

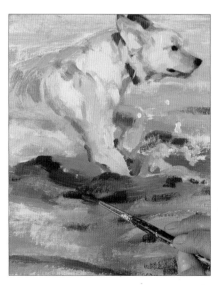

11 Mix titanium white with a little light blue violet. Using a combination of very light strokes that barely touch the paper and tiny dots, apply this colour to create the impression of water splashes and sunlight sparkling on the water. Do not make the paint too thick, or the water splashes will dominate the painting.

12 Mix a thick, dark blue from ultramarine blue and alizarin crimson and, using a small round brush, darken the shadow that the dog's body casts on the surface of the water.

13 Using a lighter version of the pale blue mix from Step 4, go back to touching in the bands of mid tone in the water, using short, curving horizontal strokes to create a sense of movement. Use the same colour to dot in more light highlights and create 'trails' of water droplets dripping from the dog's body.

14 Refine the shapes of the dog's reflection, using a slightly wetter mix than before. Remember to look at the tones carefully – there are darker and lighter patches within the reflection, so add more cadmium red for the darker areas and more white for the lighter ones.

15 Using the same orange-brown mixes as before, build up more texture and modelling on the dog's fur. Add titanium white to the mix to strengthen the highlights. To create the impression of individual strands of hair, use an almost dry brush and splay the bristles out with your fingertips.

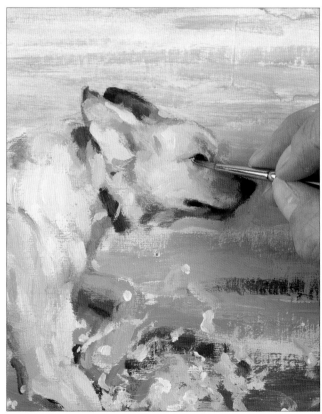

16 Refine the detailing on the head if necessary, making subtle adjustments to the tones to improve the modelling. For areas where you need a really sharp, dark line, such as the mouth and muzzle, use the black Conté pencil.

> **Tip**: Take care not to overwork things at this stage, or to get too lost in intricate detail. You need to keep the overall balance of the painting in your mind throughout.

17 If necessary, dot in the white of the eye to give it a bit of 'life' and sparkle.

The finished painting

Although it is quite loosely painted, this picture has a lovely feeling of spontaneity that suits the subject. The artist has positioned the main subject just to the left of centre, leaving more space in front of the animal than behind it. This suggests the continuing movement of the animal, rather than closing the composition by placing the subject close to the

edge of the frame. The dog has been captured mid stride, giving the picture a feeling of great energy and vitality. Although the water makes up a large part of the picture space, the artist has varied the tones and brushstrokes, so that there is enough detail to hold the viewer's interest without detracting from the main subject.

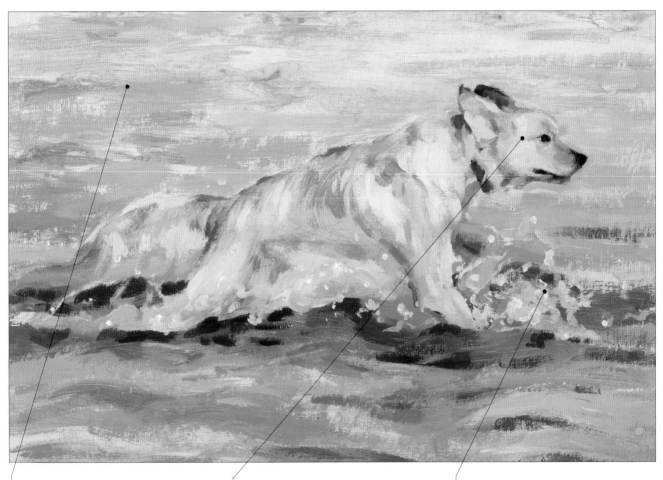

The background water is both paler and less detailed than the foreground, which helps to imply that it is further away.

The different tones on the dog's face and body have been carefully observed, creating good modelling.

The bright splashes convey a feeling of movement, as do the different tones of the ripples in the water.

Rabbit in coloured pencil

Coloured pencil is a wonderful medium for capturing the subtle colour combinations and texture of fur. By overlaying one colour on another you can create shimmering optical mixes that are often far more lively than a colour mixed on a palette. And, because pencils can be sharpened to a fine point, you can draw crisp, fine lines to depict individual hairs.

As in watercolour painting, the white of the paper has to be reserved for the whites and very brightest highlights. This means that you have to use the negative shapes – the spaces around the white elements – in order to define them. Along the edge of the rabbit's back, for example, this entails 'flicking' strokes of the greens and yellows of the background inwards, towards the animal, so that the white spaces in between the green and yellow strokes stand for the white hairs.

The soft, short fur in the ears and muzzle is drawn using a combination of very light short strokes and circular movements to give a smooth finish with no individual pencil marks being visible.

The longer hairs on the rabbit's back require a different treatment. Although they're coarser than the hairs in the ears, this coarseness is purely relative; the fur in this area still needs to look soft to the touch. Use hard strokes for the individual dark hairs, then go over

Materials
- *Tracing paper (optional)*
- *Smooth illustration board*
- *HB pencil*
- *Coloured pencils: cadmium yellow lemon, lemon, apple green, black soft, burnt sienna, burnt umber, chrome oxide green, brown ochre, pale warm grey, Payne's grey, raw umber, medium flesh colour*
- *Kneaded eraser*

Tip: Keep a small piece of kneaded eraser in your hand so that you can lift the HB pencil marks off the areas that are to be white fur.

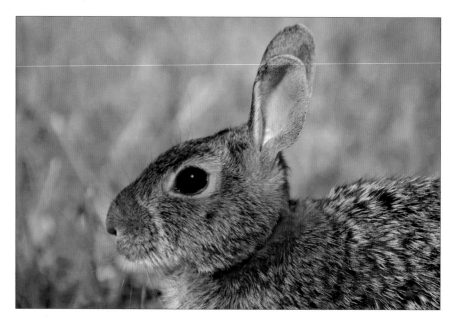

a wider area than the initial stroke with the same pencil to blend the colours. This is like applying a wash to give a base colour, as in watercolour – but here the 'glaze' is applied on top of the pencil strokes.

Most importantly, make your pencil strokes follow the contours of the body and run in the direction of hair growth to create a 3-D feel.

The subject
Note the rabbit's different fur textures – the short, velvety fur on the insides of the ears and the longer, rougher fur on the back. The low viewpoint is a good choice for a relatively small subject such as this, as it brings you down to the animal's eye level enabling you to create a small-scale, intimate animal 'portrait'.

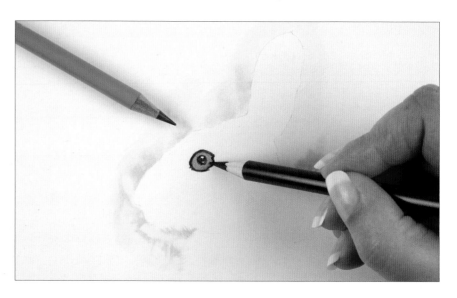

1 Using an HB pencil, trace or draw the outline of the rabbit. Block in the background with very light layers of cadmium yellow lemon, lemon and then apple green, making small, smooth strokes and circular movements of the pencil. Lightly block in the eye, using black soft for the outline and pupil and burnt sienna and burnt umber for the iris. Leave the highlight white.

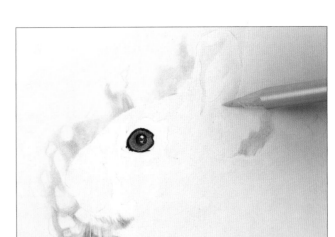

2 Develop the eye further, deepening and blending the burnt sienna and burnt umber together to create a rich brown. Deepen the pupil colour and outline with black soft, ensuring you have a sharp point so that the highlights are crisply defined. Develop the background colour further, introducing chrome oxide green and brown ochre – but remember to leave space for the white whiskers.

> **Tip**: If you need guidance with the shapes of grass in the background, place a piece of tracing paper over your picture and use this as a guide to pick out the dominant shapes.

3 Using an HB pencil, very faintly sketch the areas of pale fur. Apply a light coat of pale warm grey to all except the very palest of these and the eye. As you reach any white areas, let your soft pencil marks soften to nothing so that you do not get harsh edges. Apply a little more pressure in the dark areas of the ears, leaving the paper white in the centre.

> **Tip**: Do not worry if small areas of the white board show through the pale grey – just aim for a base colour.

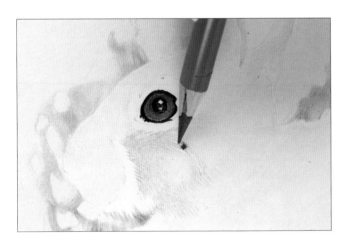

4 Pick out areas of stronger fur colour on the muzzle and cheek in brown ochre. Use close, soft strokes, allowing part of the grey underneath to show through to give the effect of different tones within the fur. Establish the position of any very dark areas, such as the spot just under the eye, with Payne's grey.

> **Tip**: Use the pencil to make strokes in the direction of hair growth, turning the paper as necessary.

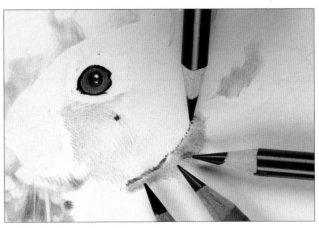

5 Apply burnt sienna and then burnt umber over the neck, which is redder in tone, blending with small circular movements for a good coverage of warm colour. In some areas, allow the lighter colours underneath to show through. Use Payne's grey to make tiny, firm strokes into the edges of the white and brown areas, following the direction of the rabbit's fur growth.

▶

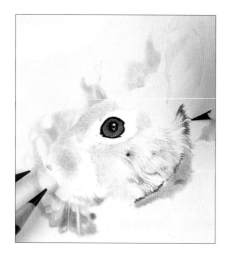

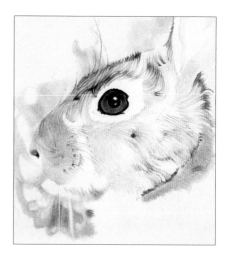

6 Build up the fur on the head, alternating between the three browns (burnt sienna, burnt umber and brown ochre) and using longer stroke marks as the fur gets longer. At the back of the head, start flicking the colour over onto the background to show the individual hairs. At the back of the head, under the ear, fill in between the dark brown lines with Payne's grey.

7 Put in longer strokes of Payne's grey over the eye and soften them afterwards with a light layer of brown ochre. Introduce some very fine black hairs on the top of the head, putting them in more strongly than they actually are. Use small strokes of black soft above the eye to darken that area of fur.

8 Draw in the nostril in Payne's grey, with burnt umber blending into the septum. The white line on the edge of the lip is now more apparent. Soften the muzzle with burnt umber, burnt sienna and brown ochre, optically blending a small area at a time. Use black soft and burnt umber for the whisker follicles. Use longer strokes in burnt umber for the darker hairs on the nose and under the eye.

Assessment time

Working in coloured pencil is a slow, painstaking process, as you gradually build up the layers of colour to the required density. It's always important to work on a picture as a whole, alternating between the subject and the background, so that you maintain the tonal balance of each part in relation to the rest. Although this drawing is still very far from finished, a lot of the basic groundwork has been done: the shape and position of the animal have been established, as have the light, mid and dark tones on the head – although all need to be strengthened further, and the longer, rougher fur on the back is still to be drawn in. As you build up the texture in the fur, the animal will begin to look more three-dimensional.

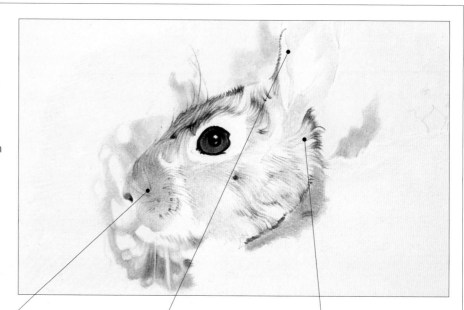

Short pencil strokes on the muzzle, layered and blended to achieve the right colour, create the impression of soft, short, velvety fur.

Only the very lightest tones on the ears have been blocked in; at this stage the colour is barely perceptible, but the artist has laid down a base colour that can be developed further.

Longer pencil strokes on the head are beginning to hint at the texture of the fur in this area.

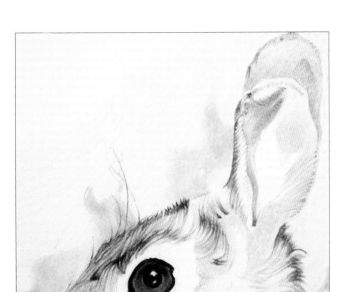

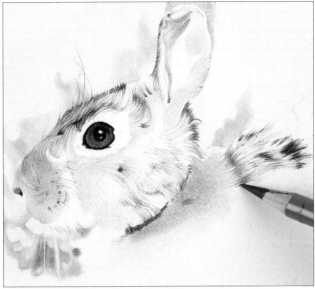

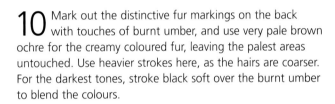

9 The ears are softer and more velvety in texture than the rest of the animal so use shorter strokes and layer the colours. On the inner near ear, which is paler in tone, apply warm grey, with brown ochre blended very lightly over the top and burnt umber strokes where necessary to add depth and tiny individual hairs. The far ear is browner and darker in tone: blend raw umber and brown ochre as you did on the face, to create a velvety texture, and apply fine strokes of burnt umber to pick out some of the darker areas. Soften the edge of the ear with very tiny flicks of warm grey.

10 Mark out the distinctive fur markings on the back with touches of burnt umber, and use very pale brown ochre for the creamy coloured fur, leaving the palest areas untouched. Use heavier strokes here, as the hairs are coarser. For the darkest tones, stroke black soft over the burnt umber to blend the colours.

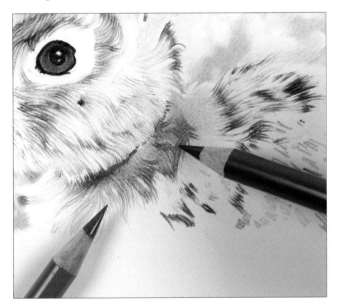

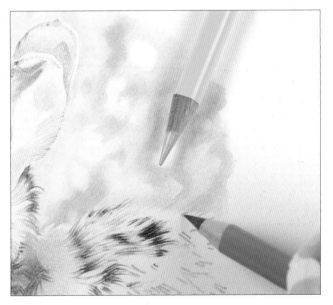

11 Continue to alternate between burnt umber and raw umber on the face and neck to create the dark and mid tones of the fur. Towards the back of the neck, introduce burnt sienna to add to the red tint of the fur. Begin blocking in the pattern of dark areas, using raw umber, so that you can work one area of fur into the next.

12 Develop the background further, using the apple green and lemon pencils, as before. Flick some of the background colour into the fur: the white paper stands for the white of the fur, so the flicks of colour define the shape of these hairs.

▶

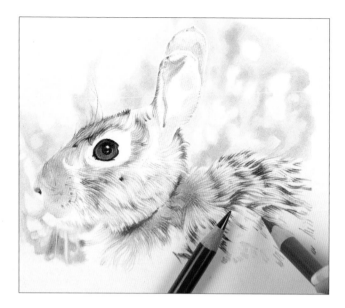

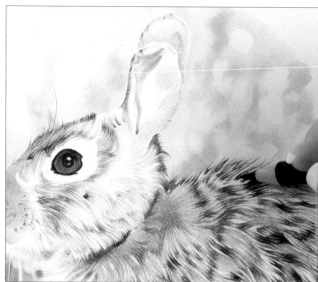

13 Continue developing the fur on the rabbit's back, using the same colours as before and working from dark to light. Around the ruff of the neck, alternate between raw umber and burnt sienna, using very light strokes and blending the marks, as the fur is very soft in this area. Leave some whites within the fur to give the impression of light hairs and highlights. Note that the fur on the back is longer and more coarse; use longer, more decisive pencil strokes here.

14 Strengthen the apple green around the rabbit's back. Using burnt umber, put in the very dark hairs around the edge, next to the background. Alternate between this and black soft, keeping a few whites on the paper. On the back, go over the burnt umber very lightly with a little black soft for the very darkest parts – the coverage should be very soft. When the individual strokes are blended together, this creates the soft texture of dense, dark patches of fur.

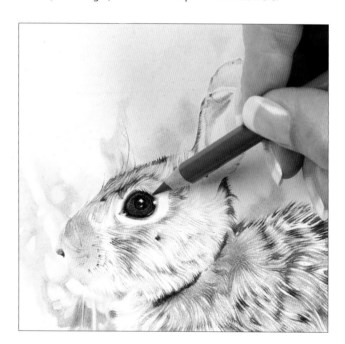

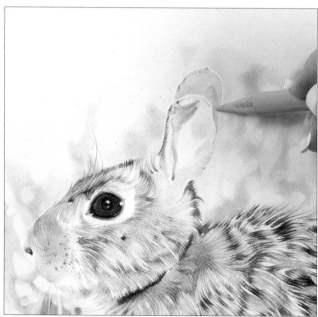

15 Draw a faint line of raw umber around the eye for the eyelid. Use medium flesh colour within the line around the eye, alternating between the two and leaving some little highlights as white. Soften the outer edge of the eye with black soft and add burnt umber to define the eye more. Stroke raw umber around the top of the eye to depict the individual hairs growing around the eye area.

16 Darken the mid tones on the head with raw umber, leaving some white showing through. Using burnt umber, lightly redefine the darker areas with short strokes. Go over the far ear using a flesh colour, then cover it with warm pale grey – but make sure that you do not darken the far ear too much or it will advance and appear to be in front of the near ear.

The finished drawing

This drawing demonstrates what a skilled artist can achieve using the medium of coloured pencil. It has a lovely tactile feel – you can almost reach out and stroke the rabbit's fur! The textures range from a soft, velvety covering on the ears to much longer, rougher fur on the animal's back. The soft, short fur is created by layering colours on top of one another to create exciting optical mixes on the paper, while the longer fur is drawn with heavier individual pencil marks. By carefully studying the different tones within the fur and by making her pencil strokes follow the contours of the rabbit's body, the artist has managed to make the animal look fully rounded and three-dimensional. The soft, mottled green background hints at an outdoor setting and complements the subject perfectly without distracting from it.

Note how the pencil strokes follow the direction in which the hairs grow.

The white hairs are not drawn in: the paper is left blank in these areas to create the impression of white hairs.

The dark tones within the fur are not just coloured markings: they are also the shadow areas that help to give the fur real depth and three-dimensionality.

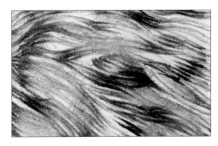

Otter in watercolour

This delightful study of an otter, peering inquisitively out to sea, is an exercise in building up textures. You can put in as much or as little detail as you wish, but don't try to finish one small area completely before you move on to the next. Go over the whole painting once, putting in the first brush marks, and then repeat the process as necessary.

Remember to work on a smooth, hot-pressed watercolour paper or board when using masking (frisket) film. If you use masking film on a rough-surfaced paper there is a risk that the film will not adhere to the surface properly, allowing paint to slip on to the area that you want to protect. Smooth paper also enables you to make the fine, crisp lines that are essential in a detailed study such as this.

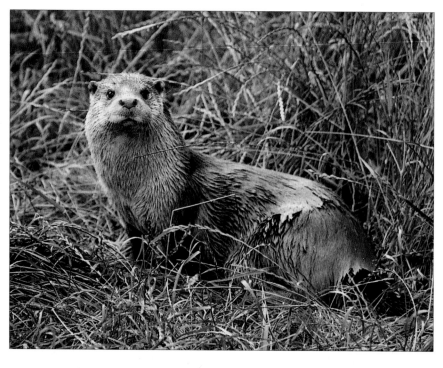

Materials
- *HB pencil*
- *Hot-pressed watercolour board or smooth paper*
- *Watercolour paints: ultramarine blue, cadmium yellow, burnt sienna, Vandyke brown, Payne's grey, cadmium red*
- *Gouache paints: permanent white*
- *Brushes: medium flat, medium round, fine round, very fine round*
- *Masking (frisket) film*
- *Scalpel or craft (utility) knife*
- *Tracing paper*

The subject and setting
Here the artist worked from two reference photographs – one for the otter's pose and fur detail, and one for the seaweed-covered rocks in the foreground. When you do this, you need to think carefully about the direction of the light. If you follow your references slavishly, you may find that sunlight appears to hit different areas of the picture at different angles, which will look very unnatural.

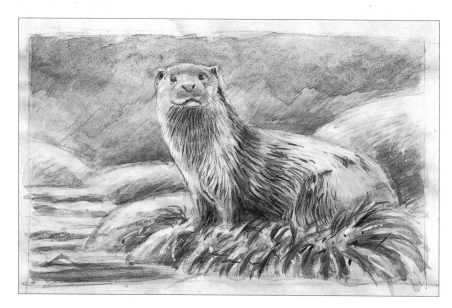

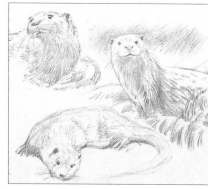

Preliminary sketches
Quick pencil sketches will help you to select the best composition, while a watercolour sketch is a good way of working out which colours to use.

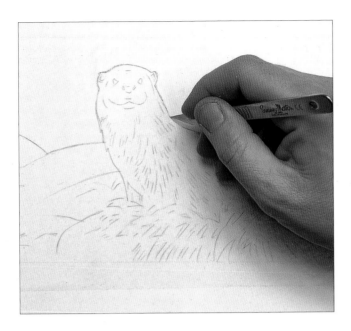

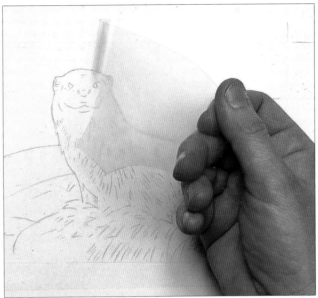

1 Using an HB pencil, copy your reference sketch on to watercolour board or smooth paper. Place masking film over the picture area. Using a sharp scalpel or craft (utility) knife, cut around the otter and rocks. To avoid damaging your painting surface, trace your pencil sketch, then place the masking film over the tracing paper, cut it out, and reposition the film on the painting surface.

2 Carefully peel back the masking film from the top half of the painting. You may need use a scalpel or craft knife to lift up the edge. You can now work freely on the sky and background area, without worrying about paint accidentally spilling over on to the otter or foreground rocks – though it is worth rubbing over the stuck-down film with a soft cloth or piece of tissue paper to make sure it adheres firmly to the surface and that no paint can seep underneath.

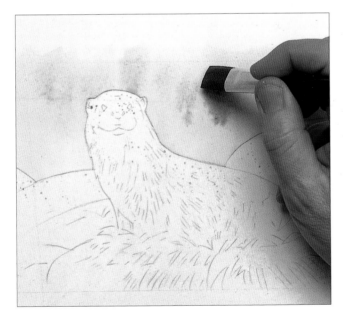

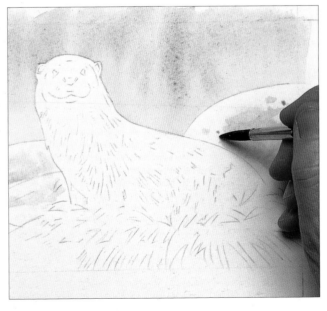

3 Mix a pale blue wash from ultramarine blue with a hint of cadmium yellow. Using a medium flat brush, dampen the board above the masking film with clean water and then brush in vertical strokes of the pale blue mixture. While the first wash is still damp, brush more vertical blue strokes along the top of the paint and allow the paint to drift down, forming a kind of gradated wash. Leave to dry.

4 Once the top area is dry, carefully peel back the masking film from the bottom half of the painting, revealing the otter and rocks. Using a medium round brush, dampen the rocks with clean water and dot on the pale blue mixture used in Step 3.

▶

5 While the paint is still damp, use a fine round brush to dot in a darker mix of ultramarine blue and start building up tone on the rocks. Because you are working wet into wet, the colours will start to blur. Stipple a very pale cadmium yellow onto the rocks in places and leave to dry.

6 Mix a pale wash of burnt sienna and brush it over the otter's head and body. Brush over the chest area with the pale blue wash used in step 3. Leave to dry. Mix a darker brown wash from Vandyke brown and Payne's grey, and brush from shoulder to abdomen. Add a line around the back legs.

Assessment time
The base colours have now been established across the whole scene. Using the same colour (here, ultramarine blue) on both the background and the main subject creates a colour harmony that provides a visual link between the background and the foreground. You can now start to put in detail and build up the fur. In the later stages of this painting, you will want lots of crisp detail, so it's important to let each stage dry completely before you move on to the next – otherwise the paint will blur and spread.

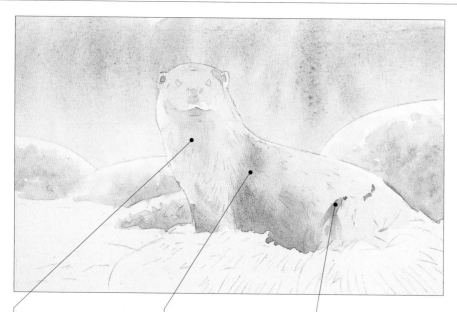

The chest, which is in shadow, is painted in a cool, pale mixture of ultramarine blue.

This darker brown helps to show the direction in which the fur is growing.

This dark line around the otter's back legs starts to establish the rounded form of the body.

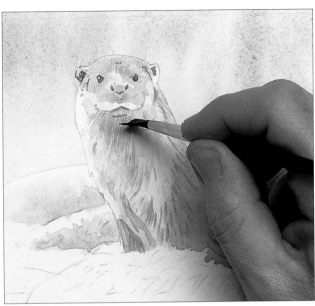

7 Mix a very dark brown from Vandyke brown and Payne's grey and, using a very fine round brush, put in the dark detail on the head – the inside of the ears, the eyes and the nose. Using the same colour, start to put in short brush marks that indicate the different directions in which the fur grows.

8 Mix a warm grey from Payne's grey and a little Vandyke brown. Using a fine round brush with the bristles splayed out in a fan shape, drybrush this mixture on to the otter's chest, taking care to follow the direction of the fur.

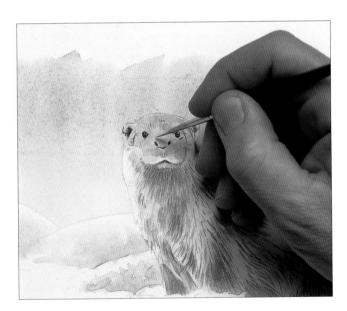

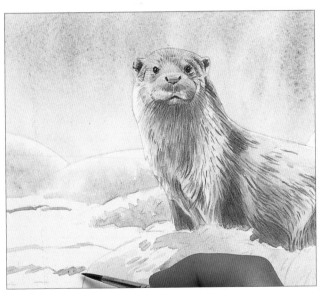

9 Continue building up tones and textures on the otter's chest and body. Paint the lightest areas on the otter's face with permanent white gouache. Mix a light, warm brown from burnt sienna and Vandyke brown and build up tones and textures on the otter's body. Darken the facial features.

10 Mix a bright but pale blue from ultramarine blue with a hint of cadmium yellow and, using a fine round brush, brush thin horizontal lines on to the rocks on the left-hand side of the painting. This blue shadow colour helps to establish some of the crevices and the uneven surface of the rocks.

Tip: The facial features help to establish the animal's character. If you can get these right, it will make it easier to overlook slight mistakes elsewhere. Spend plenty of time on this stage.

▶

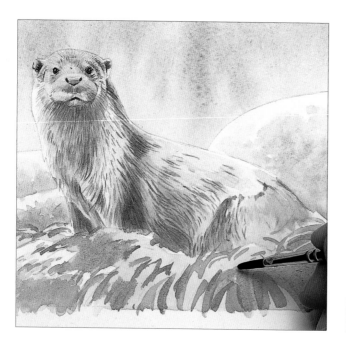

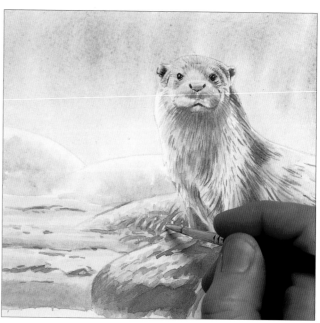

11 Mix a dark, bluish grey from Payne's grey and Vandyke brown and, using a medium round brush, paint the strands of seaweed on the rocks on the right of painting with loose, broad brushstrokes of this mixture. Leave to dry.

12 Brush a little ultramarine blue into the bottom left corner. Mix a warm brown from cadmium yellow and cadmium red and brush this mixture on to the rocks. Leave to dry. Paint lines of sea foam in permanent white gouache.

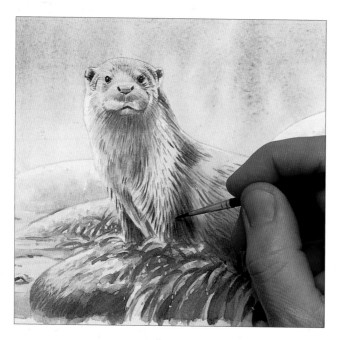

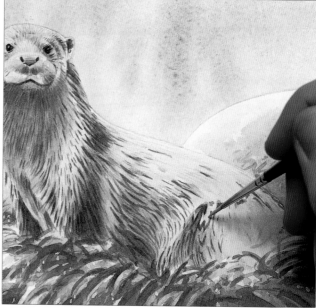

13 Now add more texture to the rock on the right, behind the otter, by stippling on a dark mixture of ultramarine blue. Note that the top of the rock, which is hit by the sunlight, is very light while the base is much darker. Using the drybrush technique, continue to add tone and form to the body of the otter, using a warm mixture of burnt sienna and ultramarine blue. Build up tone and texture on the otter's chest in the same way, using a mid-toned mixture of ultramarine blue.

14 Using a fine round brush and very short brushstrokes, paint white gouache to form the highlights along the top of the otter's back and on the body, where water is glistening on the fur. Use white gouache to paint the otter's whiskers on either side of the muzzle.

The finished painting

This is a fresh and lively painting that captures the animal's pose and character beautifully. The background colours of blues and greys are echoed in the shadow areas on the otter's fur, creating a colour harmony that gives the picture unity.

By including a lot of crisp detail on the otter itself and allowing the background colours of the sky and rocks to blur and merge on the paper, the artist has made the main subject stand out in sharp relief.

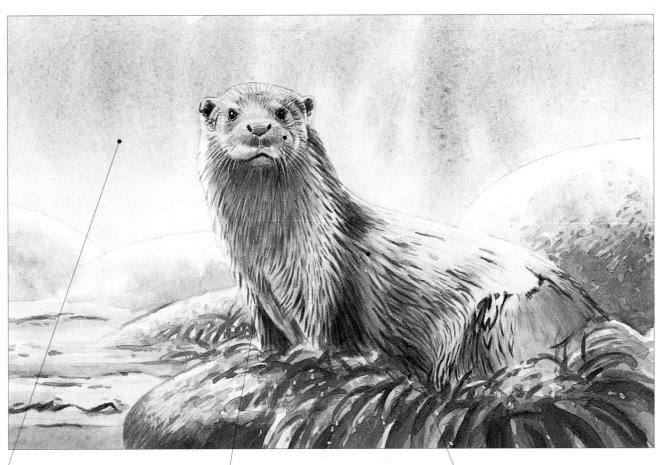

The background is painted in translucent, wet-into-wet washes that blur into indistinct shapes.

White gouache is used for very fine details such as the whiskers, which would be very difficult to achieve simply by leaving the paper white.

The crisp fur detail on the otter is made up of several layers of tiny brushstrokes, worked wet on dry – a painstaking technique but one that is well worth the effort.

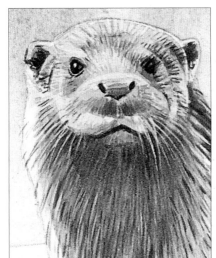

Sheep in watercolour

This painting demonstrates the importance of good composition. Animals often tend to congregate together in an untidy throng, making it difficult to pick out individuals. They may all be some distance away with nothing else to attract the eye.

You may need to move elements around, or even omit some things altogether. It's often a good idea to place one animal in the foreground and others in the middle or far distance, to create a sense of scale.

Whatever group of animals you're painting, be it a flock of sheep or a herd of wild deer, your first task is to decide on where you are going to place the focal point. Using the rule of thirds – dividing the image into nine parts – is a classic way of creating a composition.

This scene is as much about painting the setting as it is about painting the animals, so think about how you can use the landscape to enhance your composition. How much sky are you going to include? Can you use an element of the setting to direct the viewer's attention to a specific part of the image? Here, for example, the large, overhanging branch of the tree on the left-hand side of the picture space directs our eye in towards the animals in the centre of the painting; a furrow or the line of a stream could serve the same function.

In a wider landscape such as this, remember a few basic perspective rules: the sky appears paler closer to the horizon, the animals will appear to diminish in size the further away they are, and more texture will be evident in the foreground than in the distance.

Although the sheep in this demonstration have white coats, it's a distinctly off-white. This is partly due to dirt on their coats, and partly to the way the shadows fall, and the colours reflected up into the sheep's coats from the ground. Only the very brightest highlights on the sheep's coats should be reserved as pure white – and even these highlights may need to be knocked back with the application of a pale glaze in the final stages.

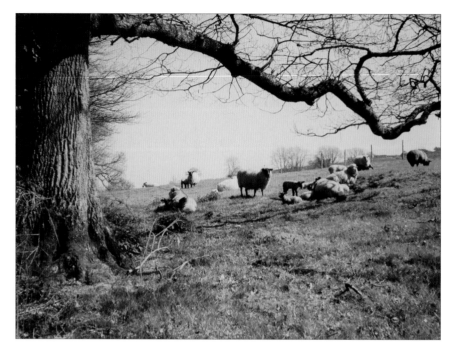

Materials
- *Good-quality watercolour paper*
- *2B pencil*
- *Masking fluid*
- *Ruling drawing pen, dip pen or old brush*
- *Watercolour paints: cobalt blue, cerulean, burnt sienna, lemon yellow, olive green, yellow ochre, sepia, blue violet, Naples yellow*
- *Brushes: medium round, rigger*

The setting
This photo shows the composition that the artist selected – a flock of sheep in a sloping field, with a tree 'framing' the image and directing the viewer's eye in toward the centre of the painting.

The detail
A close-up shot of sheep was used by the artist as a reference to capture some of the detail in the animals' coats.

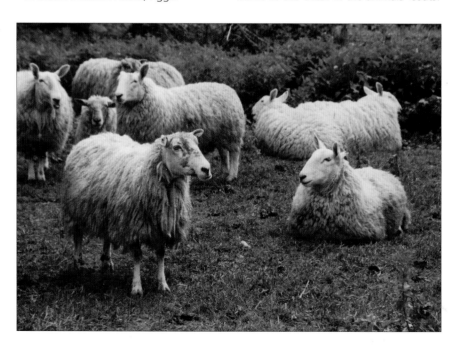

1 Using a 2B pencil, sketch the scene. With a pale-coloured subject such as this, you may find that some of your initial marks show through the watercolour glazes in the finished painting, which can be a very effective way of creating texture; if you want these linear marks to remain visible, apply more pressure to the pencil – or even go over your pencil lines in pen and waterproof ink.

2 Using a ruling drawing pen, a dip pen or an old brush dipped in masking fluid, mask out the highlights on the tree trunk and the backs and ears of the sheep. Use bold, scribbly marks so that you create some texture in these areas.

3 Dot some masking fluid into the foreground, also, for the light grasses and pebbles on the ground. Leave it to dry completely. If you're short of time, you can speed up the drying process by using a hairdryer – but make sure you do not accidentally blow the masking fluid on to areas where you do not want it to go.

4 Using a medium round brush, wet the sky area with clear water. Mix dilute washes of cobalt blue, cerulean and burnt sienna. While the paper is still wet, brush cobalt blue over the top one-third of the sky, fading into cerulean further down as the sky pales towards the horizon, and going into burnt sienna at the base of the sky to add a touch of warmth. The paint will spread wet into wet, leaving no brush marks or hard edges.

5 Add a little cobalt blue to the burnt sienna to make a warm grey. While the sky is still wet, brush on small vertical strokes for the trees in the distance. The paint will spread and blur, wet into wet, to create the effect of distant tangles of branches.

6 Mix a bright, yellowy green from cobalt blue and lemon yellow, and a mid green from cobalt and olive green. Working around the sheep and tree trunk, brush the bright yellow-green over the distant field and the darker green over the foreground.

▶

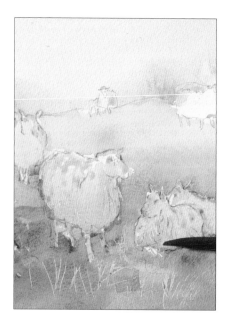

7 Wet the foreground with clean water. While the paper is still damp, drop yellow ochre and burnt sienna into the immediate foreground, where patches of bare earth can be seen.

8 Wash yellow ochre over the tree trunk and main branch, as a warm undercolour, dropping in burnt sienna and the mid green mix from Step 6 at the base of the tree, which is much darker in tone.

9 Mix a pale, warm orange from yellow ochre and a little burnt sienna. Brush this mix over the darkest parts of the sheep's coats. The masking fluid applied in Step 2 will preserve the white highlights.

Assessment time

Underpainting has set the warm tones of the scene. Already the strength of the composition is clear, with the tree trunk on the left holding in the image and the overhanging branch leading our eye through the picture and in to the sheep in the centre. From this point onwards, you can concentrate on building up the necessary depth of colour, adding texture and detailing, and making both the sheep and the tree look three-dimensional.

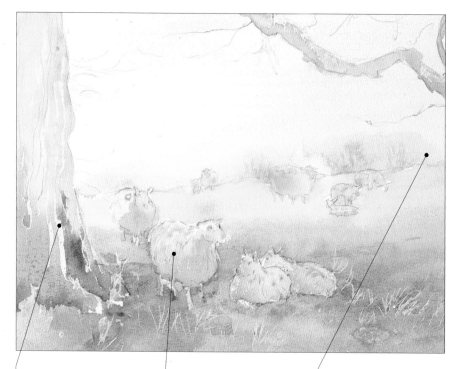

Once you've established the basic tones of the tree, you can add textural detailing to the bark.

By building up layers of colour, you can make the sheep look rounded and three-dimensional.

Note how both the sky and the grass pale towards the horizon.

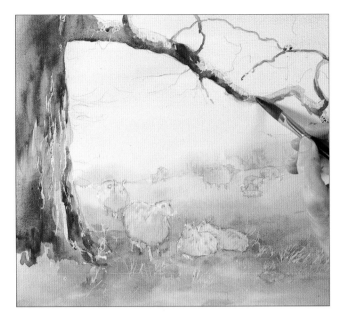

10 Mix a warm brown from sepia and a little burnt sienna. Wash this colour over the tree trunk and overhanging main branch, adding more burnt sienna to the mix for the underside of the branch, which is in shade. Allow some of the underlying colour to show through, so that you begin to develop some texture on the trunk.

11 Using a rigger brush, paint in the smaller branches, varying the proportions of the colours in the mix as necessary to get darker or lighter tones. Use warmer, darker tones for the nearest branches and cooler, lighter ones for those that are slightly further away so that you create some sense of distance.

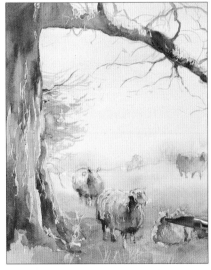

12 Add blue violet to the sepia and sienna mix for the darker areas. Put in the small branches protruding from the right-hand side of the trunk; this area is still wet, so the colours will blur together creating a soft, diffuse effect that will contrast well with the firmer, more deliberate brushstrokes used on the tree trunk.

13 Mix a warm, blue-grey from blue violet and a tiny bit of cobalt. Brush this colour mix over the darkest areas of the sheep to develop the form. Although we think of the sheep as being white, it is surprising how dark the shaded areas actually are. Leave the paint to dry before you make a final assessment about the tone; you may find that you need to darken it still further.

14 Using dilute cobalt blue, brush in the shadows on the ground under the sheep. Use the same colour on the underside of the overhanging branch and the tree trunk, which are in shadow, so that the tree begins to look more three-dimensional.

Tip: Drag the brush down, in long vertical strokes, to create the ridges and crevices in the tree trunk.

▶

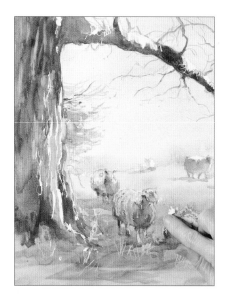

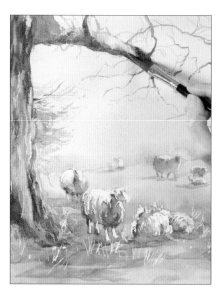

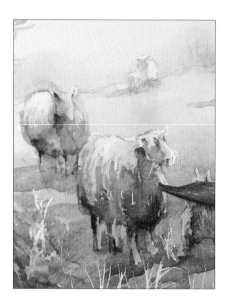

15 Using your fingertips, carefully rub off the masking fluid to reveal the white highlights on the tree trunk, sheep and foreground area.

16 Wash a thin glaze of very dilute yellow ochre over the tree to knock back the very bright highlights. The colour should be so pale that it is barely perceptible.

17 Brush very dilute Naples yellow over the exposed white parts of the sheep. Again, the colour should be barely perceptible – just enough to 'kill' the bright white of the paper, which would otherwise stand out too much.

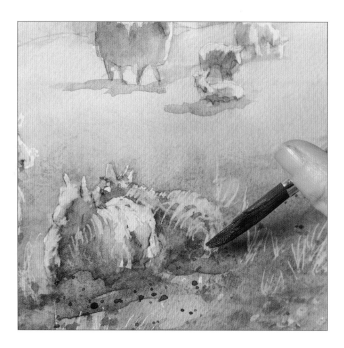

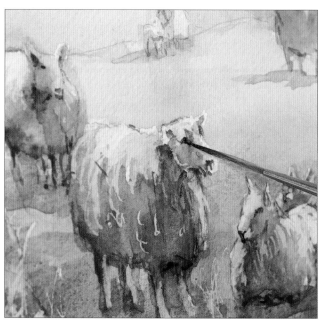

18 Spatter a warm brown mix of cobalt blue and burnt sienna over the immediate foreground to create a pebbly texture on the ground.

19 Use the warm brown mix to add a just little extra texture to the sheep's coat with a few short paint strokes. Mix a dark indigo from blue violet and burnt sienna. Using a rigger brush, put in the detailing on the sheep's faces – the eyes and noses.

Tip: To spatter, either tap the brush handle with your fingertip or drag your finger lightly across the tips of the brush hairs so that tiny droplets of paint fly off onto the surface of the painting. Do not overload the brush with paint, or the droplets of spattered paint may be too large.

The finished painting

This is an atmospheric painting of a tranquil rural scene. The burnt sienna and yellow ochre washes on the tree, along with the bright, yellow-green grass, create a feeling of warm afternoon sunlight; the pale but bright blue sky enhances this. Note how well-balanced the composition is: our eye is led from the standing sheep to the kneeling sheep in the foreground, and then around almost in a circle to the animals in the distance – and this circular motion imparts a feeling of great calm to the scene. Beyond this, the tree on the left 'frames' the subject and adds a lovely textural contrast.

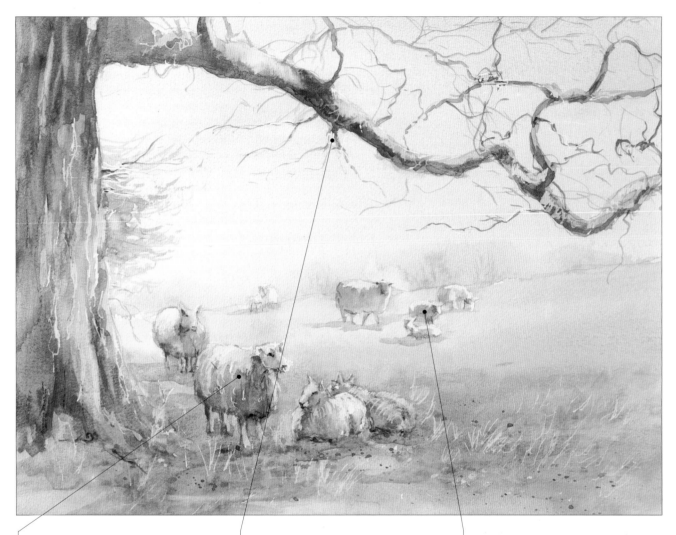

Rough, downward brush strokes create the shaggy texture of the sheep's coats.

The overhanging branch points downwards, directing the viewer's eye towards the centre of the image.

The background sheep are painted quite loosely and freely; they are pale in colour, almost hazy, and this enhances the impression of distance.

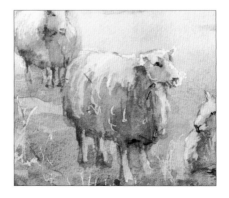
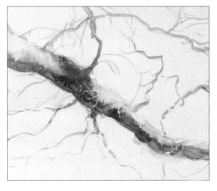
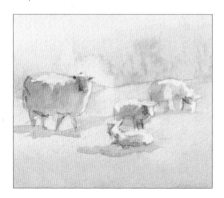

Fighting stags in oils

With an 'action' scene such as this, you will have to combine observations made in the field with reference photos and sketches. The benefit of photos, of course, is that you can 'freeze' the action at its peak. However, there's really no substitute for doing at least some of the work from life, even if you only make a few quick compositional sketches. Not only does the very act of looking and sketching imprint the scene much more vividly on your mind than taking a photo, but you will also be able to conjure up other memories of the day – the cold, frosty morning, the bellowing of the stags, and the clash of antler on antler.

Although these two animals appear to be locked head to head and barely moving, it's vital that you get a feeling of energy and the sheer physical strength of the stags into your painting. To do this, you need to show how the muscles are tensed as the animals push against each other. Look at where the muscles are visible on the surface – in the shoulders and powerful hind quarters – and observe how the shadows on the skin reveal what is going on underneath.

At first glance, the antlers look very complicated in shape. The trick is to block them in as one single unit to begin with, without attempting to define how one set relates to the other or where the areas of light and shade lie. In oils, it's very easy to paint a light colour over a dark one, so you can refine the tones in the later stages of the painting to make the antlers look three-dimensional.

Note how many different colours there are in the stags' coats – different tones of dark chocolate brown, reddish brown, cream and grey can all be seen. The fur is mostly short, and the best way to paint it is wet into wet, blending the marks so that no brush marks are visible and the texture looks soft and velvety. For longer fur use a very small amount of thinner with the paint to help it flow (take care not to thin it too much) and feather the brushstrokes to look like long strands of hair.

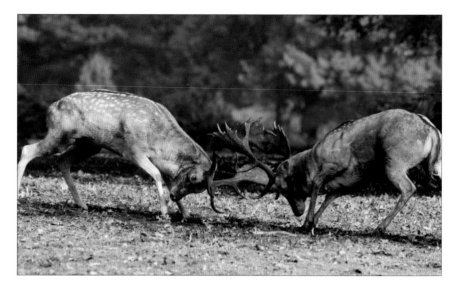

Materials
- *Stretched primed canvas*
- *3B pencil*
- *Oil paints: indigo, yellow ochre, titanium white, raw umber, cadmium yellow medium, lamp black, chrome green, brown ochre, burnt umber, cadmium orange*
- *Brushes: selection of small and medium filberts, rigger*

The subject
This is a dramatic image of two stags in their prime, antlers locked together as they do battle at the height of the mating season. The stags' antlers are somewhat lost against the leaf-strewn foreground, so the artist decided to bring the wooded background down lower, so that the antlers would stand out against the green of the trees.

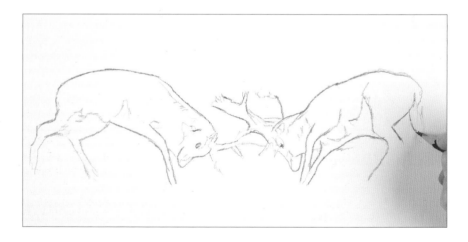

1 Using a 3B pencil, lightly sketch the stage to establish the main shapes and the composition of the picture. The benefit of using a relatively soft pencil, rather than an HB, is that it is easy to erase the marks from the canvas if you get something in slightly the wrong place.

> **Tip**: It's up to you whether you paint the background in detail, or opt for a vignette effect, as the artist did here, but whatever you choose, make sure you leave space on either side of the stags, as well as above and below – otherwise the composition will look cramped.

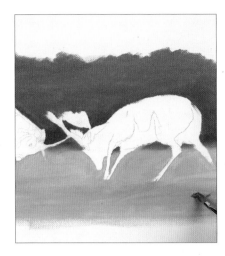

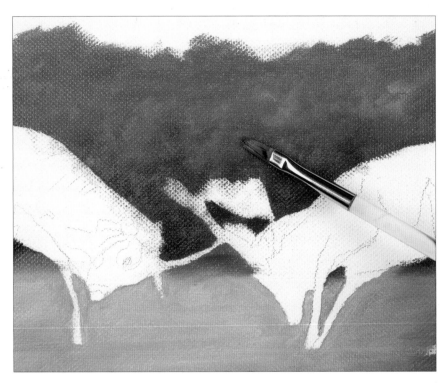

2 For the green background, mix a dark, blue-toned green from indigo, yellow ochre and a little white. For the foreground, mix a pale brown from raw umber and white. Using small filbert brushes, block in the background and foreground around the stags by paint the colours on quite roughly. Don't worry if some of the background colour goes over the antlers, as you can paint over it later.

3 Mix a bright mid-toned green from cadmium yellow medium, a little lamp black and indigo and dot it into the background to create a mottled, leafy effect, adding more yellow and white as you work up the picture.

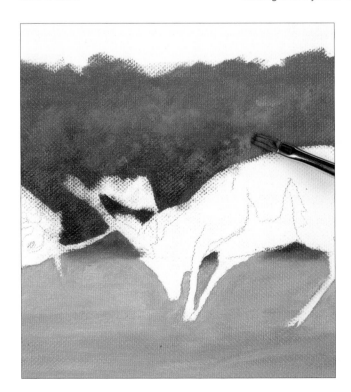

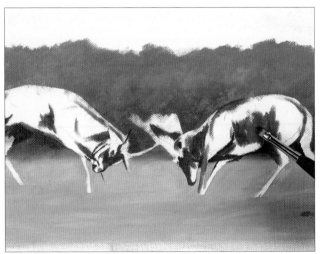

5 Now begin working on the stags. Mix a very dark brown from raw umber and a tiny bit of lamp black and, using a filbert brush, put in the darkest parts. The next darkest tone is a redder brown, mixed from brown ochre and burnt umber. Apply this colour, blending it into the first mix wet into wet so that you do not get any hard edges.

4 Repeat Step 3 using a lighter, brighter green mixed from chrome green and cadmium yellow medium. You are gradually beginning to build up some texture and form in the woodland background.

Tip: Vary the size of the brush as necessary, depending on how fine a mark you need to make.

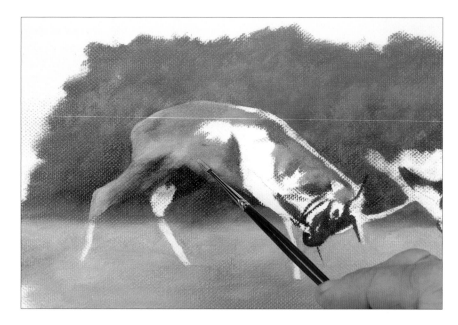

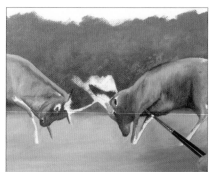

6 Mix a mid-toned base colour for the stags from brown ochre, white and a little raw umber and burnt umber. Lightly brush this across the stags, leaving the very lightest parts untouched. Smooth out the brushstrokes to blend the edges where one colour meets another, taking away any hard edges.

Tip: The light spots will be applied on top of this mid-toned base colour, so it's important to get it right – otherwise the spots will look wrong.

7 Add more white to the base colour for the lightest tones. Blend the mix wet into wet into the existing colours, taking care not to obliterate any definite lines such as the crease of the legs. You can build up more tone later to get more of a 3-D effect. On the belly and upper legs of the right-hand stag, there are some patches of fur that are grey rather than brown: put these in using a mix of white and lamp black.

Tip: Do not paint the stag's legs at this stage as the colour would merge into the background.

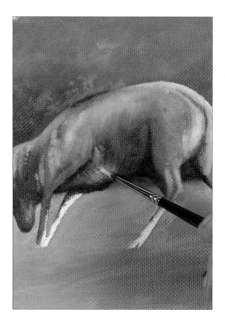

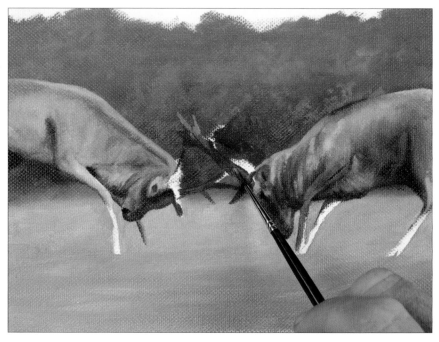

8 Brush a little of the brown ochre and white base colour mix around the eyes, to begin to define their form. Add yellow ochre to the base colour from Step 6 and put in the paler fur on the underbelly.

9 Mix a rich reddish brown from burnt ochre and raw umber and block in the antlers, including the points where they overlap. (This is the mid tone of the antlers. The shape and structure will become clearer later when you put in the dark and light tones.) Add white to the mix for the lighter tones at the tips of the antlers.

Assessment time

Ask yourself whether you need to do any more work on improving the sense of form. Here, the shadows on the legs and hind quarters hint at the muscles lying beneath the surface and imply the strength of the animals as they push against one another, and only minor adjustment to the tones is required. The most obvious omission is that the lower legs have not yet been painted: this is because the foreground needs to dry first, otherwise the legs would blend into it. The antlers look rather flat and seem to merge together – it is hard to tell where one set ends and the other begins. Refining the tones by adding more yellow ochre or white to the mixes will separate them from each other and make them look three-dimensional. The final stages will be to put in the missing details – the spotted markings on the stags' bodies, some foreground texture, and shadows underneath the animals to 'anchor' them in the scene.

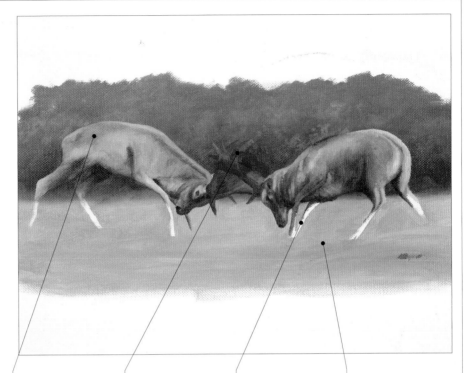

Pale spotted markings are characteristic of this species of deer; these can be added almost as the final stage of the painting.

The antlers need more tonal differentiation in order to look fully three-dimensional and to stand out from each other.

The lower legs can be painted once the background is dry.

There is no detail in the foreground; adding texture to this area will help to imply that it is closer to the viewer.

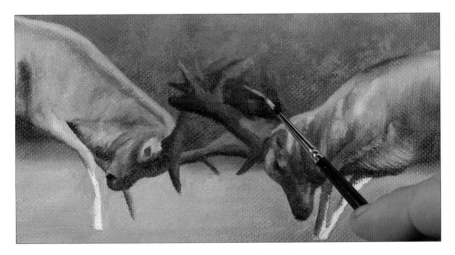

10 Using a rigger brush (or an old brush with very few hairs left on it), put in the light areas such as the back-lit hairs on the right-hand stag's rump in a pale mix of brown ochre and white. Refine the tones on the antlers to make them look more three-dimensional and to separate the two sets of antlers visually from one another. For the darker areas, use a mix of raw umber with a tiny bit of lamp black; for the lighter areas, use a mix of white, yellow ochre and brown ochre.

11 Using a fine brush, paint the spots on the animals' bodies in a pale mix of yellow ochre and white with a little brown ochre. Note that the spots are not uniform in size or shape; nor do they sit in neat rows.

▶

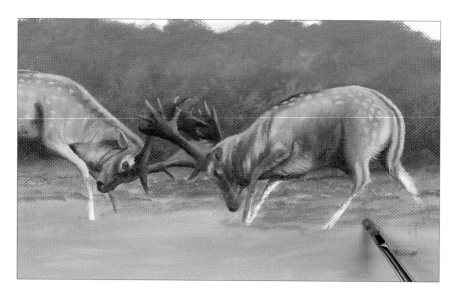

12 For the base colour of the brown leaves in the foreground, mix a rich brown from yellow ochre, a little brown ochre and white. Loosely scrub this colour on using a scribbly circular motion to create the effect of scrunched-up fallen leaves. Add touches of cadmium orange for the more golden leaves and touches of raw umber for the darker patches.

 Tip: Don't worry if the foreground base colour goes over the stags' legs; you can easily paint in the legs again once the foreground colour has dried.

13 Mix a very pale, thin brown from raw umber and white (dilute with linseed oil if necessary) and dot it into the foreground to create the pebbly texture of the ground. Paint the shaded parts of the stags' lower legs in a mix of brown ochre, white and a tiny bit of lamp black. Mix a pale cream from white and yellow ochre and, using a fine brush, paint the lower part of the stags' legs so that the shape of the legs stands out against the background.

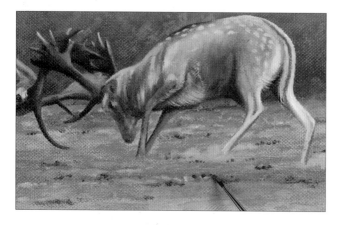

14 To create the impression of movement, mix a very pale dust colour from raw umber and white and dab it in around the stags' feet. Using a soft brush, smooth out the brushstrokes. Add a tiny amount of black into the mix to create shadows in the dust. Also dab on small dots of cadmium orange for the warmer, golden-coloured leaves on the ground.

 Tip: Try not to overdo the orange dots of leaves on the ground; this is a very strong colour and could easily dominate the foreground, pulling attention away from the stags.

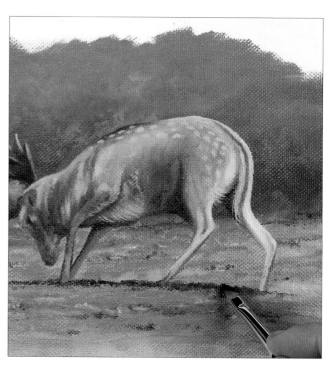

15 Using a warm brown mix of raw umber with a tiny bit of black, lightly stroke in the shadows under the stags, using short, scribbly strokes to retain the rough texture in the scuffed earth of the foreground.

The finished painting

A relatively restricted palette of colours – mostly soft browns and greens – has been used for this painting of two rutting stags. This colour mix gives a gentle colour harmony to the painting that belies the tension in the scene itself. Most of the painting was done wet into wet, allowing the artist to create subtle blends of colour on the canvas without any harsh edges or obvious brush marks. There is enough detail in the background and foreground to evoke the woodland setting, while the animals form the main focus of the picture. The vignetted edge is a nice effect, although you could take the background right up to the edge of the picture to produce a squared-up image if you wish.

The shadows have been carefully observed to imply the tension in the muscles and create a good sense of modelling on the animals.

The contrast between the light and dark tones makes the antlers look three-dimensional and establishes the spatial relationships between them.

The shadow on the ground anchors the animals in the landscape.

Horse in pastels

At first glance, the horse in this demonstration appears to be a rich, chestnut brown colour. Look closely, however, and you will see not only different tones of brown, but also different hues – reddish browns, pinks, oranges and even peachy yellows. Soft pastels and pastel pencils are a wonderful medium for conveying these subtle shifts of hue, as you can overlay one colour on another and gently blend them with your fingertips so that they merge almost imperceptibly.

Note, in particular, how the highlights and shadows on the horse's body indicate the bones and muscles that lie just below the surface of the skin and convey the horse's form. The entire painting is about building up tones to the right density to make the horse look three-dimensional.

When painting a moving animal, you must know the order in which the legs move and whether they are bent or extended. In this demonstration, the artist worked from a photograph taken on a fast shutter speed.

Whatever you're drawing or painting, careful measuring is essential. Here, the horse's body is slightly foreshortened. First, decide on a unit of measurement against which you can measure the size of other features. The artist used the length of the head, from the tip of the ear to the nose, as her basic unit of measurement. She discovered that the distance from the tip of the nearside ear to the top of the hoof of the near foreleg is equivalent to two 'heads'. From this viewpoint the distance from the foremost point of the chest to halfway along the flat part of the tail is also two 'heads' – although one might expect the body to be longer.

Materials

- *Cream/buff-coloured pastel paper*
- *Pastel pencils: dark brown, permanent rose, orange, Indian red, flesh, black, white, Naples yellow*
- *Soft pastels: sandy orange, pinky-brown, mid green, bright yellow, bright olive green, light green*
- *Cotton bud (cotton swab)*

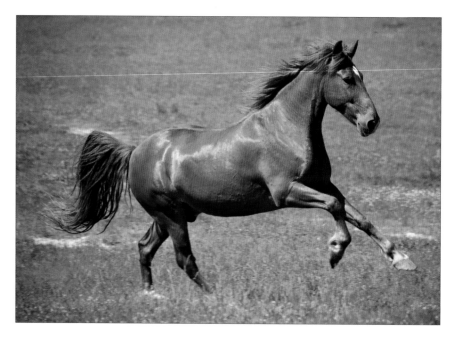

The scene

All the emphasis in this scene is on the moving horse – there is nothing in the background to distract from it. Although the photograph 'freezes' the horse mid gallop, the flowing tail and mane help to show how quickly it is moving, as do the muscles and tendons under tension.

1 Using a dark brown pastel pencil, sketch the horse's head and put in the darkest tones, between the ears and under the mane. Measure the length of the head on your pencil, so that you can gauge the size of other features in relation to it.

> **Tip**: Before you put pencil to paper, check the proportions and lightly mark the highest, lowest and widest points of your subject, to make sure you leave enough space on the paper to fit the whole animal in.

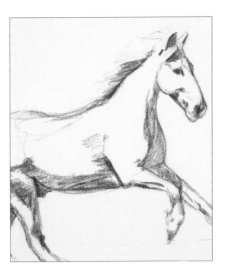

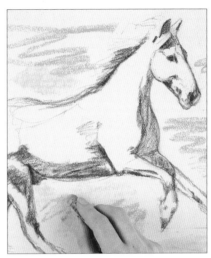

2 Continue sketching the horse, using the length of the head as your basic unit of measurement. Here, the distance from the tip of the near ear to the top of the hoof of the near foreleg is equivalent to two 'heads'.

3 Complete the sketch, measuring carefully throughout. Here, the distance from the foremost part of the horse's chest to the rump is just under two 'heads'. Block in the most deeply shaded areas on the chest and under the belly. Pay particular attention to the angles of the legs: getting this right is an essential part of conveying a sense of motion.

4 Although the background appears at first glance to be a lush, green meadow, there are small patches of earth show through in places. Put this underlying colour in first, before you begin to apply the green. Loosely scribble a sandy orange soft pastel over the background, followed by a pinky-brown.

5 Apply a bright mid-green on top, then blend all the colours together with your fingertips, rubbing right up to the edge of the horse. Put in some bright yellow, too, for the little clump of flowers in the grass.

6 Scribble a permanent rose pastel pencil over the darkest parts of the horse – around the chest and underbelly – so that you begin to create the warm chestnut colour of the horse's coat.

▶

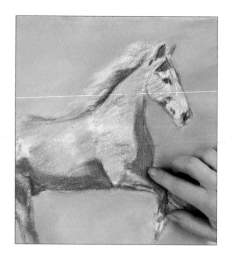

7 Block in the mid tones on the body and legs with an orange pastel pencil, then go over these areas with an Indian red pencil. Already, you are beginning to develop some modelling on the horse, indicating where bones and muscles lie just below the surface.

8 Using a flesh-coloured pastel pencil, go over the previous colours, going right up to the edges of the very brightest highlights. This softens the transition from mid to light tones. Leave the very brightest highlights untouched. They may look stark and bright at present, but the tones will be adjusted as you work on the drawing; getting them right is a gradual process.

9 Fingerblend the darkest areas, and then the lightest ones.

Tip: When fingerblending, work on either the dark areas or the light areas at one time. Don't switch from one to the other, or you may transfer pigment to an area where it's not wanted.

Assessment time
The light and dark areas have been established and already the horse is beginning to take on more of a three-dimensional feel – although the colours are far too pale overall and the transitions from dark to mid and light tones are too abrupt. From this point onwards you can start to be more precise about your marks as you continue to refine the modelling on the horse.

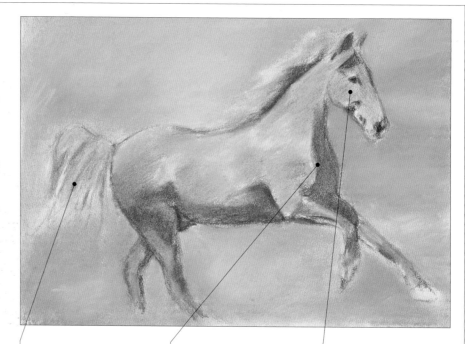

The underlying colours of the tail and mane have been blocked in, but the texture of the long, flowing strands of hair needs to be developed much further.

The transition from dark to mid tones is too abrupt.

Much more modelling is required on the head and body to prevent them from looking flat and one-dimensional.

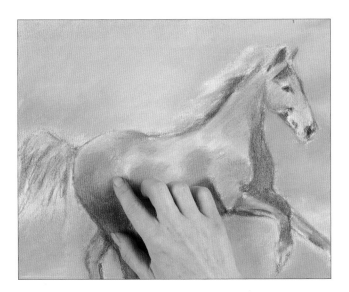

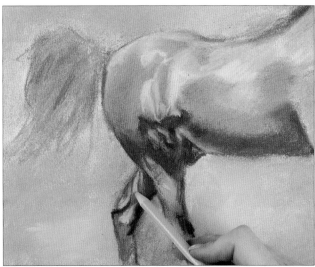

10 Using a pale orange pastel pencil, scribble in the light chestnut mid tones on the horse. Then go over the darker mid tones with an Indian red pastel pencil, and fingerblend the colours together. Go over the head, too, to match the tones to those on the body.

11 Go over the most deeply shaded areas again with brown pastel pencil. Using black or dark brown as necessary, put in the creases around the back legs. Put in the very brightest highlights on the body with a white pastel pencil. For the highlights on the hocks, use a mid orange. Keep fingerblending as you go.

Tip: It's a good idea to work on the head at the same time as the body. If you leave the head right to the end of the drawing, you may forget which colours you used.

Tip: Keep assessing the tonal values of the picture as a whole as you work the pastels. A drawing like this has to be a continual process of adjustment.

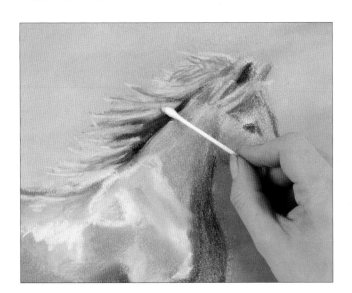

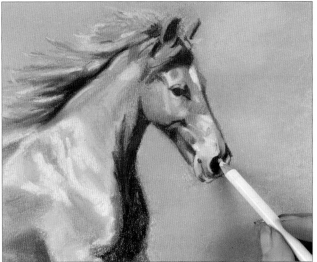

12 Use a black pastel pencil to put in the dark detailing on the inner ears and the underside of the mane. Apply permanent rose, orange and Naples yellow for the mid tones in the mane, using pastel pencils for more linear marks and soft pastels for the underlying soft hair. Blend the colours carefully, using a cotton bud and taking care not to smudge dark colours into the light areas or vice versa.

13 Continue building up the form on the shoulder, flanks and head. Darken the area between the ears with a black pastel pencil, and use the same pencil for the dark shadows in the mane. Go over these areas with pink to reduce the intensity and solidity of the black without affecting the darkness of the tone. Put in the details of the eye and nostrils in black, then add the highlight in the nostril in white.

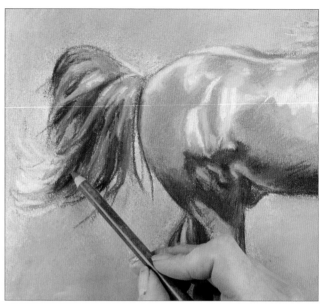

14 Put in the dark recesses on the legs in black and the highlights in white. Look carefully at where the bones and tendons are visible just below the surface of the skin; observe the shadows carefully and use crisp, sharp lines, so that these areas look really hard.

15 Using the same colours as on the mane, put in the long, flowing strands of the tail. Note that the strands of hair are much thicker on the tail than they are on the mane, so you can afford to make your pencil strokes much stronger and bolder.

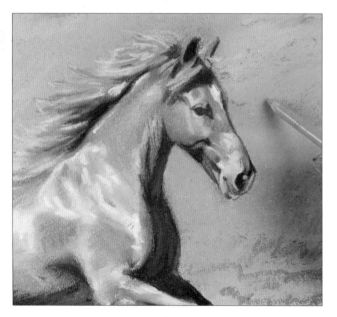

16 Scribble a bright olive green soft pastel over the background, as the base colour for the grass. Add a lighter green on top, particularly in the background behind the horse, then use your fingers to blend. Having a lighter colour behind the horse implies that this area is further away.

17 Dot and scribble some shorter white and yellow pastel marks into the background to give the impression of small meadow flowers. Gently stroke a little pinky-brown pastel into the foreground to give the effect of patches of exposed earth. Using a yellow pastel pencil, draw in some spiky grasses. You don't need to be too precise with your marks here; all you're aiming for is a general impression of the meadowland setting.

 Tip: Do not overblend the colours, or you will lose the texture. Allow some of the underlying colour to show through.

The finished drawing

This is a deceptively simple-looking drawing that has a wonderful feeling of movement, which comes partly from getting the lines and balance of the horse right and partly from the flowing mane and tail. The pastel marks have been skilfully blended to create a surprisingly wide and rich range of colours and tones, which capture the horse's shiny coat to perfection. The rich, reddish browns of the animal are complemented by the mid greens of the background.

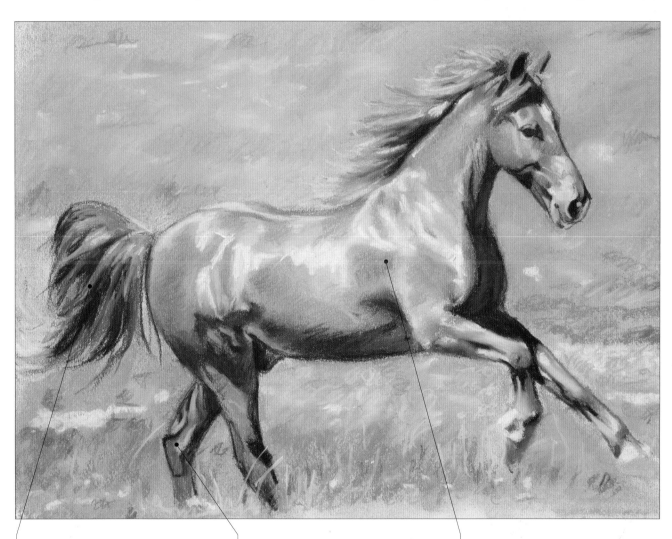

Long, flowing pencil strokes capture the texture of the thick strands of hair in the tail and mane.

Sharp, crisp marks delineate the bones and tendons in the legs.

A wide range of colours, gently blended with the fingers, captures the subtle tonal differences in the coat.

Fox in soft pastels

Soft pastels are a lovely medium for drawing fur. You can overlay one colour on another and blend the pigments on the paper to create subtle optical mixes and transitions of tone. You can also use the tip of the pastel to create short, spiky lines that capture the texture and the direction in which the hair grows.

The fox in this demonstration has relatively short, flat fur. This makes it easier to see the shape of the animal, as you're not confused by the sheer volume of the fur in the way that you might be with a long-haired animal such as an orang-utan or a fluffy cat. Whatever animal you're drawing or painting, however, think of the fur in much the same way as clothing on a human being and look at how it 'drapes' over the body beneath. Observe carefully and you will see shadowed areas within the mass of fur which help to make it look three-dimensional and suggest the underlying anatomy of the animal.

Deciding how to treat the background is as important as deciding how to treat the subject itself. In this drawing, the landscape is secondary and so the artist deliberately left much of the background behind the fox as little more than a flat expanse of colour, so as not to detract from the animal. She did, however, put in some of the immediate foreground – the spiky grasses poking up through the snow – in order to place the animal in a recognizable landscape setting.

Note the use of complementary colours – the violet/blue of the background next to the rusty orange of the fur. These colours work well together and can give a sense of energy.

Materials
- *Blue pastel paper*
- *Conté pencils: brown ochre, black, white*
- *Soft pastels: white, rusty brown, creamy yellow, chocolate brown, black, blue-grey, blue-violet, dark olive green, yellow-olive green, apricot*
- *Kitchen paper*

The subject
In this image, the fox's head is slightly lowered and the left foreleg raised off the ground as it stealthily stalks its prey – a stance that is typical of the animal. Note that, because we're looking at the fox from head on, the body appears slightly foreshortened. The low viewpoint focuses attention on the fox's head and eyes, adding to the drama of the composition; had the artist been looking down on the animal, the composition would have had far less of an impact.

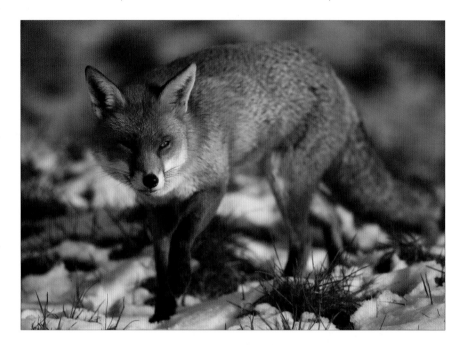

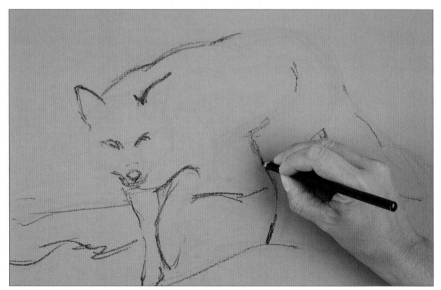

1 Using a brown ochre Conté pencil, sketch the fox. Look for where features align to help you place things correctly; here, for example, the tip of the nose is almost directly above the paw of the right foreleg, while the tip of the right ear is roughly level with the top of the tail. Switch to a black Conté pencil and put in the areas that create the movement in the pose: the tensed back, the lowered head and the delicately raised front paw.

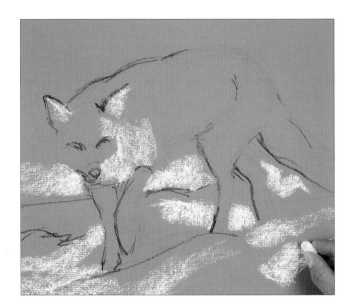

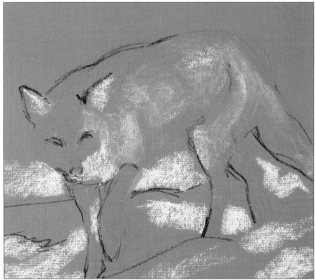

2 Using the side of a white soft pastel stick, roughly block in some of the whites on the fox's fur and the patches of snow on the ground. Use the negative shapes – the spaces around the fox – to help define the shape of the animal more clearly. Note that you are not attempting to create any texture at this stage, but simply blocking in the lightest tones and establishing the highlights.

3 Roughly block in the mid tones in the fox's fur with a rusty brown soft pastel, making loose scribbles with the side of the pencil. Do not cover the paper completely – allow some of the paper colour to show through so that you can build up a range of fur tones. Note how different the colour looks depending on whether it's applied to blank blue paper or over the white pastel marks from the previous step: already, you are beginning to develop some form in the fur.

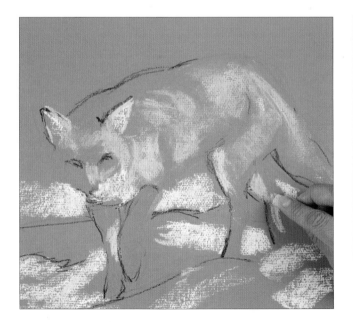

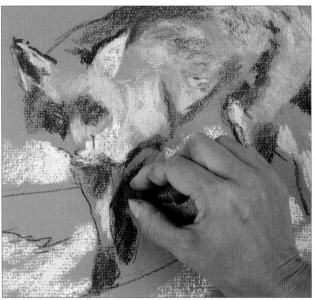

4 Scribble over the rusty brown with a creamy yellow soft pastel to create some of the lighter mid tones, allowing some of the underlying colour to show through so that you get some tonal variation within the fur. In a subject such as this, you do not want any one area to appear completely flat and a single tone. Touch a little of the creamy yellow into the snow, too, picking up on any areas where you can see the same colour, as this helps to unify the picture.

5 Using the tip of a chocolate brown soft pastel, put in the darkest patches of fur and those areas of the fur that are in deep shadow. The fox's fur is now beginning to look much more three-dimensional.

▶

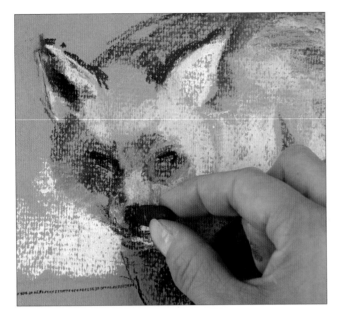

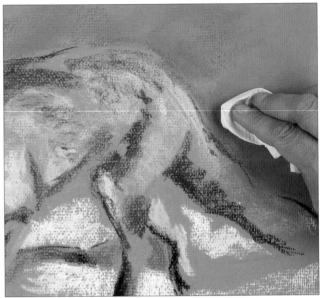

6 Put in more mid tones on the head, using the rusty brown pastel. Outline the eyes and put in the nose using the tip of a black pastel.

7 Put in the darkest tones in the foreground with a black pastel, so that you begin to get some sense of the way the land undulates, then scribble in the background and the mid tones in the foreground with a pale, bright blue-violet. Blend the background with kitchen paper or your fingertips to get rid of any textural marks that might detract from the fox.

> **Tip**: Having more texture in the foreground helps to imply that it's closer to the view and on the same plane as the fox.

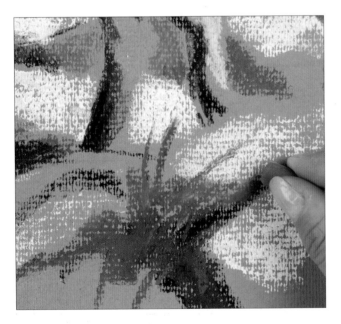

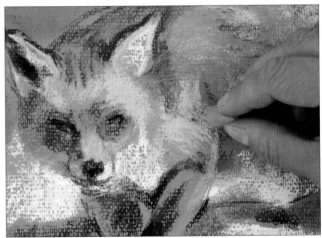

8 Using a dark olive green pastel, block in the clumps of low-lying grass in the foreground. Use short, vigorous, upright strokes for the blades of grass that poke up through the snow in the immediate foreground.

> **Tip**: If you're finding it difficult to 'see' the exact shape of the head, work up to it with a blue-grey pastel that's similar to the colour of the paper. Using the 'negative' shapes (the spaces around the subject) is a good way of defining 'positive' shapes like the head.

9 Continue building up the tones on the head, using finer, shorter strokes to develop more texture. Gently stroke a yellowy olive green into the fur for some of the lighter mid tones on the body. It might seem strange to use a green tone on a subject that is basically red or rust in colour, but colours in nature are not pure, unlike artists' pigments, so adding a touch of a complementary colour can really enliven and enhance the overall effect.

Assessment time

At this stage, all the main elements of the drawing have been put in and the tonal values carefully assessed. However, more texture and detailing are required on the fox – particularly on the head, as this is both the focal point of the image and the part of the animal that is nearest to the viewer. The foreground, too, looks a little flat and empty. Adding more texture (in the form of grasses) and mid tones (the blue-violet colour) will help to bring it forwards in the image and make the spatial relationships clearer.

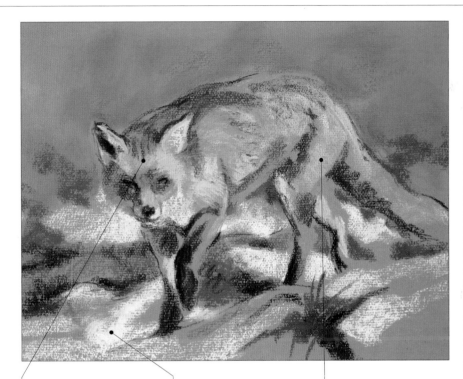

More detail and texture are needed on the head, in order to make it the focal point of the drawing.

This area attracts attention because it is so bright. Counteract this – and add that all-important foreground detailing at the same time – by adding a few blades of grass.

This area of fur has received little more than a base colour and requires more layers of colour.

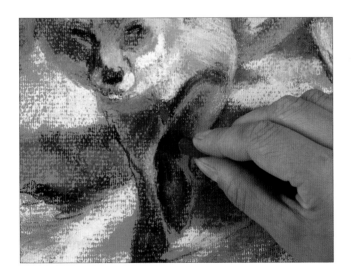

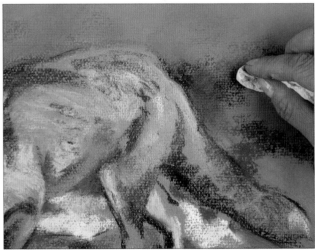

10 Using the same colours as before, continue building up texture in the fur. Take care not to obliterate the underlying colours: you need to keep some variety in the fur tones so that it doesn't look flat and lifeless. Where necessary, block in more grass with a dark olive green pastel to help define the shape of the fox more clearly.

11 Part of the background behind the fox is in shadow. Block this in lightly using the side of a dark olive green pastel, then blend the marks with a scrunched-up piece of kitchen paper, a torchon or your fingertips, so that there are no obvious marks or hard edges.

▶

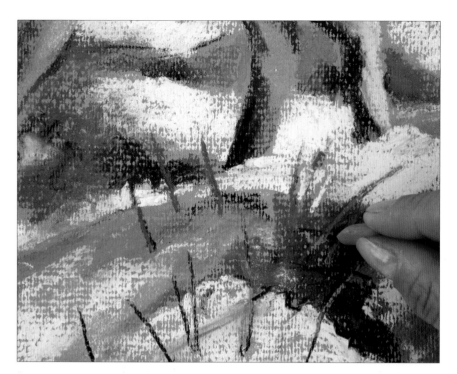

12 Now turn your attention to the foreground, which needs to have more texture and detail than the background so that it comes forwards in the image. Make short, vertical strokes of olive green for the blades of grass, adding a little yellow-olive to the right-hand side of some blades, which receive more direct light. Using blue-grey and blue-violet pastels as appropriate, block in the mid tones of the snow, and then blend the marks with your fingertips. Work in between some blades with a blue-grey pastel, if necessary, to define their shapes more clearly.

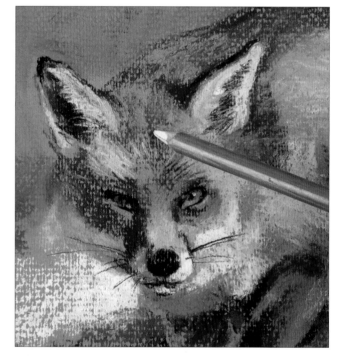

13 Using a white pastel, sharpen up the edges around the fox to anchor it in the landscape so that it doesn't appear to be floating. Put in any bright patches of snow that are missing.

14 Strengthen the shadows on the fox's head to bring more three-dimensionality to it: this is the most important part of the image. Using the tip of an apricot-coloured pastel and a white Conté pencil, make a series of short strokes for the brightest hairs on the head; immediately, this area takes on more texture. Refine the shape of the muzzle and the eyes, and draw in the whiskers, using a black Conté pencil. Using a rich apricot-coloured pastel, put in the irises of the eyes, remembering to add a tiny dot of white for a highlight in the left eye.

The finished drawing

Ears pricked up, eyes alert, this is a very lifelike portrayal of a fox in characteristic stalking mode. The artist has included just enough of the surroundings to tell us the season of the year and reveal something of the habitat, but the focus of the image is very much on the animal. The different tones and textures have been carefully observed without being overworked or laboured. On the head, short pastel and pencil strokes, which follow the direction of the fur growth, give the general impression of the fox's short and softly textured fur – although the artist has sensibly refrained from attempting to put in every single hair. Elsewhere, broad pastel strokes, with colours overlaid on one another and then gently blended, create vibrant optical mixes that capture the many different tones within the fur.

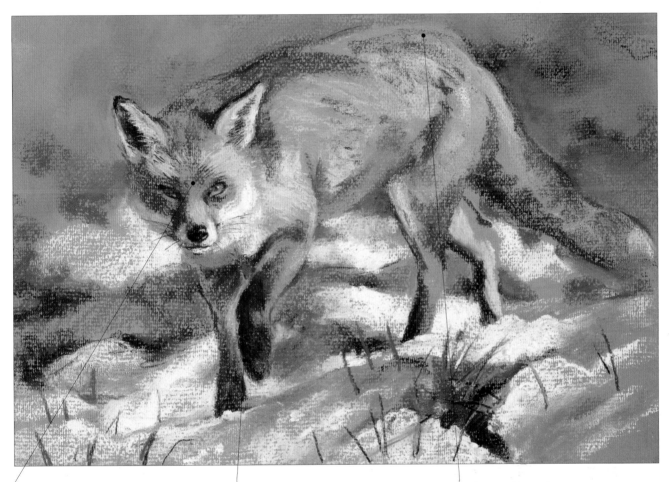

Short strokes of both soft pastels and Conté pencils create delicate textures on the head.

Note how the tones on the left front leg are warmer than those on the right front leg; this helps to bring the left leg forwards in the image and imply that it is closer to the viewer.

Note the effective use of complementary colours – blue/violet in the background and rusty orange on the fox. This adds a dynamic quality to the drawing.

Lion in oils

This demonstration was done using fast-drying alkyd oils, although you could use conventional oil paints if you wish. Bear in mind, however, that if alkyds are painted on top of conventional oils, there may be more risk of the paint cracking.

You will need to assess the tones very carefully in order to make the fur look sufficiently bulky and three-dimensional. Start by putting in the darkest areas using long, flowing brushstrokes that follow the direction in which the hair grows. Then add the mid tones and finally the highlights. Don't be afraid to wipe off the paint if you make a dark mark in the wrong place – that's the beauty of working in oils. You may be surprised at how dark the dark

areas really are; be prepared to go over them again once you've put in the mid and light tones and are able to assess the tonal values of the painting.

Work wet into wet, so that you can smooth out the transition between one tone and the next and avoid making any harsh lines. If you find that the alkyd paint is drying too quickly, go over the initial colour again so that you can blend subsequent colours wet into wet in to the edges of the first colour. (Unlike watercolour, applying a second layer of the same colour of paint will not create a darker tone.)

Remember that your aim is to create a general impression of the fur: even with the finest brushes in the world, and an unlimited amount of time and

patience, you couldn't possibly paint every single hair. (The coat of a Siberian tiger, for example, contains about 3000 hairs per square inch!) And don't worry about placing each hair exactly: this is not intended to be a photo-realistic interpretation.

It's also worth spending time on the mouth and teeth, as that is what this painting is all about. Teeth are never just one colour and, although the differences in tone between one part of a tooth and another may be very slight, these differences are what give the teeth their form and make them look so fearsome. Similarly, the lips and gums have small highlights that, if captured accurately, will help to make the mouth look rounded.

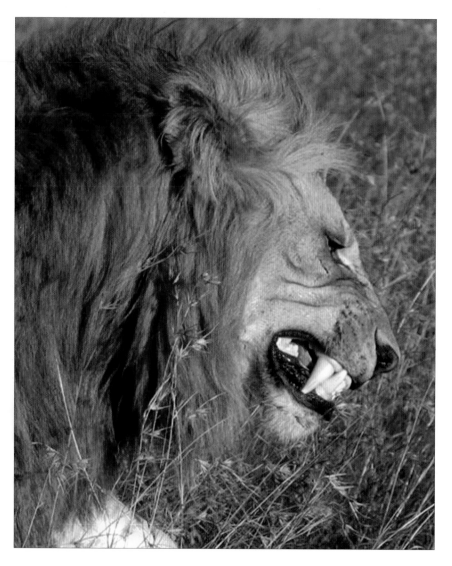

Materials
- *Stretched oil canvas*
- *4B pencil*
- *Alkyd oil paints: cadmium red, titanium white, burnt umber, lamp black, brown ochre, chrome green, cadmium yellow medium, raw umber, yellow ochre, alizarin crimson, ultramarine blue, cadmium orange*
- *Brushes: selection of small rounds and filberts, rigger (or old round brush with just a few hairs)*
- *Low-odour thinner*
- *White spirit (paint thinner) for cleaning brushes*

The subject
With his massive jaws and dagger-sharp teeth, there's no mistaking the strength and power of this lion. The low viewpoint makes the viewer feel almost a part of the scene. Here, the animal is well camouflaged against the background; however, the artist decided to intensify the greens of the grasses in his painting in order to make the lion stand out more. Pay particular attention to details such as the dots of the whiskers: each lion has a specific pattern of whiskers, just as every human has his or her own fingerprint, and this pattern can be used by scientists to identify particular animals.

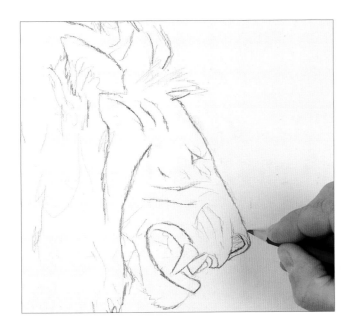

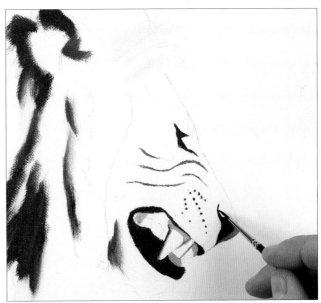

1 Using a 4B pencil, lightly sketch the lion. The benefit of using a soft pencil is that it's easier to rub out if you make a mistake. Look at how different features align and use these as points of reference: here, for example, the eye is roughly in line with the outermost point of the lower lip, and the foremost point of the ear aligns with the base of the mane.

2 Using a small round brush, paint the pink of the nostrils and gums in a mix of cadmium red and titanium white. Mix a very dark brown from burnt umber and a little lamp black and put in the darkest marking of the fur, the facial markings and the dots for the whiskers. Add more black for the nose, the lips and the inside of the mouth.

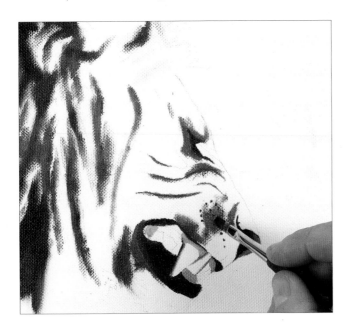

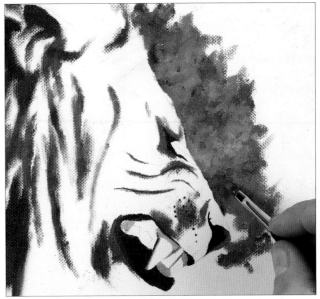

3 Mix a slightly lighter and redder brown from brown ochre and burnt umber and, using a small filbert brush, pick out the dark areas of the mane. Alternate between this mix and the dark brown from the previous step as necessary, Apply the paint quite roughly, using vertical strokes that follow the direction in which the hair grows. Allow the key triangle of the face – the eyes, nose and mouth – to dry, so that the paint cannot be moved wet into wet when you start to paint the fur on the face.

4 Mix a dark, olivey green from chrome green, cadmium yellow medium and raw umber. Using short, vigorous strokes, scumble on the background colour varying the proportions of the colours in the mix and adding a little yellow ochre in parts to create some tonal variation. Don't attempt to create any texture at this stage – simply try to see the background as random blocks of colour.

▶

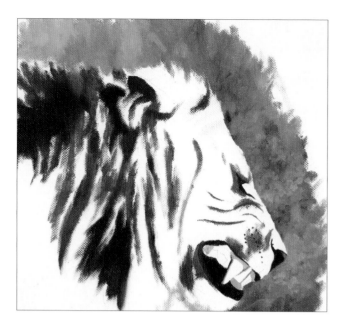

5 Continue with the background, creating a 'vignette' effect around the head. Make the background slightly darker at the base and lighter (with more yellow ochre) at the top. Try not to clean your brush when painting the background; you'll get a more random and spontaneous effect. If you do clean it, make sure it's completely dry before you apply more paint – otherwise the solvent will thin the paint too much and cause the colours to blur uncontrollably.

6 To create the mid tones, add titanium white to the burnt umber/lamp black and brown ochre/burnt umber mixes from Steps 2 and 3, and yellow ochre to the brown ochre/ burnt umber mix. While the first colours you put down for the mane are still wet, put in these mid tones, blending the colours smoothly wet into wet so that you do not get any hard edges and making your brushstrokes follow the direction in which the fur grows.

7 Continue working on the mane, blocking in a base colour over which you can then begin to develop more texture. Use broad, flowing brushstrokes to suggest the thick clumps of shaggy hair.

8 Using mid-toned mixes of raw umber and a little white and a small round brush, dab the paint onto the face, varying the tones as necessary. Dab with a stippling motion: the fur in this area is quite short and flat, and stippling creates a velvet-like texture that gives the impression of short, individual hairs without attempting to show every single one.

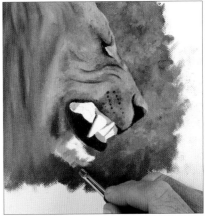

9 Continue stippling mid and pale tones on to the face, working up to – but not over – the dark markings that you put down previously and making sure you don't blend the different fur colours together too much. If necessary, touch in the dark folds in the skin with the dark brown mix from Step 2, using a thin rigger brush so that you don't lose them. Turn the painting around or even upside down as you work to avoid smudging wet paint with your painting hand.

10 Using a small filbert brush, scumble over the background at the base of the image again if necessary, making it slightly darker than before so that the lion stands out. Mix a greenish grey from titanium white, lamp black and raw umber and scumble it over the chin. (This grey picks up some of the background colour and helps to unify the picture.)

Assessment time

The mane and face have been blocked in and from this point onwards you can concentrate on refining those all-important details. Here, the mane is predominantly dark and mid tones; adding highlights will improve the feeling of depth and volume. Adding another layer of stippled colour to the face will also give it more texture and tonal contrast. The fearsome-looking teeth and mouth require most work, as this area is the main focus of the painting.

The mane needs to have more depth; this can be achieved by adding more highlights to contrast with the dark and mid tones.

The face looks a little flat because the tones are too similar; by increasing the tonal contrast, and adding another layer of stippled paint to create more texture, you can improve the modelling in this area.

The teeth have not been painted at all and are too stark and white; assess the shaded areas and highlights very carefully to make the teeth look rounded and three-dimensional.

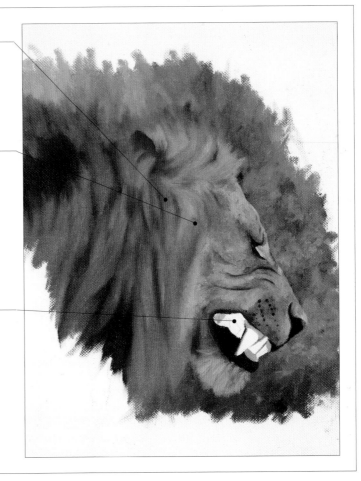

▶

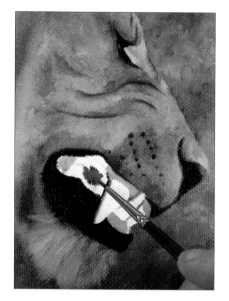

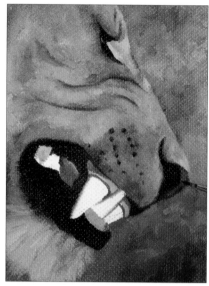

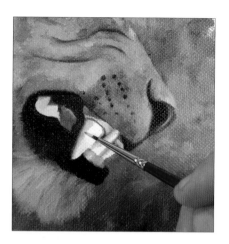

11 Using a fine round brush, paint over the gums and around the edge of the mouth in a mix of lamp black with a little burnt umber, blending the colour into the wet paint that you applied previously so that there are no hard edges. Mix a bluish purple from alizarin crimson and ultramarine blue and paint the underside of the curled tongue.

12 Where the gums are in shadow – directly under the upper lip, for example – go over them in the same purple mix used for the tongue. Use the same colour for the nostril, blending it into the surrounding black so that the nostril appears rounded. These are very subtle adjustments, but they are important in creating a sense of the form of the mouth.

13 Using a slightly paler version of the cadmium red and white mix that you used for the initial gum colour in Step 2, paint the highlights on the gums and nostrils. Mix a very pale orangey brown from cadmium red and cadmium orange and put in a fine line along the left-hand edge of the teeth to begin to create some modelling. This colour should be so pale that it is barely perceptible. Add white to the orangey-brown colour already on the brush and brush this over the rest of the teeth. Then apply any highlights on the teeth using pure white.

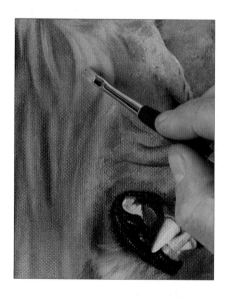

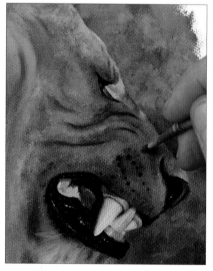

14 Mix a light-toned brown from yellow ochre, brown ochre and raw umber and, using a small filbert brush, put in the highlights on the mane to add more texture and increase the three-dimensional feel. Hold the brush almost vertically and make flowing, calligraphic strokes that follow the direction of the hair growth.

15 Go over the face again, using the same colours and stippling action as before. Now that the underlying paint has dried, this stippling gives the effect of short fur; if the underlying paint was still wet, the broken brush marks would merge together on the canvas and much of the textural effect would be lost.

16 Mix a pale, yellowy green from yellow ochre, a little of the green mix used on the background and lots of white. Using a very fine brush, draw in some of the individual grasses in the foreground to create some texture and visual interest. Note that the grasses are not constant, unbroken lines: occasionally, where the grasses are bent or turn into the shade, the lines break.

The finished painting

This 'portrait' really captures the strength and ferocity of the animal as the viewer's attention is drawn to those razor-sharp teeth and powerful jaws. It is also a skilled demonstration of how to paint both long and short fur, with the artist exploiting the potential of the medium by working both wet into wet to create the long flowing mane and wet on dry for the velvet-like texture of the short fur on the face. Note how the background has been painted a darker green than it was in reality, in order to allow the lion to stand out.

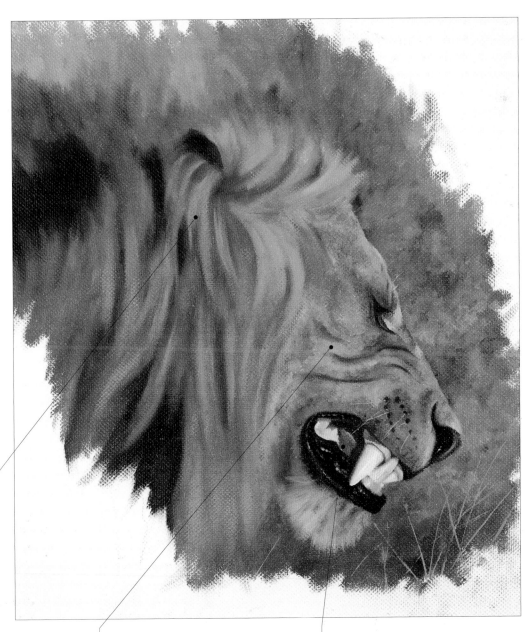

Flowing, calligraphic brushstrokes and the careful blending of tones wet into wet create the long fur of the mane.

The facial markings are allowed to dry completely before the fur is painted, so that they retain their shape.

Subtle highlights on the lips and gums and barely perceptible shading on the teeth make the mouth look rounded and the teeth three-dimensional.

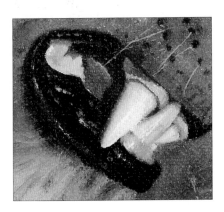

Elephant in charcoal and pastel pencil

In this demonstration, the artist used charcoal for most of the drawing, with the addition of black and white pastel pencils for the very darkest areas and the highlights. She worked on a grey pastel paper, which enabled her to use the colour of the support for the mid tones in the subject – a traditional technique in pastel drawing.

This project is really an exercise in assessing tone. You may find that it helps to half-close your eyes when looking at the scene, as this makes it easier to see the differences and transitions between light and dark without getting distracted by the detail of the subject.

Although it might seem tempting to begin by drawing the elephant in outline, simply to establish the shape,

it is worth noting that some parts – the right flank and right side of the head for example – are very brightly lit. Were you to enclose such areas with a dark outline, the impression of strong side lighting would be lost. It is better to draw the outline only in those places where a dense, dark line is appropriate (the edges of the ears, for example) and to block in the rest with approximately the right tone, using your fingers to blend and move the pigment around on the paper and position it in the right place.

Materials
• *Grey pastel paper*
• *Thin willow charcoal*
• *Pastel pencils: black, white*
• *Kneaded eraser*

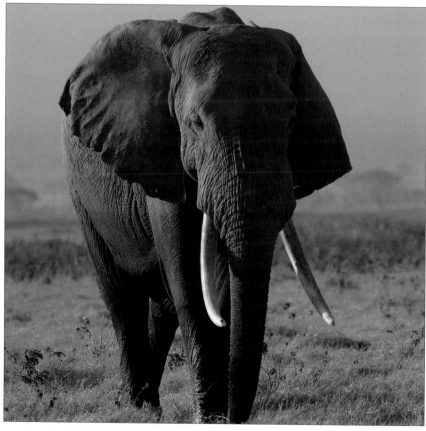

The subject
This is a dramatic viewpoint, with the elephant looking directly at the viewer. The light comes from the left, picking out textural detail in the skin on one side of the animal while leaving the right-hand side largely in shadow. Had the light been the same on each side of the animal, the texture would be less evident.

1 Using thin willow charcoal and working on grey pastel paper, which approximates to the mid tones in the subject, begin sketching the elephant. Instead of adopting a linear approach and drawing the whole animal in outline, try to see this as a tonal study from the outset. Work your way gradually around the elephant: very lightly map out the position of the head and the animal's left ear and then block in the dark tones with the side of the charcoal before blending the pigment on the paper to get a smooth coverage.

> **Tip**: Measure carefully and make sure that you can fit the full width of the elephant on the paper, with room to spare on either side. You may find it helps to make small dots on the paper to mark the widest points – the tips of the ears.

2 Continue mapping out the elephant by adding the right ear and the trunk, and scribbling in the very darkest tones with the tip of the charcoal.

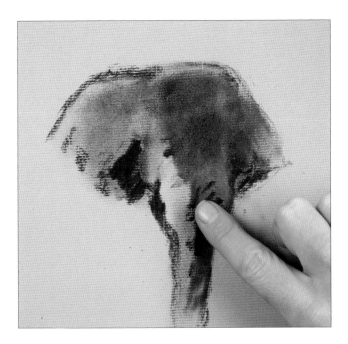

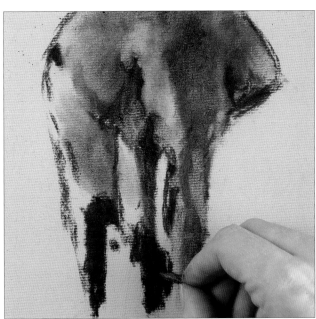

3 Work down the trunk, scribbling in the darkest tones and blending them with your fingertips as you go. You are, in effect, drawing with your fingers to establish the different tones and begin to develop a sense of the form of the animal.

4 Add the body and legs, always assessing the tones carefully and blending the charcoal marks as you go. Note that the lower legs are much darker than the rest of the animal, as they are covered in mud, so you can scribble quite hard with the charcoal. The tusks are relatively thin and you may find it hard to draw them precisely; instead, define their shape by blocking in the legs around them – by using the negative shapes, in other words.

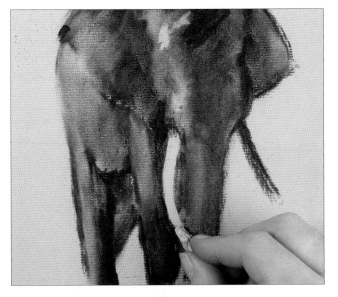

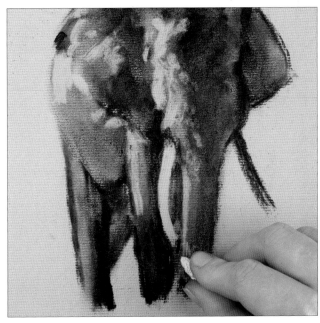

5 Blend the charcoal marks on the legs, as before. Note that the inside edge of the right back leg is darker than the left back leg; this difference in tone makes it clear which leg is in front. Pull a small piece of kneaded eraser to a fine point and wipe it over the tusks to reveal the colour of the paper.

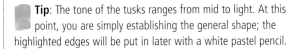

Tip: The tone of the tusks ranges from mid to light. At this point, you are simply establishing the general shape; the highlighted edges will be put in later with a white pastel pencil.

6 Use the eraser to wipe off pigment and create more mid tones on the head and down the highlighted side of the trunk, twisting and rolling the eraser in your fingers as necessary to create a point so that you can make a range of curved and straight marks with it.

▶

7 Using the tip of the charcoal, put in the dark folds in the ears and blend the marks as before, so that you gradually begin to build up the textural detail.

8 Scribble in the dark tones on the trunk, avoiding the tusk. Using a black pastel pencil, put in the eyes and some of the very dark fold lines around the eyes. Still using the pastel pencil, hatch in the shaded sides of the right tusk and the elephant's right foreleg.

Assessment time

By this stage, the main areas of dark and mid tone have been established and we are beginning to get a sense of the form of the animal. From this point onwards, you can concentrate on putting in the highlights, which will make the subject look really three-dimensional and will also give the impression of strong sunlight, enhancing the mood of the scene. Before you put in the highlights, take the time to make sure that all the dark and mid tones are where they need to be. (Remember that the highlights will be put in with white, whereas the mid tones are created by wiping off pigment to reveal the grey of the paper.)

Textural detail – the folds in the elephant's skin and the grasses in the foreground – is also important in this scene. However, it's very easy to get carried away and put in so much detail that you lose sight of the drawing as a whole. Your aim should be to create a general impression rather than to put in every single line. You also need to put in the foreground in order to 'anchor' the animal in the picture space.

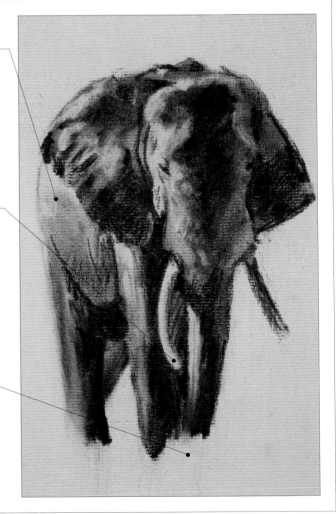

The elephant's skin looks too smooth; putting in the highlights in the folds of skin will create the necessary texture.

Pigment has been wiped off to reveal the mid tones of the tusks. Adding a highlight along one edge will make the tusk look three-dimensional.

Adding the foreground will 'anchor' the elephant in the scene.

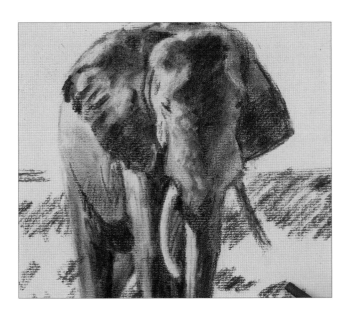

9 Using the charcoal, put in the horizon line and then smudge it with your fingertips to soften it. Scribble in the clumps of grasses in the foreground. There's no need to try to include every single one – a general impression will suffice.

10 Using a white pastel pencil, put in the highlighted edges of the tusks. Remember that it's only the edge that is highlighted: if you make the whole tusk white, it will not look rounded.

11 Using a white pastel pencil, put in the highlights on the head and right flank, to create some texture in the folds of skin. Vary the amount of pressure you apply to the pencil, depending on how bright you want the highlights to be. These highlights are the edges of the skin creases, which catch the light.

12 Using the black pastel pencil, lightly put in some textural markings on the flank, right foreleg, head and trunk – the deep creases and folds in the skin. Note that there is no real 'line' around the edge of the brightly lit flank. If you put in a dark outline, you would not be able to get rid of it.

Tip: Place a piece of scrap paper over the part of the drawing that you're not working on, this will help to prevent you from accidentally smudging it with your drawing hand.

Tip: Don't press too heavily on the pencil: you need to put in some light markings first to assess exactly how deep and dark these creases and folds in the skin need to be.

▶

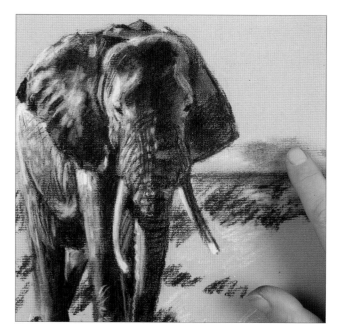

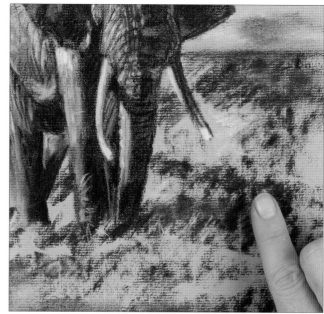

13 Using the white pastel pencil, lightly scribble in some light tones in the foreground. Using the side of the charcoal, block in the shapes of the mountains in the background, then blend the marks with your fingers.

> **Tip**: Make sure that you make the background mountains lighter in tone than the foreground, as this helps to create an impression of distance.

14 Using the side of the charcoal, roughly block in the mid tones in the foreground, leaving the earlier marks for the clumps of grass showing through and leaving some gaps for the lighter parts. Blend the marks with your fingertips. Note that the elephant's body casts a shadow on the grass; this area needs to be darker than the rest of the foreground.

> **Tip**: It is easier to assess the tones if you half-close your eyes.

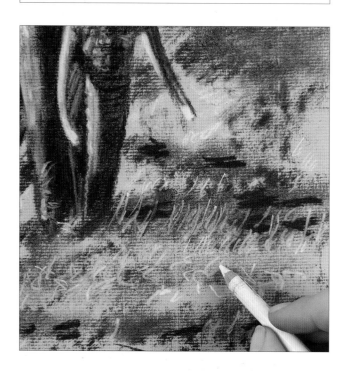

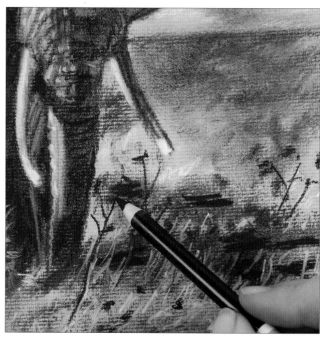

15 Using a white pastel pencil, scribble in only the most brightly lit grasses.

16 Using the black pastel pencil, put in some of the tall, dark grasses to add more texture in the foreground.

The finished drawing

This deceptively simple-looking charcoal study is full of interest. By carefully observing the different tones, the artist has created a real feeling of the bulk and solidity of the animal. The skin textures are convincing, but not overworked or fussy. The bright light on one side gives an impression of the strong African sunlight and contributes to the overall mood of the scene. The surroundings have been kept simple, so as not to detract from the elephant, but there is enough detail to place the animal in a recognizable environment and create an impression of scale and distance.

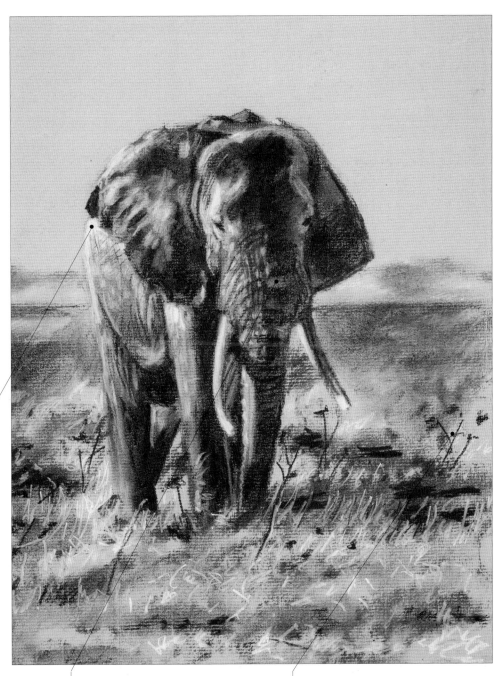

Note how the absence of a dark outline around this area conveys the feeling of strong sunlight hitting the animal.

The contrast between deep, dark creases and sharp, highlighted edges beautifully conveys the texture of the elephant's skin.

The contrast between the textured foreground grasses and the smooth background creates a sense of distance.

Tree frog in gouache

With its emerald green head and back, bright blue inner legs, orange toes and huge, comically bulging eyes, the red-eyed tree frog is tremendously appealing to paint.

You can see from the photograph on the right how well the green coloration of the frog blends in with the foliage on which it spends much of its life. Your main challenge here is to create subtly different tones of green so that the frog stands out sufficiently from the background. Careful assessment of the tones and colour mixes is essential; test your mixes on a piece of scrap paper before you apply them.

Here the artist elected to use a beginner's 'starter set' of ten gouache paints. The set included just one ready mixed and relatively dark green, so virtually all the greens had to be mixed from scratch. This is a really useful exercise; why not try to see how many different greens and tones of green you can mix from the colours in your own set of paints.

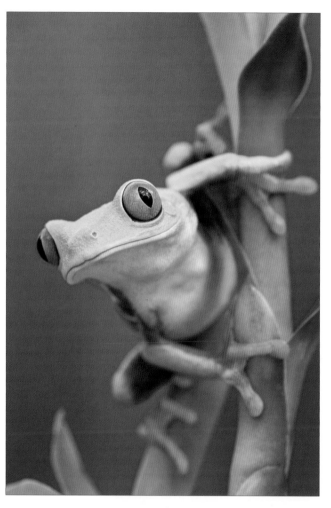

Materials
- *NOT or cold-pressed fine-grain watercolour paper*
- *6B pencil*
- *Gouache paints: permanent green, permanent yellow deep, yellow ochre, zinc white, primary yellow, primary blue, spectrum red, primary red, ivory black, ultramarine*
- *Brushes: selection of rounds and flats*

The subject
The most important thing with this subject is to take note of how many different tones and shades of green there are, from blue-tinged greens near the base of the main stalk to yellowy greens in the more brightly lit upper sections and the pale green of the frog's body.

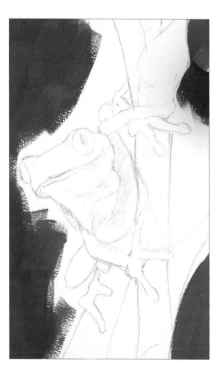

1 Using a soft (6B) pencil, sketch the subject. Put in some light hatching for the shadow across the frog's chest to use as a point of reference when you come to lay down the colours. Mix a rich, dark green from permanent green, permanent yellow deep and yellow ochre. Using a medium flat brush, put in the darkest green in the background, painting around the frog and stalks.

2 Add white and a little primary yellow to the background mix to make a paler green, and put in the mid green of the leaves. Add more yellow as you work towards the top of the stalks. Mix a pale blue from primary blue and white and put in some of the blue-tinged leaves at the base of the stalks. Add blue to the dark green mix from Step 1 and put in the dark green of the curled, shaded leaves.

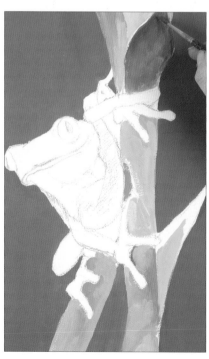

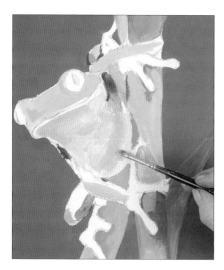

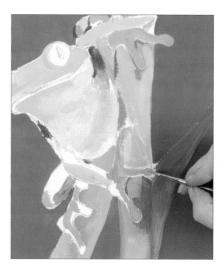

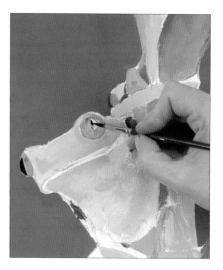

3 Using a paler version of the green from Step 2, block in the green of the frog. Add primary yellow for the edges of the arms. Mix a purple from spectrum red and primary blue and put in the most darkly shaded parts of the frog's body. Add white and scrub this colour on the frog's chest, leaving the highlights white. Mix a pale pink from spectrum red and white and paint the shadow on the frog's chest.

4 Parts of the feet and 'hands' are more pink than orange; paint them with a pink mixed from primary red and white. Mix a bright orange from permanent yellow deep, primary red and a little primary yellow and paint the orange parts of the feet and hands, blending the orange into the pink so that there are no hard-edged transitions between the two colours.

5 Mix a rich orange from spectrum red and permanent yellow deep and paint the orange of the eyes, leaving the pupils untouched. Apply pure ivory black for the pupils, leaving a tiny highlight in the left pupil untouched.

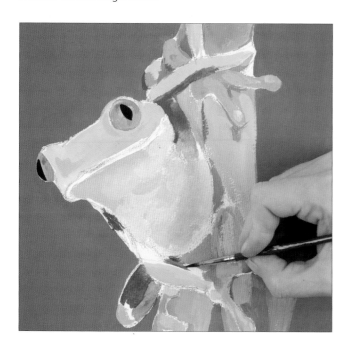

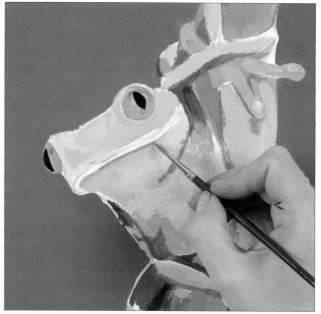

6 Parts of the frog are a surprisingly bright and rich blue. Mix ultramarine blue and primary blue together to create this colour and touch in this blue wherever necessary on the arms and legs. If you want a paler blue, add water rather than white. If you add white, you won't get the degree of brightness that you require.

7 Using a slightly darker version of the purple and white mix from Step 3, put in the shadows under the toes, fingers and mouth and across the chest.

▶

Assessment time

The painting is nearing completion and it's time to step back and work out what final refinements are required. The background and foliage are complete, but the frog still looks rather flat and one-dimensional – almost like a cartoon caricature. Putting in highlights on the head and shadows under the mouth and across the chest will make it look more three-dimensional and lifelike.

With no highlight, the eye looks dull and lifeless.

Shadows are needed under the upper lip and chin to make the mouth appear three-dimensional.

More modelling is required on both the head and chest.

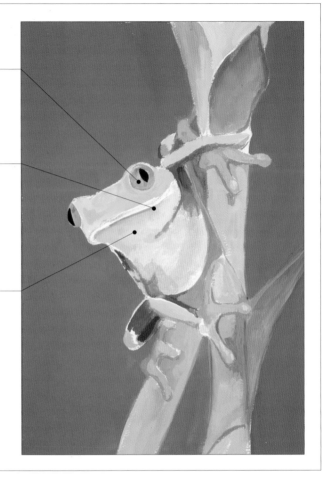

8 Add lots of white to the pale green mix from Step 2 and, using a fine round brush, put in the lightest tones on the frog's head, so that you begin to create more modelling in this area.

9 Mix a very pale yellow from permanent yellow deep and white and put in a line under the mouth. Use very dilute white for the highlights on the body to create more modelling. Apply fine lines of blue to the edges of the frog's legs and some of the leaves to make the edges recede. Deepen the colour of the pink shadow on the chest.

10 Strengthen the purple shadow under the mouth and across the chest. Using the same pink and orange mixes as before, improve the modelling on the arms and legs. Paint around the inside edge of the eyeballs in black. Note that this black line does not go all the way around the eye, but only halfway: only part of each eyeball is visible. Add the highlight in the left eye, using white.

The finished painting

This is, at first glance, a deceptively simple-looking painting, but it requires very careful observation of the tones in order to look convincing. It is normally not recommended that a subject is placed in the very centre of the picture space, but here the approach works; it imparts a feeling of calm to the composition. Note how the artist has slightly exaggerated the tonal differences in the greens – a bit of artistic licence that is essential in order for the stalks and the frog to stand out from each other and from the dark green background. The highlights and shadows on the frog are subtle, but make it look really three-dimensional.

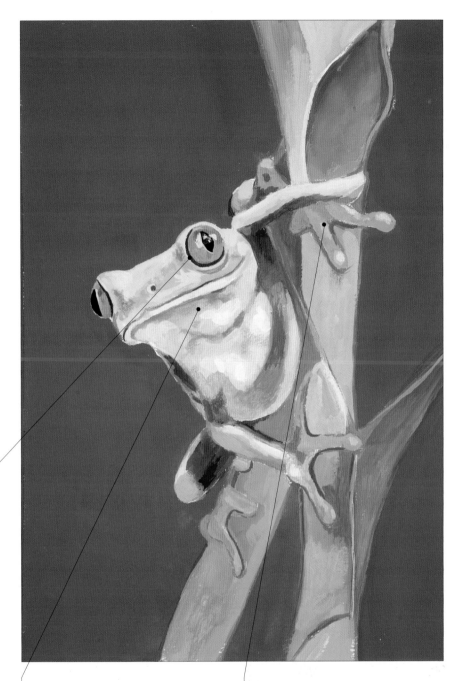

The black line around the rim and the highlight in the centre of the eye are vital in bringing the subject to life.

Shadows on the chest and under the chin reveal the form of the frog's body.

Note the shadows and highlights on the feet – essential to making the frog look three-dimensional.

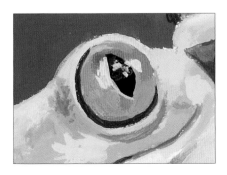

Tortoise in mixed media

Tortoises and turtles have striking and often quite intricate shell markings. As they age, ridges are formed on the shells in much the same way as growth rings form year by year in a tree. Along with scuffs and scratches acquired along the way, these ridges create fascinating textures that are a delight to draw and paint. This mixed-media demonstration combines watercolour and oil pastel, together with several textural techniques.

Watercolour washes in the initial stages provide a warm undercolour, with oil pastel being stippled on top for the scales on the animal's head and legs. The ridged highlights on the shell are created in two ways. First, masking fluid is used to preserve the white of the paper. Second, in a variation on the traditional sgraffito technique, lines are carefully incised into the paper and then it is covered with oil pastel; the oil pastel adheres to the surface of the paper but not to the incised lines, creating thin lines for the ridges on the tortoise's shell. It's absolutely vital that you are not heavy-handed: if you

scratch too vigorously you will tear the paper, and if you press too heavily on the oil pastel, the pigment will sink into the incised lines.

Do not attempt to put in every single line, highlight or scratch that you can see – otherwise you'll get bogged down in a plethora of detail and will lose sight of the painting as a whole. Instead, aim to create a general impression of the lines and textures, and treat the subject in quite a loose way. Above all, keep looking at your painting as a whole throughout the process, so that you do not fall into the trap of overworking one part at the expense of the rest.

Materials
- *Watercolour paper*
- *HB pencil*
- *Masking fluid with applicator (or old brush)*
- *Watercolour paints: cadmium yellow, yellow ochre, indigo, alizarin crimson*
- *Brushes: medium round, fine round*
- *Oil pastels: dark grey, blue-grey, pale grey, off-white, yellow ochre*
- *Scraperboard tool*

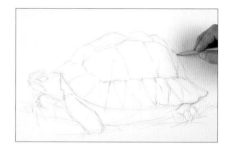

1 Using an HB pencil, lightly sketch the subject and begin marking in the triangular sections of the shell.

2 Carefully apply masking fluid over the highlit ridges on the shell and some of the paler grasses under the tortoise's body and leave to dry.

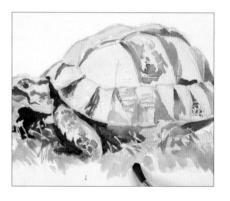

3 Mix a dilute warm yellow from cadmium yellow and yellow ochre watercolour paints. Wash it over the tortoise and grass to give a warm-coloured undertone. Mix a dark blue-black from indigo and alizarin crimson. Put in the dark shadow under the shell and head, then paint in the dark markings on the head and shell. Mix a dark green from cadmium yellow and indigo. Put in the foreground grass, using jagged, spiky strokes.

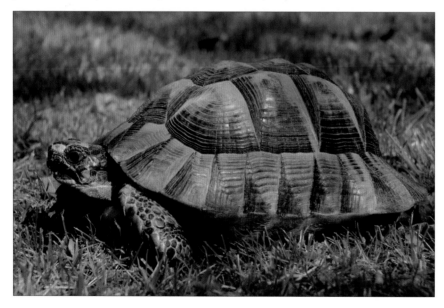

The subject
With relatively small animals such as this tortoise, your viewpoint can make a huge difference. Here, the artist crouched down in order to be able to view the tortoise more or less at eye level and from the side; as a result, the head, front legs and a small portion of the underbelly are all visible. This provides a more engaging image than an overhead viewpoint.

Assessment time

The watercolour stage of the painting is now complete, with the warm base colour and the dark areas of the shell and head applied as very light watercolour washes. From this stage onwards, you need to concentrate on developing the tonal contrasts, so that the shell looks three-dimensional, and on picking out the textural detail on both the shell and scaly head and legs.

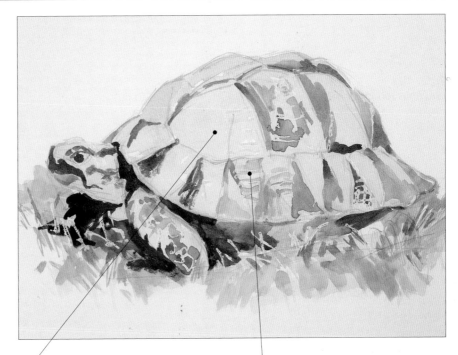

The different planes of the shell are not clearly defined.

The masking fluid preserves the white of the paper for the very brightest highlights on the shell.

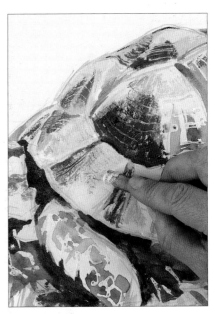

4 Using a scraperboard tool, scratch thin lines into the tortoise shell.

Tip: Use the back of the blade, so that you don't tear the paper.

5 Gently stroke dark grey, blue-grey, pale grey and off-white oil pastels over the scratches. The oil pastel will adhere to the surface of the paper but not to the indentations, leaving a series of thin, bright lines for the ridges on the shell.

6 Continue using the scraperboard tool and oil pastels to create textural marks all over the shell.

▶

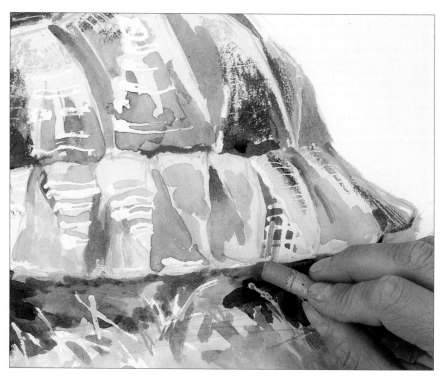

7 Using your fingertips, carefully rub off the masking fluid to reveal the white of the paper for the very brightest highlights.

8 Strengthen the shadow areas and paint the tortoise's back legs, using the blue-black colour mix from Step 3. Where the masking fluid has been rubbed off in the foreground grasses, touch in a watered-down version of the green colour mix from Step 3. Apply more warm yellow tone to the shell and underbelly using a yellow ochre oil pastel.

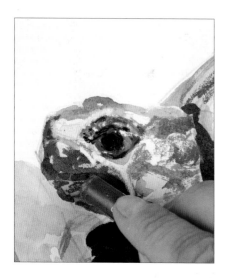

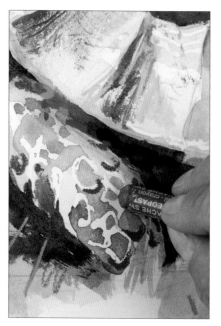

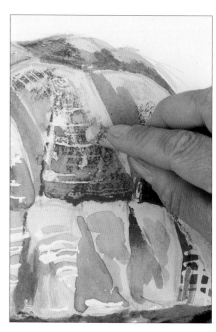

9 Colour the iris of the eye with a yellowy olive green oil pastel, remembering to leave some tiny flecks of white paper showing through for the highlights. Reinforce the detail on the head with grey and blue-grey pastels, paying careful attention to the tones to describe the different planes of the head.

10 The left front leg is a little too bright and distracting; stipple on dark grey pastel to tone down the brightness and create the scaly texture of the skin.

11 Using the grey oil pastels, tone down any overly bright areas on the shell.

The finished painting

This study exploits the translucency of watercolour and the smooth, opaque nature of oil pastels without allowing either medium to dominate. The ridges and scratches on the tortoise's shell add interesting textures to an otherwise simple painting. Note how well the artist has observed the light that reflects off both the scaly skin and the shell, indicating minor changes of plane; these highlights, created by using masking fluid to preserve the white of the paper, contrast with the darker tones to create a realistic and convincingly three-dimensional study.

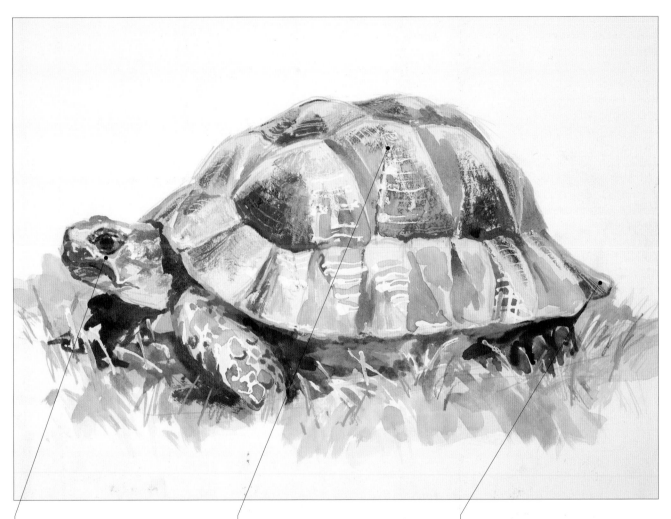

The head and eye are the focal points of the painting; had the eye been closed, the image would not have had nearly so much impact.

The highlights on the shell are created by using masking fluid and by scratching into the support.

The background has been deliberately left untouched, so as not to detract from the tortoise.

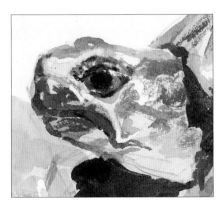

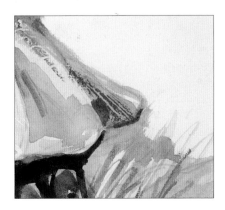

Glossary

Additive A substance added to paint to alter characteristics such as the paint's drying time and viscosity.

Alla prima A term used to describe a work (traditionally an oil painting) that is completed in a single session. *Alla prima* means 'at the first' in Italian.

Blending Merging adjacent colours or tones so that they gradually merge into one another.

Body colour Opaque paint, such as gouache, which can obliterate underlying paint colour on the paper.

Charcoal Charcoal is made by charring willow, beech or vine twigs at very high temperatures in an airtight kiln. It is available in powder form and as sticks. It can also be mixed with a binder and pressed into sticks ('compressed' charcoal).

Colour
Complementary: Colours opposite one another on the colour wheel.
Primary: A colour that cannot be produced by mixing other colours, but can only be manufactured. Red, yellow and blue are the three primary colours.
Secondary: A colour made by mixing equal amounts of two primary colours.
Tertiary: A colour produced by mixing equal amounts of a primary colour and the secondary colour next to it on the colour wheel.

Colour mixing
Optical colour mixing: Applying one colour on top of another in such a way that both remain visible, although the appearance of each one is modified by the other. Also known as *broken colour*.
Physical colour mixing: Blending two or more colours together to create another colour.

Cool colours Colours that contain blue and lie in the green-violet half of the colour wheel.

Composition The way in which the elements of a drawing are arranged within the picture space.

Closed composition: One in which the eye is held deliberately within the picture area.

Open composition: One that implies that the subject or scene continues beyond the confines of the picture area.

Conté crayon A drawing medium made from pigment and graphite bound with gum. Conté crayons are available as sticks and as pencils.

Drybrush The technique of dragging an almost dry brush, loaded with very little paint, across the surface of the support to make textured marks.

Eye level Your eye level in relation to the subject that you are drawing can make a considerable difference to the composition and mood of the drawing. Viewing things from a high eye level (looking down on them) separates elements in a scene; when viewed from a low eye level (looking up at them), elements tend to overlap.

Fat over lean A fundamental principle of oil painting. In order to minimize the risk of cracking, oil paints containing a lot of oil ('fat' paints) should never be applied over those that contain less oil ('lean' paints) – although the total oil content of any paint mixture should never exceed 50 per cent.

Fixative A substance sprayed on to drawings made in soft media such as charcoal, chalk and soft pastels to prevent them from smudging.

Foreshortening The illusion that objects are compressed in length as they recede from your view.

Form *See* Modelling.

Format The shape of a drawing or painting. The most usual formats are landscape (a drawing that is wider than it is tall) and portrait (a drawing that is taller than it is wide), but panoramic (long and thin) and square formats are also common.

Glaze A transparent layer of paint that is applied over dry paint. Light passes through the transparent glaze and is reflected back by the support or any underpainting. Glazing is a form of optical colour mixing as each glaze colour is separate from the next, with the mixing taking place within the eye.

Gouache *see* Body colour.

Graphite Graphite is a naturally occurring form of crystallized carbon. To make a drawing tool, it is mixed with ground clay and a binder and then moulded or extruded into strips or sticks. The sticks are used as they are; the strips are encased in wood to make graphite pencils. The proportion of clay in the mix determines how hard or soft the graphite stick or pencil is; the more clay, the harder it is.

Ground The prepared surface on which an artist works. Also a coating such as acrylic gesso or primer, which is applied to a drawing or painting surface.

Hatching Drawing a series of parallel lines, at any angle, to indicate shadow areas. You can make the shading appear more dense by making the lines thicker or closer together.

Crosshatching: A series of lines that crisscross each other at angles.

Highlight The point on an object where light strikes a reflective surface. Highlights can be drawn by leaving areas of the paper white or by removing colour or tone with an eraser.

Hue A colour in its pure state, unmixed with any other.

Impasto Impasto techniques involve applying and building oil or acrylic paint into a thick layer. Impasto work retains the mark of any brush or implement used to apply it.

Line and wash The technique of combining pen-and-ink work with a thin layer, or wash, of transparent paint (usually watercolour) or ink.

Mask A material used to cover areas of a drawing, either to prevent marks from touching the paper underneath or to allow the artist to work right up to the mask to create a crisp edge. There are three materials used for masking – masking tape, masking fluid and masking (frisket) film.

Medium (1) The material in which an artist chooses to work – pencil, pen, pastel and so on. (The plural is 'media'.) (2) In painting, 'medium' is also a substance added to paint to alter the way in which it behaves – to make it thinner, for example. (The plural in this context is 'mediums'.)

Modelling Emphasizing the light and shadow areas of a subject through the use of tone or colour, in order to create a three-dimensional impression.

Negative shapes The spaces between objects in a drawing, often (but not always) the background to the subject.

Overlaying The technique of applying layers of watercolour paint over washes that have already dried in order to build up colour to the desired strength.

Palette
(1) The container or surface on which paint colours are mixed.
(2) The range of colours.

Perspective A system whereby artists can create the illusion of three-dimensional space on the two-dimensional surface of the paper.

Aerial perspective: The way the atmosphere, combined with distance, influences the appearance of things. Also known as *atmospheric perspective*.

Linear perspective: This system exploits the fact that objects appear to be smaller the further away they are from the viewer. The system is based on the fact that all parallel lines, when extended from a receding surface, meet at a point in space known as the vanishing point. When such lines are plotted accurately on the paper, the relative sizes of objects will appear correct in the drawing.

Single-point perspective: This occurs when objects are parallel to the picture plane. Lines parallel to the picture plane remain parallel, while parallel lines at 90° to the picture plane converge.

Two-point perspective: This must be

used when you can see two sides of an object. Each side is at a different angle to the viewer and therefore each side has its own vanishing point.

Picture plane An imaginary vertical plane that defines the front of the picture area and corresponds with the surface of the drawing.

Positive shapes The tangible features (figures, trees, buildings, still-life objects etc.) that are being drawn.

Primer A substance that acts as a barrier between the support and the paints. Priming provides a smooth, clean surface on which to work.

Recession The effect of making objects appear to recede into the distance, achieved by using aerial perspective and tone. Distant objects appear paler.

Resist A substance that prevents one medium from touching the paper beneath it. Wax (in the form of candle wax or wax crayons) is the resist most commonly used in watercolour.

Sgraffito The technique of scratching off pigment to reveal either an underlying colour or the white of the paper. The word comes from the Italian verb *graffiare*, which means 'to scratch'.

Shade A colour that has been darkened by the addition of black or a little of its complementary colour.

Sketch A rough drawing or a preliminary attempt at working out a composition.

Solvent *See* Thinner.

Spattering The technique of flicking paint on to the support.

Support The surface on which a drawing is made – often paper, but board and surfaces prepared with acrylic gesso are also widely used.

Thinner A liquid such as turpentine which is used to dilute oil paint. Also known as *solvent*.

Tint A colour that has been lightened. In pure watercolour a colour is lightened by adding water to the paint.

Tone The relative lightness or darkness of a colour.

Tooth The texture of a support. Some papers are very smooth and have little tooth, while others have a very pronounced texture.

Torchon A stump of tightly rolled paper with a pointed end, using for blending powdery mediums such as soft pastel, charcoal and graphite. Also known as *paper stump* or *tortillon*.

Underdrawing A preliminary sketch on the canvas or paper, over which a picture is painted. It allows the artist to set down the lines of the subject, and erase and change them if necessary, before committing irrevocably to paint.

Underpainting A painting made to work out the composition and tonal structure before applying colour.

Value *See* Tone.

Vanishing point In linear perspective, the vanishing point is the point on the horizon at which parallel lines appear to converge.

Viewpoint The angle or position from which the artist chooses to draw his or her subject.

Warm colours Colours in which yellow or red are dominant. They lie in the red-yellow half of the colour wheel and appear to advance.

Wash A thin layer of transparent paint. Flat wash: An evenly laid wash that exhibits no variation in tone.

Gradated wash: A wash that gradually changes in intensity from dark to light, or vice versa.

Variegated wash: A wash that changes from one colour to another.

Wet into wet The technique of applying paint to a wet surface or on top of an earlier wash that is still damp.

Wet on dry The technique of applying paint to dry paper or on top of an earlier wash that has dried completely.

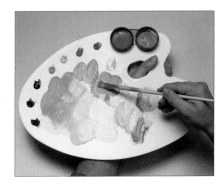

Index

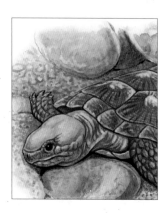